the best

MUSIC
CD ART
+DESIGN

the best

MUSIC CD

ART
+DESIGN

ROCKPORT PUBLISHERS
Gloucester, Massachusetts

Distributed by
North Light Books, Cincinnati, Ohio

The Best Music CD Art & Design

First published in the
United States of America by:

Rockport Publishers, Inc.

33 Commercial Street
Gloucester, Massachusetts
01930-5089
Telephone: (508) 282-9590
Fax: (508) 283-2742

Distributed to the book trade and
art trade in the United States by:

North Light Books,
an imprint of
F & W Publications
1507 Dana Avenue
Cincinnati, Ohio 45207
Telephone: (800) 289-0963

Other Distribution by:

Rockport Publishers, Inc.
Gloucester, Massachusetts

ISBN 1-56496-367-5

10 9 8 7 6 5 4 3 2 1

Designer:
PandaMonium Designs/Boston

Manufactured in China

Color separations by
Primaz Production Ltd.

Front cover cover, Aerosmith *Pump* (see p.128)
disc sleeve, John Coltrane *The Heavyweight Champion* (see p.85)

cover, Jay Geils & Magic Dick *Bluestime* (Rounder)—designers, Scott Billington and Nancy Given; photographer, Jean Hangarter

Back Cover panel from booklet, B.B. King *Blues Summit* (MCA)—designer O'Brien; art director, Vartan; photographers, Vartan and Cesar Vera; printer, Colby Poster

panel from booklet, R.L. Burnside *Too Bad Jim* (Fat Possum/Capricorn)—designer and imager, Richard C. Allen; art director, Bill Brunt Designs; photographers, Sue Kellog and Lauri Lawson

Contents

Foreword

by Ronnie Earl

When I was growing up in New York City, blues was not popular, so all I had to go by a lot of times was the album covers. I used to go to Greenwich Village to hear jazz, and I'd visit Dayton Records while I was there. And I started to discover an entire world of the blues.

I saw Magic Sam's *West Side Soul,* and the cover was totally green. I thought, "Wow! I've gotta have that!" There was Lightnin' Hopkins, who looked so cool in his Ray-Ban shades. *Freddie King Does Bonanza* had a picture of Freddie, this huge, mysterious guy in a green suit sitting on a park bench. The back of *South Side Blues Jam,* where Buddy Guy is playing guitar and Junior Wells is pleading, with his hands held out before the microphone—that's my favorite picture in the blues. It's a live shot, in the studio—the essence of Chicago blues.

And that T-Bone Walker album, *T-Bone Blues*, where he's playing his ES-5 behind his head. That was such an exciting thing to see. Vanguard had this series, *Chicago! The Blues! Today!*, and seeing the city scenes—the snow and the "El" trains—made me want to go there. And on all of his covers, Magic Sam seemed to be wearing a three-colored shirt. I spent hours looking at that shirt, wondering where I could get one just like it.

Those covers helped me understand more about the lives of the people playing the songs. I looked at some of those pictures for hours, seeing the sad expressions that were often on their faces. I looked at how long their fingers were, what they wore—anything that could help explain why these records sounded the way they did.

Great album covers give you something special to look at while listening to the music, like a program at a ball game. And if there are liner notes, that's a bonus. You can read and listen and look at the artwork for hours, just trying to figure it all out. But the most important thing that I started to feel coming from those album covers is a lot of soul. And *that's* where the blues comes from.

Introduction

by Ted Drozdowski and Laurie Hoffma

There's something ironic about collecting album art in the CD era, when a 12-by-12-inch canvas has been shrunk to a 5-inch square. Especially for blues recordings, because the music has no room for irony. Blues performers wear their hearts on their sleeves in every song, tell their life stories in every breath, in each note.

And so the visual artists charged with creating blues CD covers must evoke that spirit; they must convey the essence of a musician's life and work in a medium barely a flash card on a record store shelf. This is considerably less daunting than working the cotton fields or the juke joints for a living, but still a formidable challenge.

"The goal is to express the music visually," says Flournoy Holmes, who designed the iconic rendering of Arkansas bluesman CeDell Davis featured in this book. But the means to that end have changed radically since the day when Holmes was creating classic LP covers such as the Allman Brothers' *Eat a Peach*. Oil paintings and the glorious photos of the Blue Note heyday have been replaced by computer-manipulated type and images.

Yet the standardized use of software such as QuarkXPress and Adobe Photoshop brings an esthetic to CD packaging design egalitarian as the themes of the blues itself. Now, albums released by small, independent labels like Evidence and Black Top can compete visually with big-budget giants like MCA Records. And studying the blues sections in today's music emporiums, common ground emerges.

The half-dozen chapters of this collection each represent a style, a prevalent look that blues labels have chosen to speak for their artists. The CD designs reproduced herein aim to convey in their flash-card statements whether an artist is working in a mode that speaks directly of an earlier era ("Retro-Nuevo"), coming from a deep-roots place ("Downhome"), or trying to compete within the clean, modern world of pop and R&B ("Classic"). Some designs convey a distinct personal take—from the point of view of the designer, or the musician—on their music ("Conceptual"). Others aim to extend the boundaries of audience and period with bold, modernist visual appeal ("Pop Art"), or to deconstruct pat images to transcend the expectations that the familiar can impose on a musical form and its potential audience ("Post-Modern").

For the reader and blues fan, we hope that time spent with this volume is nearly as pleasurable and rewarding as the music itself. And we hope that the album covers do their job: enticing the listener to discover the music that lies within.

John Lee Hooker
Chill Out *(Pointblank Records)*

Photographer Anton Corbijn's taken the same wry approach with John Lee Hooker as he's often done with his well-known photos of rock stars like the members of U2 and Nine Inch Nails' Trent Reznor. This is a parody of a classic photo-studio shoot, with the world's coolest octogenarian shown seated in front of a faux winter scene. (Remember those terrible class pictures you posed for in grade school?) But the joke plays into the singer/guitarist's savvy hipster persona. The light-hearted theme continues on the back of the booklet and on the facing tray card, where Corbijn works with Hooker's hands—the conduit of his musician's spirit. Hooker turns them into otherworldly paws; and when you remove the CD from the case, his right hand seems to have been holding it in place.

designer
Rex Sforza

art director
Len Peltier

photographer
Anton Corbijn

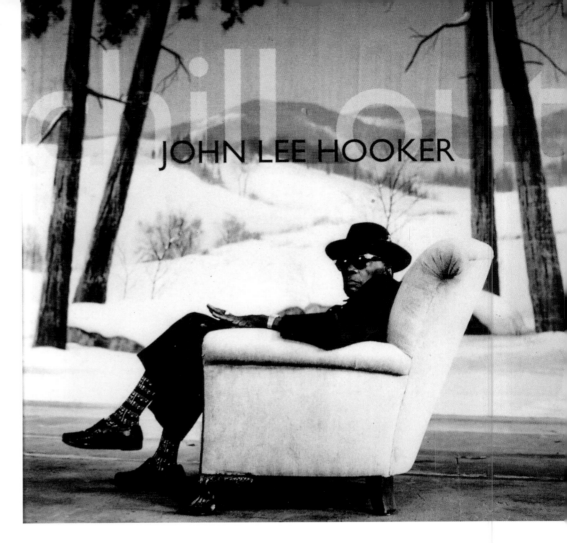

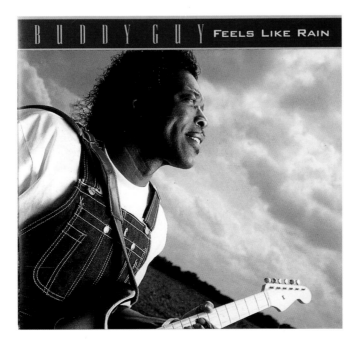

Buddy Guy
Feels Like Rain *(Silvertone Records)*

It took Buddy Guy, the legendary singer/guitarist and a primary architect of Chicago's hard West Side sound, nearly thirty years to rise to a major label. This contemporary look reflects *Feels Like Rain*'s crossover instincts. Obviously the result of a big-budget photo shoot, this cover fits comfortably into racks next to releases by such mainstream R&B singers as R. Kelly and Mary J. Blige.

designer
ZombArt:NG

photographer
Gary Spector

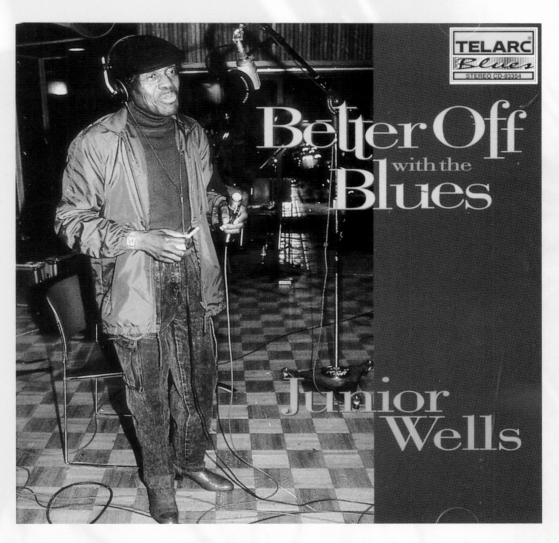

Junior Wells
Better Off with the Blues *(Telarc)*
Mood and personality meet in this portrait of Chicago harmonica legend Junior Wells at work in the studio. The subdued lighting sets the tone for Wells's bittersweet music. Although he's not in the bowler hat or clean-pressed button-down shirt with gold cuff links that's become his stage uniform, he looks every bit the hipster in jeans with deep side pockets to hold his harps.

designer and art director
Anilda Carrasquillo

photographer
Frank Micelotta

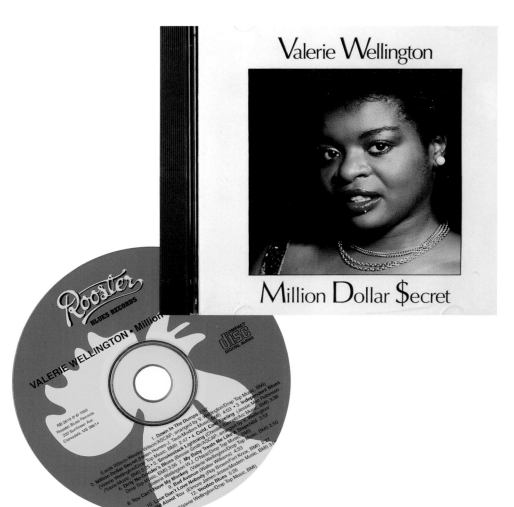

Valerie Wellington
Million Dollar $ecret
(Rooster Blues)

This photo captures Valerie Wellington's youth, but her finely made hair, simple-but-elegant jewelry, and exposed gown strap place her in the context of such great blues divas as Bessie Smith and Ma Rainey. By the time Rooster Blues reissued this 1983 debut recording—which features an ensemble of all-star Chicago musicians—the promising singer and actress had died of a brain aneurysm at age thirty-three.

photographer
Doyle Wicks

typographer
Colin Buchanan

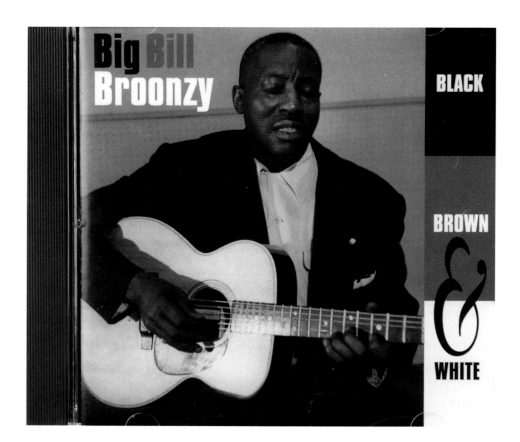

Big Bill Broonzy
Black, Brown & White
(Evidence Music)

Big Bill Broonzy was a fixture of the Chicago scene when McKinley Morganfield took the name Muddy Waters and moved north from Mississippi. Waters appropriated Broonzy's performance style, recorded here in the early 1950s, and electrified it. He also adopted his sartorial bent; compare Broonzy's tieless shirt, matching handkerchief, and jacket to photos of young Waters in his performing glory.

art director
Rothacker Advertising & Design

photographer
David Gahr

Bonnie Lee
Sweetheart of the Blues
(Delmark Records)

Fifty years after beginning her career as a blues singer, Chicago's sweet-faced Bonnie Lee finally has released her first full-length album. So if she seems content here, that's understandable. Looking at Lee, you can tell a lot about her style of blues: it echoes an earlier, more romantic era when singers like Koko Taylor and Etta James were the reigning tough-but-vulnerable balladeers.

designer
Preface, Inc.

photographer (cover)
Peter Amft

photo (inside)
**Courtesy of Jim O'Neal/
Living Blues Collection**

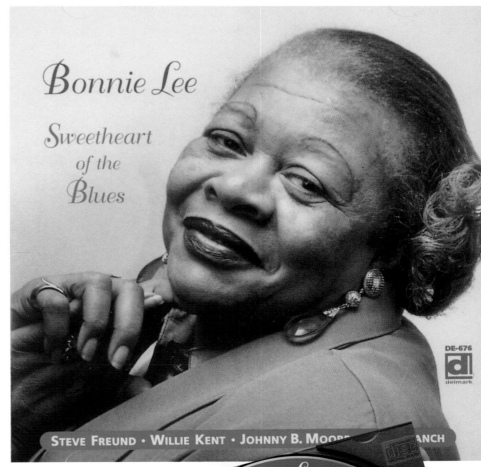

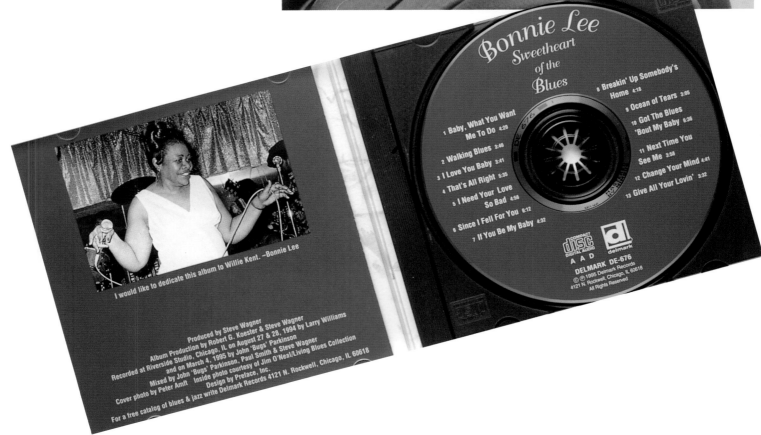

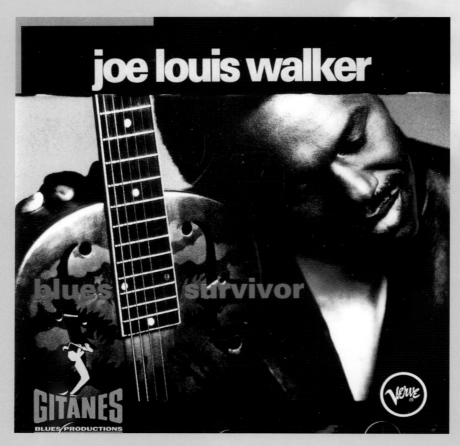

Joe Louis Walker
Blues Survivor *(Gitanes Blues Productions/Verve Records)*
Graduating to a major label was more than a matter of survival for West Coast singer/guitarist Joe Louis Walker. His explorations of horn-tinted arrangements and gospel harmonies required more elaborate production values than his independent label releases. But the country blues connotation of the cover photo, which portrays the man and his dobro, implies he hasn't strayed too far from his down-home roots.

designer
CB Graphic

art director
Patrice Beauséjour

photographer
Carol Friedman

Kim Wilson
Tigerman *(Antone's)*

This cover is a good example of a character portrait that doesn't jive with the CD's title. Observe the balding pate, the slightly bulging eyes, the pudgy cheeks. *Tigerman?* More like pussycat. Luckily, Fabulous Thunderbirds frontman Kim Wilson is a serious musician and a blues scholar, so his Detroit-via-Dixieland hard-blues sound nonetheless delivers on this CD of mostly chestnuts.

designers and art directors
Bill Narum and Dick Reeves

photographer
Will Van Overbeek

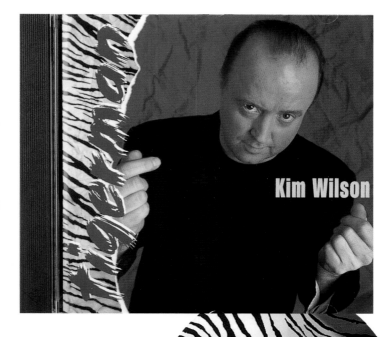

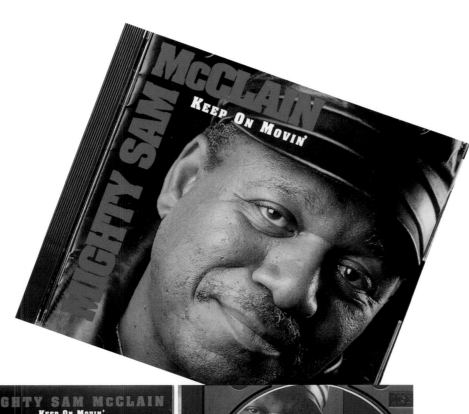

Mighty Sam McClain
Keep On Movin'
(AudioQuest)

Words like "sincere" and "soulful" best describe the Florida-born Mighty Sam McClain's face. They can be used to describe his music, too, which broils the details of his colorful life into blues, R&B, and gospel-fired vignettes. Although he looks peaceful and unassuming, the Handy-nominated McClain—who sings with unbridled passion—may be the last great red-clay soul singer in America. And he's one of the best contemporary songwriters in blues, to boot.

designer and art director
Hillary Weiss/HW Design

photographer (cover)
Mark Morelli

photographer (liner)
Catherine Sebastian

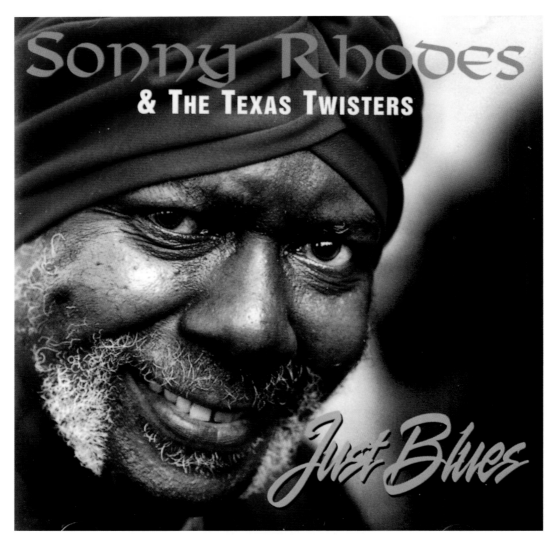

Sonny Rhodes & the Texas Twisters

Just Blues *(Evidence Music)*

A lupine grin and turban are as much trademarks of this Texas guitarist as his proclivity for playing the blues on lap-steel guitar. Although the nine songs on this 10-year-old recording are mostly classics, the photo is current—state of the art(ist) Sonny Rhodes. Originally, this album had a black and white cover, and was put out by Rhodes himself on a $5,000 budget.

art director
Rothacker Advertising & Design

photographer
Robert Barclay

Pinetop Perkins

Pinetop Perkins with the Blue Ice Band featuring Chicago Beau
(Earwig Music Company)

The Blue Ice Band is from Iceland, but Joe Willie "Pinetop" Perkins was born in Belzoni, Mississippi, the Delta city known as the "catfish capital of the world." Look at the guy: at 83 years old, he's still feisty, still touring, and still practicing the barrelhouse, boogie-woogie piano he first learned from his stepfather in the 1920s, and then from 78s by Leroy Carr, Roosevelt Sykes, and Pinetop Smith.

designer
Terran Doehrer, Earth Star Graphics

photographer
James Fraher

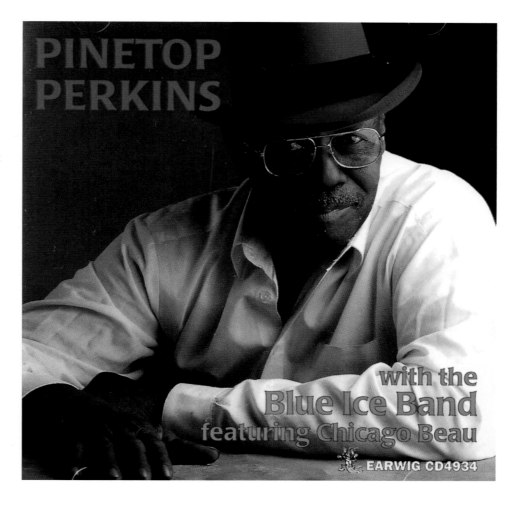

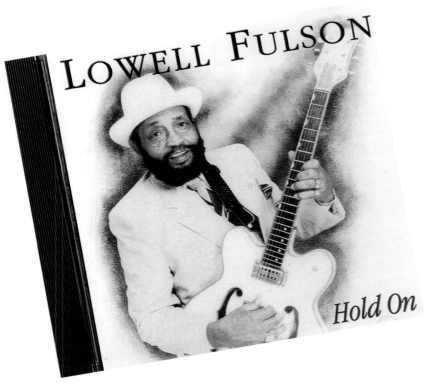

Lowell Fulson

Hold On *(Bullseye Blues)*

Here's a strong variation on the old standby of the bluesman with his instrument. With a little computer manipulation, this E. K. Waller photo of the author of the classics "Reconsider Baby" and "Black Night" becomes a pastel portrait, and the shades of Lowell Fulson's skin tone and matching tie and handkerchief emerge warmly from the cover. The music inside is equally vivid.

designer
Nancy Given

photographer
E. K. Waller

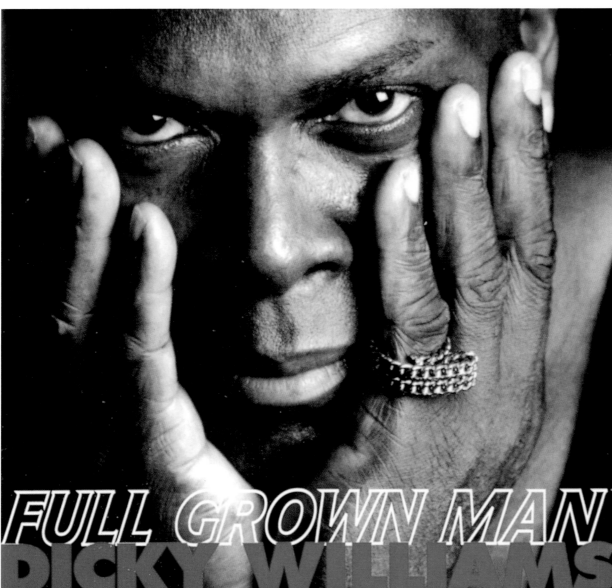

FULL GROWN MAN
DICKY WILLIAMS

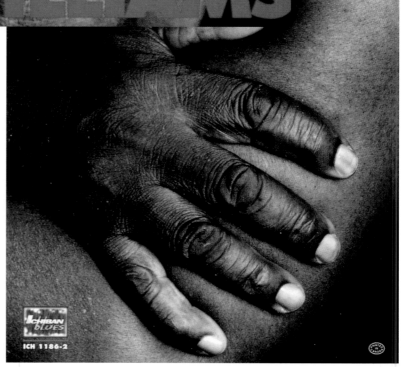

Dicky Williams
Full Grown Man *(Ichiban)*
Photographer Emmett Martin may have taken some inspiration from Irving Penn's photo on the back cover of Miles Davis' *Tutu* LP. But, as any good musician knows, if you're gonna cop licks, you should cop them from the best. This is a beautiful shot, capturing the rich texture of soul-blues singer Dicky Williams' skin, letting his eyes invite us into his lovers' music.

designer and art director
Cole Gerst

photographer
Emmett Martin

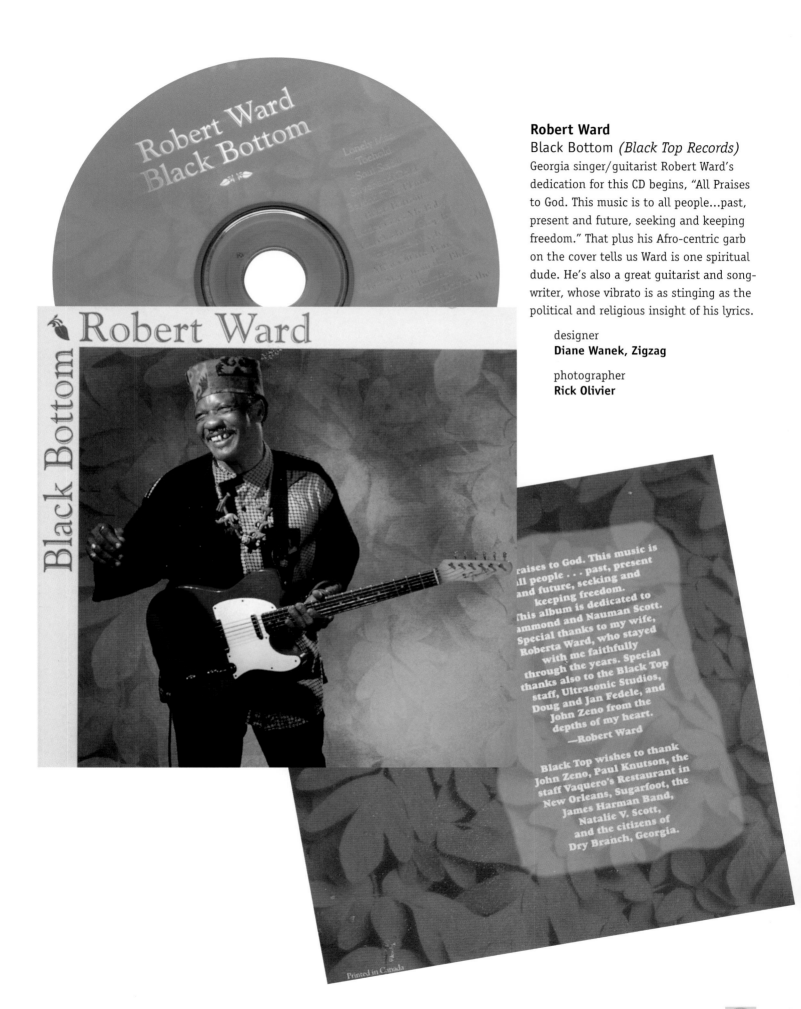

Robert Ward
Black Bottom *(Black Top Records)*
Georgia singer/guitarist Robert Ward's dedication for this CD begins, "All Praises to God. This music is to all people...past, present and future, seeking and keeping freedom." That plus his Afro-centric garb on the cover tells us Ward is one spiritual dude. He's also a great guitarist and songwriter, whose vibrato is as stinging as the political and religious insight of his lyrics.

designer
Diane Wanek, Zigzag

photographer
Rick Olivier

Denise LaSalle
Still Bad *(Malaco)*
With tunes like "Right Side of the Wrong Bed" and "Dial 1-900-GET-SOME," Denise LaSalle has a reputation for sassy, sexy, good-humored fun. She's the ladies' answer to Bobby Rush, her fellow Malaco recording artist and another favorite of urban audiences in the Deep South. *Still Bad*? You bet. And by the glint in her eyes, you can tell LaSalle's loving every minute of it.

designer
Jane Doe Design

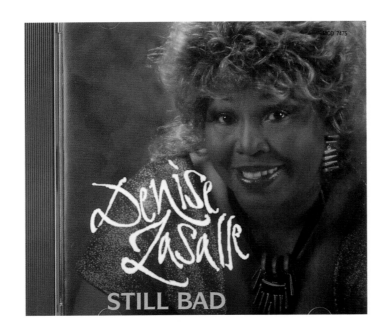

Johnnie Johnson
Johnnie Be Back *(Music Masters)*
The title is a play on "Johnny B. Good," the Chuck Berry standard on which Johnnie Johnson played piano back when he was Berry's partner in rock's rhythmic invention. Today, as you can see, Johnson's one of the grand old men of distinctly American piano—the pop equivalent of jazzman Oscar Peterson. Thankfully, Johnson's music is not as buttoned-down as this photo.

designer
Darlene Alberti

art director
Susan Zoppi

photographer
Marc Norberg

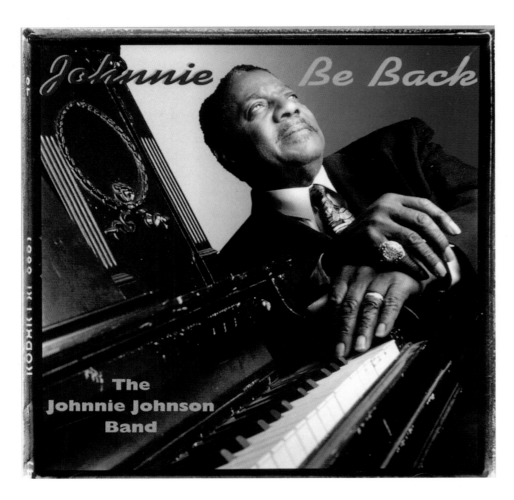

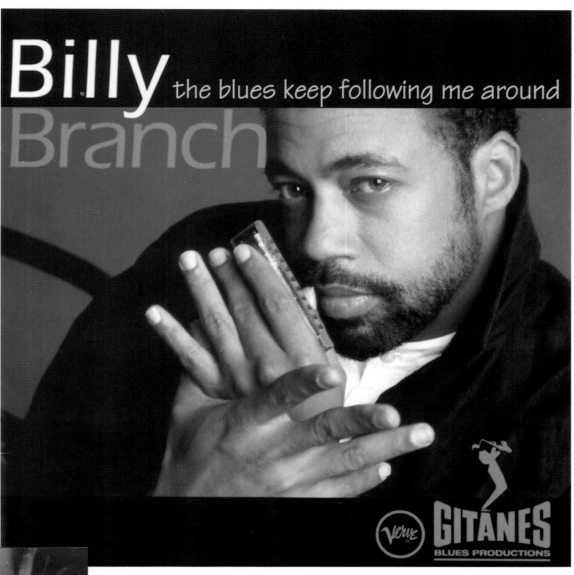

Billy Branch
The Blues Keep Following Me
Around *(Gitanes Blues
Productions/Verve Records)*
Charismatic Sons of Blues frontman Billy
Branch is easy on the camera lens: dap-
per and handsome, with penetrating
eyes. And, of course, pictured with his
harmonica. After all, this is a blues CD.
Without his Mississippi saxophone, this
rising Chicago star could be mistaken for
the latest R&B crooner instead of the
spiritual inheritor of James Cotton, Little
Walter, and Carey Bell.

designer
CB Graphic

art director
Patrice Beauséjour

photographer
Carol Friedman

The Best Music CD Art+Design

Conceptual

We wanted something that had the gospel feel, but not the religious clichés. I worked with the light and the shade, the dimension, to convey a very finished look. The marble added that solid feeling. I didn't want gray marble—too heavy and oppressive—but the blue went back to the sky and the title, *Taking Flight.*" —Bruce Gardner, designer/illustrator

The Gospel Hummingbirds
Taking Flight *(Blind Pig Records)*
This cover presents the music of the quintet—middle-aged men in tuxedos performing in the classic style exemplified by the Swan Silvertones—in a more timeless light than a group photo would have. Yet the stained-glass sunrise and bird-on-the-wing place the music within the church, and the marble background alludes to rock-solid tradition.

designer and illustrator
Bruce Gardner

photographer
Stu Brinin

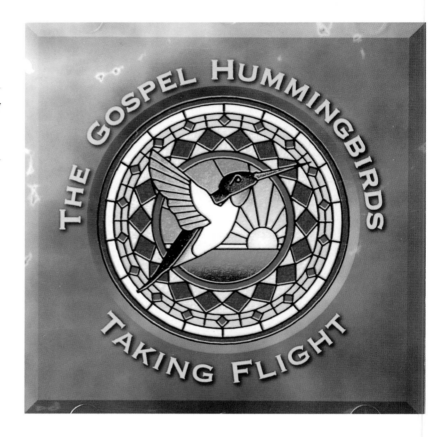

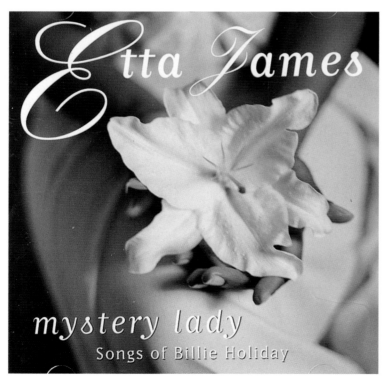

Etta James
Mystery Lady: Songs of Billie Holiday *(Private Music)*
Although Etta James' voice remains one of the most beautiful instruments in the blues, she's not traditionally photogenic. So how to convey the elegance of this dynamic singer's art as well as that of her subject—the songs of the immortal Lady Day—and play into this Grammy-winning CD's title? This cover speaks eloquently to those concerns.

designer
Kurt DeMunbrun

art director
Melanie Penny

photographer
Lendon Flanagan

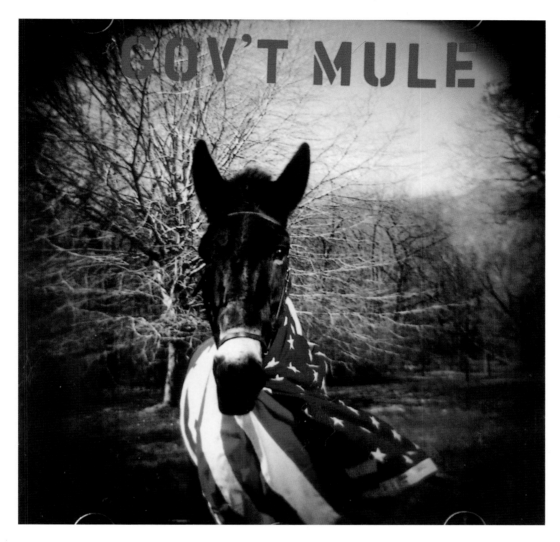

Gov't Mule
Gov't Mule *(Relativity Recordings)*
There's nothing subtle about this cover.
Here's the mule, here's the flag: depend-
ability, stubbornness, and—with its fade-
to-black edges—an echo of the psyche-
delic, protest-torn 1960s. Damned if the
music isn't that way, too. This is acid-
drenched blues-rock that refuses to be
dragged into the present. Featuring
Allman Brothers' guitarist Warren
Haynes, this group's blustery and bril-
liant CD was one of 1995's best debuts.

art director
David Bett

photographer
Danny Clinch

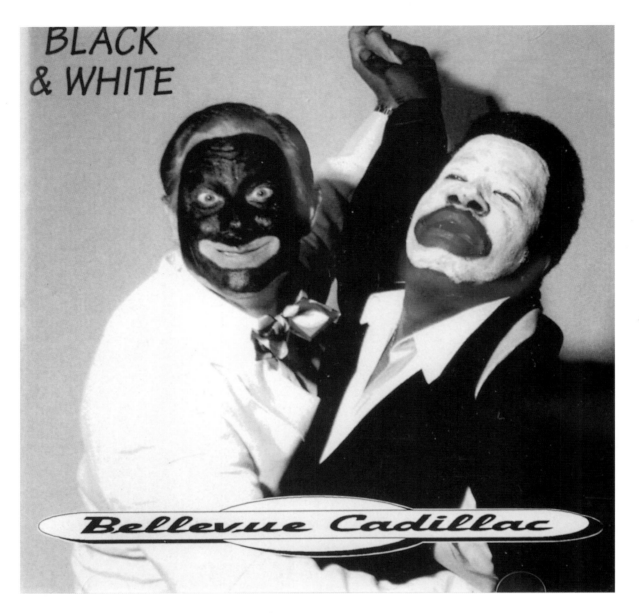

Bellevue Cadillac
Black & White *(Ardeo Records)*
This playful cover—from a band named
after the big white car that hauls patients
off to the nuthouse—subverts the black-
face stereotypes of minstrelsy to make a
statement about the universality of the
blues and the human bonds that music
creates. As Whoopi Goldberg and Ted
Danson know, flirting with blackface
sometimes presses the wrong buttons. But
it certainly gets attention.

art director
"Scano"

photographer
Bill Edmunds

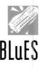

I went through my jewelry box, which is mostly junk, and my junk drawer, which is all junk, and found just about everything you see on the house. Rounder is good about letting me do what I want. They feel my audience knows me. I think the cover's a little dark. The impact on the shelves might be better if it was lighter. But I think I got a beautiful piece of work by Scott."
—Marcia Ball

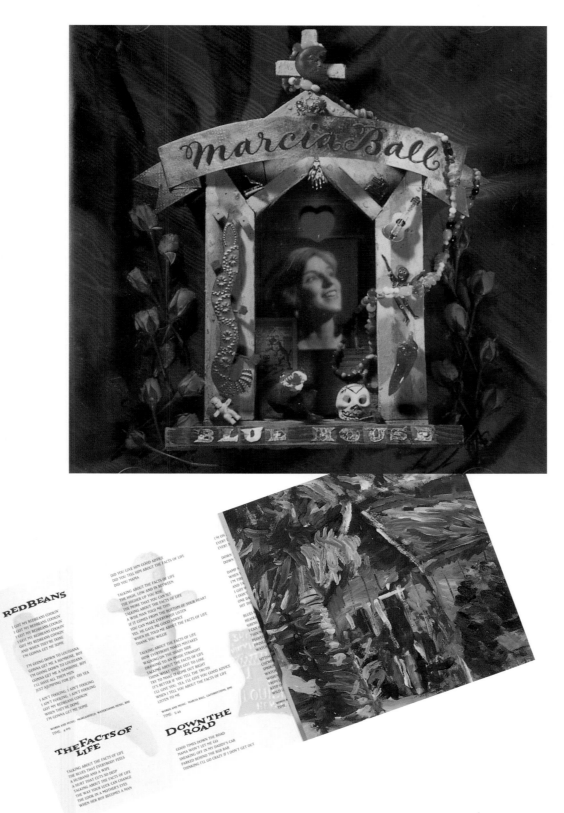

Marcia Ball
Blue House *(Rounder Records)*
Marcia Ball's *Blue House* is named after a painting by her husband Gordon Fowler, which appears inside the CD booklet. It also inspired the house-like picture frame on the cover by Scott Van Osdol, an Austin photographer who lushly decorates his work with found objects.

designer and art director
David Kampa

photographer
Scott Van Osdol

Inspirational Blue House painting
Gordon Fowler

Elvin Bishop
Ace in the Hole *(Alligator Records)*

Butterfield Blues Band veteran and 1970s solo artist Elvin Bishop has come back with a playful series of CDs for Chicago's Alligator label that pair his rockin' blues chops with tongue-in-cheek lyrics. The expression on Bishop's face and the visual wordplay of the card game scenario send a message that resonates throughout the party music inside.

designer
Matt Minde

photographer
Kent Lacin

Mem Shannon
A Cab Driver's Blues
(Hannibal Records/Rykodisc)

This cover shot tells the story of Mem Shannon's life in a flash. The hack speaks to Shannon's previous vocation, the artist stands with his instrument, and the sign for shrimp po-boys places us in New Orleans. Before this debut CD was released, the singing cabby had never been north of Louisiana. Now he's traveled the world.

designer
Kristin Johnson

photographer
Patti Perret

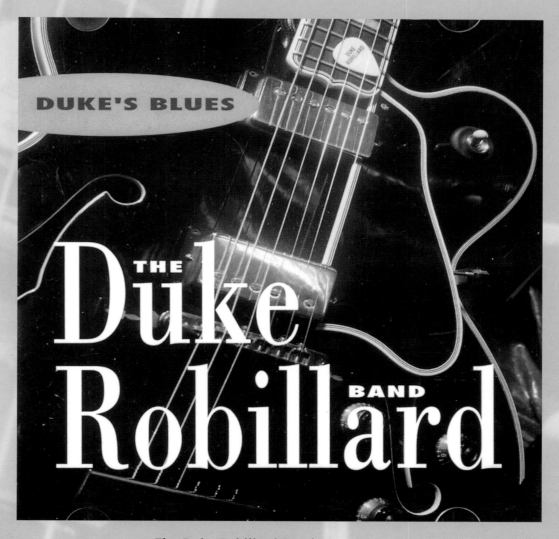

DUKE'S BLUES

THE **Duke Robillard** BAND

The Duke Robillard Band
Duke's Blues *(Pointblank; Stony Plain Records)*
There's a joke in the blues biz that the best CD covers feature guys with guitars. Here there's no middleman, just the instrument, telegraphing its message to the legion of six-string junkies who got hooked by modern guitar heroes like Robert Cray, Stevie Ray Vaughan, and Buddy Guy. The guitar's the star here. You'll find Robillard pictured on the back.

designer
Halkier & Dutton

photographer
Duke Robillard

Catfish Hodge
Adventures at Catfish Pond
(Music for Little People)

An enticing, colorful way to help introduce children to the blues. This picture immediately conveys the mood of the album: it's upbeat, colorful, fun. No mean, mistreatin' women or low-down, two-timin' men. Just Hodge and his critter accompanists capering about, cornbread cakes cookin' on the hot griddle. Even the turtle and the catfish are ready to join the party. What would Robert Johnson think?

designer and art director
Sandy Bassett

illustrator
Terry Kovalcik

layout
David Stern

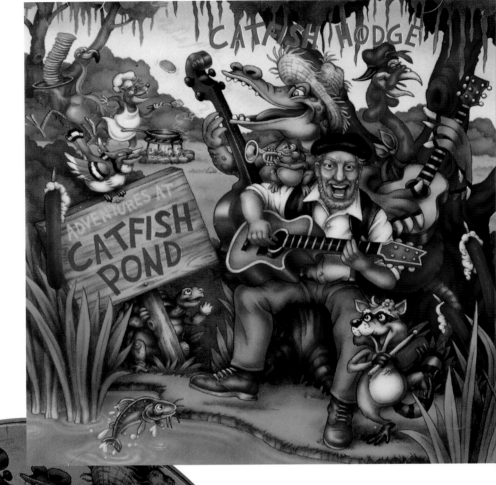

Dave Hole
Steel on Steel *(Alligator Records)*
Australian string-slinger Hole specializes in a fast and loose, self-made style of (literally) over-the-top slide guitar, playing with a zeal that sometimes approaches punk rock. He's a perfect match for the Chicago label that was once home to Roy Buchanan and Albert Collins. The wild energy of Hole's playing is captured here, as well as his technique. Sometimes a picture is worth a thousand notes.

designers
Steve Back and Tony Williams

photographer
Gary Peters

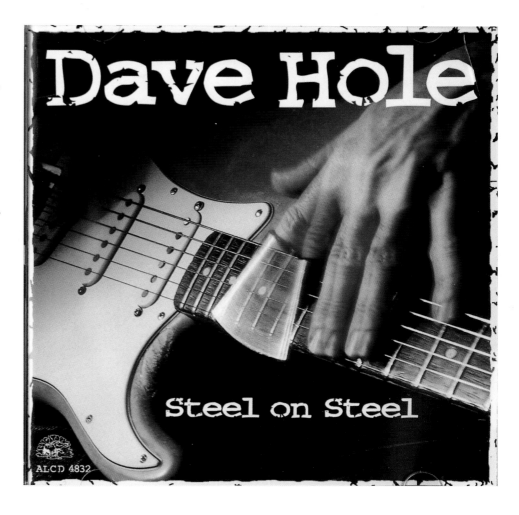

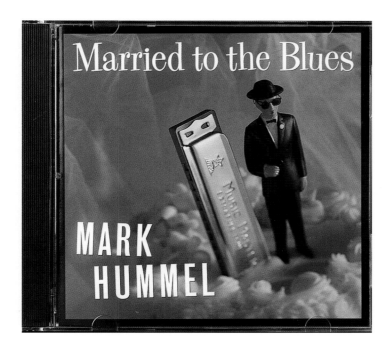

Mark Hummel
Married to the Blues
(Flying Fish Records)
With accuracy and fluid control, Mark Hummel has mastered the harmonica styles of Little Walter and such lesser-knowns as Johnny Waters, Charles Huff, and Buddy Ace. This photo takes the notion of Hummel's long-term commitment delightfully over the top. But the icing on the cake is in the music itself, with guest shots from guitar ace Duke Robillard and veteran harp genius Charlie Musselwhite.

designer
Al Brandtner

art director
Eric Babcock

photographer
Kevin Smith

"**T**his is the album that really started getting my name around. After this, I started slowly getting more and more dates, and traveling, and a few years ago I finally got so busy I knew I wouldn't have to go back to driving that oil truck again." —Big Jack Johnson

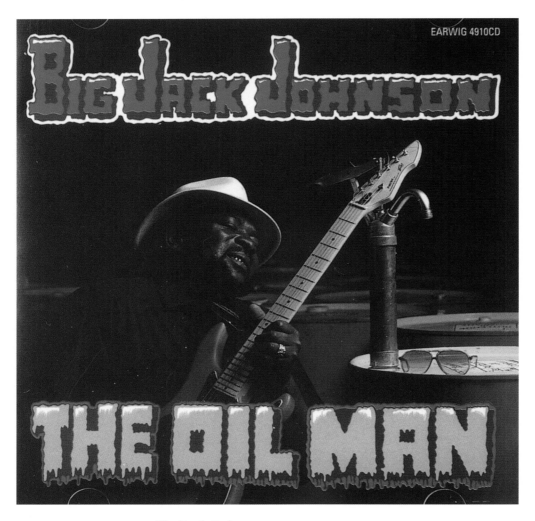

Big Jack Johnson
The Oil Man
(Earwig Music Company)
Clarksdale, Mississippi's Big Jack Johnson's solo debut was first released in 1987. But in 1995 Johnson did more than three hundred gigs across the globe, so the Oil Man—a nickname he earned delivering heating fuel in northwest Mississippi—is an oil man no more. He remains, however, perhaps the greatest guitarist/singer currently dwelling in the Delta, with flawless technique and a Howlin' Wolf-like stage presence.

original designer and artist
George Hansen

redesigner
T. Doehrer, Earth Star Graphics

photographer
Alan Howell

Compilation

Deep Blue: 25 Years of Blues on Rounder Records *(Rounder Records)*
The age in the piano player's hands, his clothes, his character...it all adds up to authenticity, which is fitting for a collection commemorating Rounder Records' silver anniversary of recording the blues. As a double CD in a single jewel case, it's an admirably compact compilation of 30 artists, from such long-standing blues stars as Clarence "Gatemouth" Brown and the late J. B. Hutto to new talents like Johnny Nocturne and Preston Shannon.

photographer
Karen Pulfer Focht

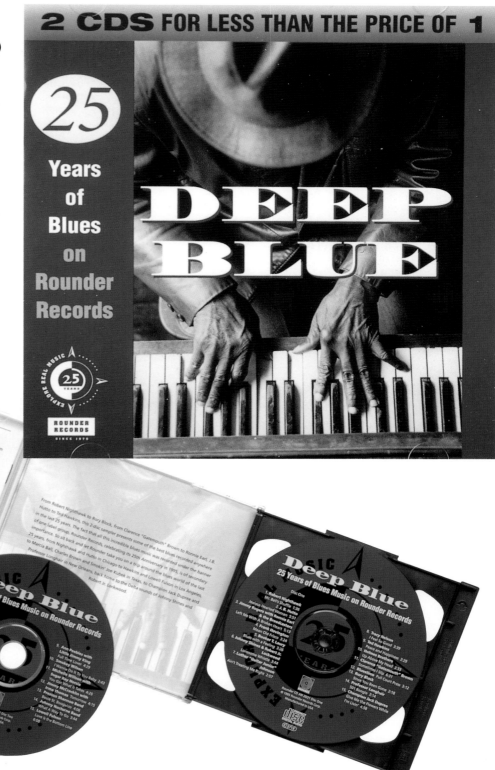

T a b B e n o i t

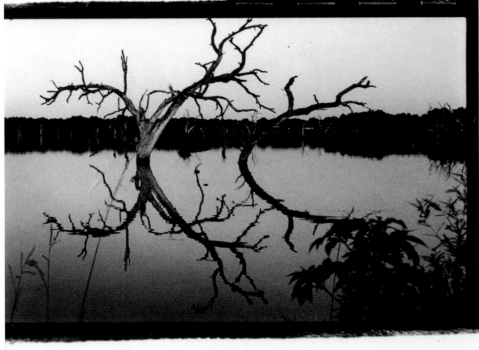

S t a n d i n g O n t h e B a n K

Tab Benoit
Standing on the Bank
(Justice Records)
This beautiful photograph is reminiscent of the work of such great nature photographers as Ansel Adams. The scene, like singer/guitarist Benoit himself, is out of the swamps of Louisiana—and poignantly evocative of the aura of Cajun country's watery byways at sunset. Benoit's dozen songs are just as dramatic and rewarding, a breakthrough for the artist.

designer and photographer
Cynthia S. Kinney

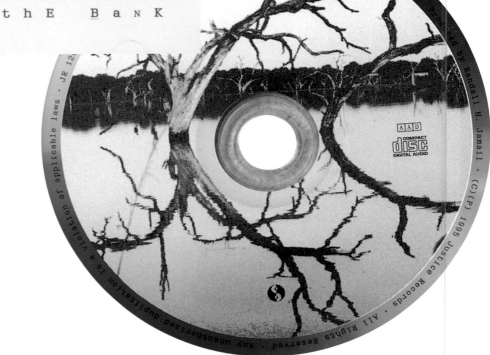

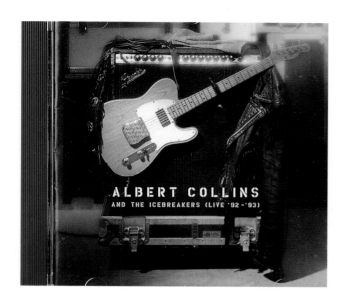

Albert Collins
Albert Collins & the Icebreakers
(Live 1992–1993)
(Pointblank/Virgin Records)
A tribute to the late Texas guitar slinger, this CD of performances recorded in the two years before his death uses Collins' trademark trappings to evoke fond memories for fans. Pictured is his beloved customized Telecaster, slung one-shouldered over his specially rewired, loud-as-hell Fender amp, and the fringed leather jacket that Collins wore in his later years. The back cover features his beloved tour bus, which Collins drove himself while on the road.

art director
Tom Dolan

photographer
Mark Silverstein

Koko Taylor
Force of Nature *(Alligator Records)*
Chicago's Koko Taylor comes from the old school of blues singers. Much like her inspiration Memphis Minnie in the 1930s and 1940s, Taylor belts out elemental tragedies about love, declaring her strength as a woman and an artist. Her music is powerful and timeless, well served by this embossed image of an arm seemingly carved from one of the elements itself, stone.

designers
Dave Forte and Matt Minde

photographer
Peter Amft

cover concept
Marc Lipkin

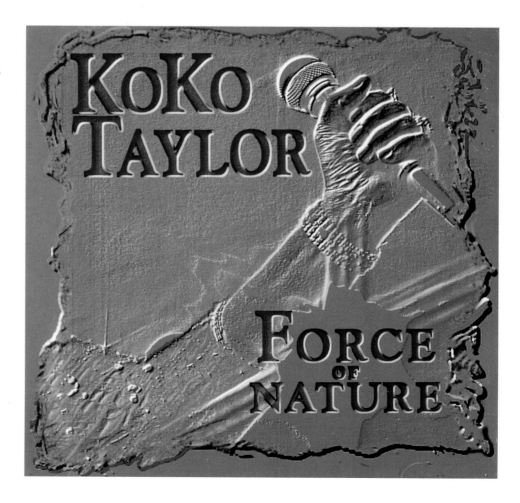

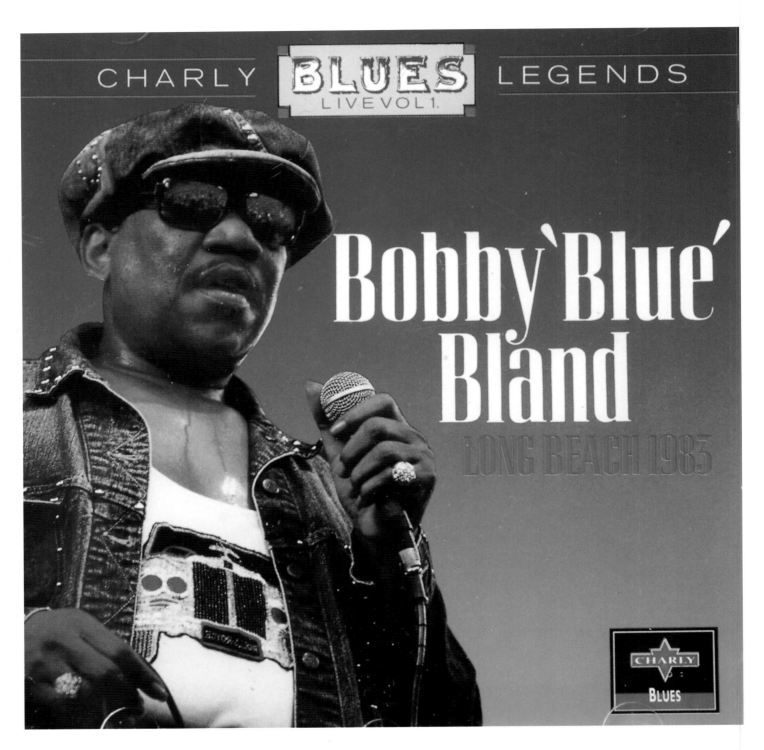

Bobby 'Blue' Bland

LONG BEACH 1983

CHARLY

BLUES

Bobby "Blue" Bland
Long Beach 1983 *(Charly Records)*
Down-home design most often means a
shoestring budget. Hence, a shot of the
great blues crooner in action on this live
album, sparing even the expense of a
rudimentary studio photo session. But
there's a nice synchronicity here: the
rivulets of sweat, the shades, the infor-
mal threads—this cover is an essay in the
kind of hardworking nonchalance that is
Bland's specialty in concert.

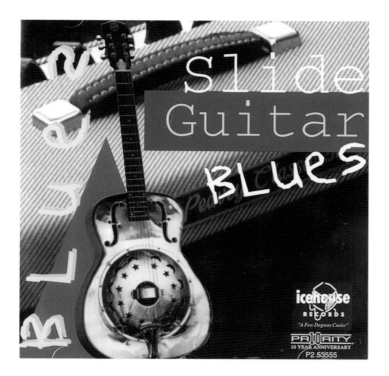

Compilation
Slide Guitar Blues
(Icehouse Records)
This is a guitar player's CD. And to guitar players, there's just one thing a steel resonator guitar and a tweed amplifier says: This is the blues. The bright pastel colors say it's not all ancient, either, as this excellent collection spans history from Elmore James to Sonny Landreth. Purists will note, however, that the pictured amp's a Peavey, not a Fender. Tsk...

designer
**Dale Franklin for
Street Level Graphics**

John Cephas & Phil Wiggins
Bluesmen *(Chesky Records)*
Traditional blues, traditional photo: a black-and-white torn right from the pages of a Dust Bowl-era history book. Indeed, Cephas and Wiggins seem the same when they play their hard-edged Piedmont-style blues, just a harmonica and a guitar plying a driving sound that has echoed through the mid-South hills since the 1920s. A couple of bluesmen, tried and true.

art director
Ross Hudson

photographer
Stan Schnier

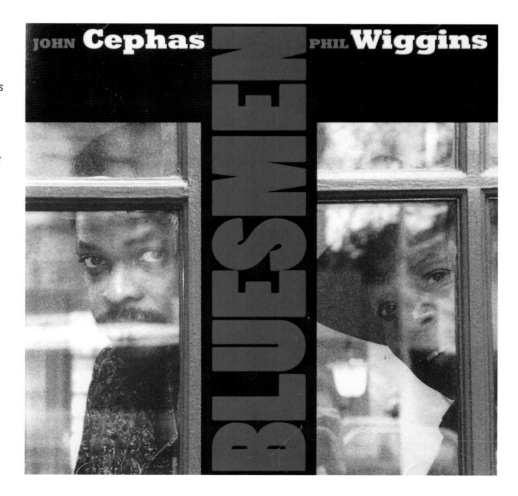

Jon has a vision, and he spends a lot of time and money on the designs of his covers....[The foil-coated paper jewel box creates a look] more of the 1970s, more like a record than a CD. Jon identifies a lot with used records. That's a theremin on the front, which Jon plays for oddball sounds. But he used a crappy scan, low resolution, instead of the nice drawing."

—Mark Ohe, art director, Matador Records

The Jon Spencer Blues Explosion
Orange (Matador Records)
Jon Spencer's whole gig is conceptual. Rather than play blues, his Explosion mines clichés for exploitable cues, reassembling hoary licks into balmy lo-fi independent-label rock. As his music borrows from the past, so do his visuals. It's lo-fi for the eye.

photographer
Michael Lavine

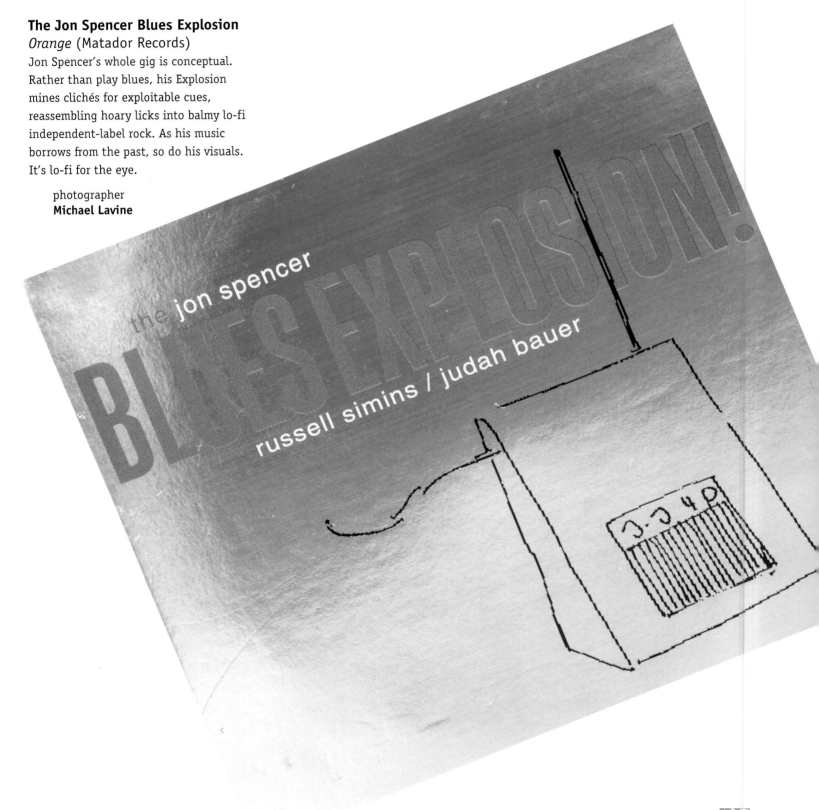

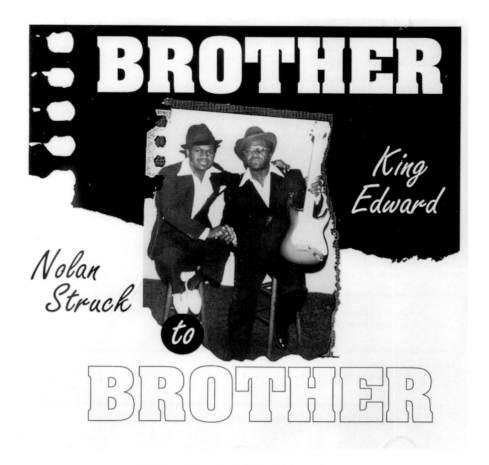

Nolan Struck & King Edward
Brother to Brother *(Paula Records)*

artist and art producer
Ron Rice

cover concept
Frank O. Jones

ou'd be surprised how our little down-home cover sticks out from the rest of those slick-lookin', major label-type CDs when you see it on the shelf at Tower. We first recorded it for our own label, Top Stars. [My brother and I] named it that because we thought that if it caught on, maybe we could get some stars to hang on with us. So we went into the studio ourselves, and designed the cover ourselves. It took a long time for us to make a CD together. We've been playing 25 or 30 years. Now, we're both working on new albums of our own."
—Nolan Struck

Compilation
Mississippi Delta Blues,
Vol. 1: Blow My Blues Away
(Arhoolie Productions)
The cover for these field recordings is a
history lesson. Reed-flutist Napoleon
Strickland leads the Como Drum Band in a
hypnotic pre-blues hybrid of African
polyrhythms and American martial music.
Only one drum troupe, the Rising Star Fife
and Drum Band, remains active today. The
woman behind him is doing the slow-
drag, an erotically charged step that also
has an unfiltered link to Africa.

photographer
George Mitchell

cover
Wayne Pope

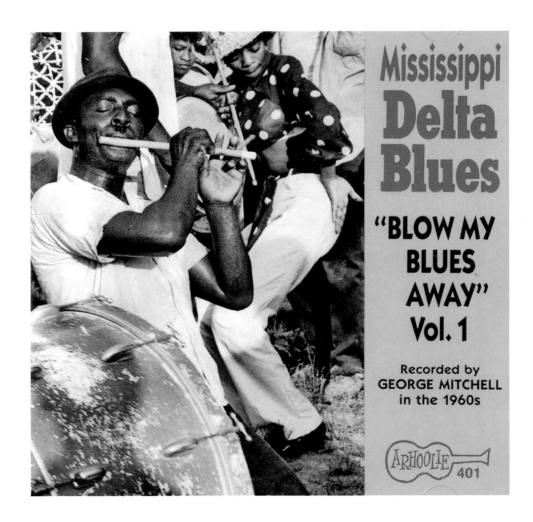

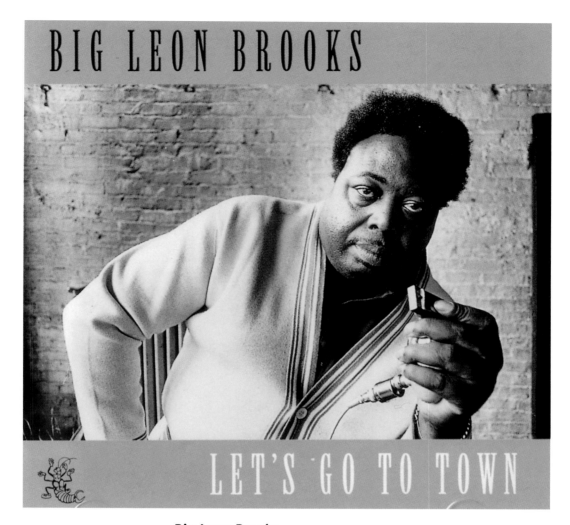

Big Leon Brooks
Let's Go to Town
(Earwig Music Company)
When Big Leon Brooks died in 1982,
shortly before this album was first
released, he was making a comeback after
twenty years away from the blues. But he
was still plagued by the doubts that had
made him quit. Would people appreciate
his music? Could he make it in the busi-
ness? Those questions seemed locked tight
behind his beefy jaw in this photograph.

designer
Al Brandtner

photographer
D. Shigley

The Best Music **CD** Art+Design

Kelly Joe Phelps
Lead Me On *(Burnside Records)*
Kelly Joe Phelps plays back-porch blues
with ringing authenticity. So this laid-
back picture, with an implied bridging of
the generation gap, offers listeners some
clues as to what they'll hear inside. Note
the slide in Phelp's left hand. It's a steel-
guitar slide, rather than a bottleneck or
cut-pipe style slide, indicating he's a man
who has carefully considered the issues of
weight and resistance in slide-playing. In
other words, a perfectionist.

photographer
James Rexroad, Project 47

graphics
Zap Graphics

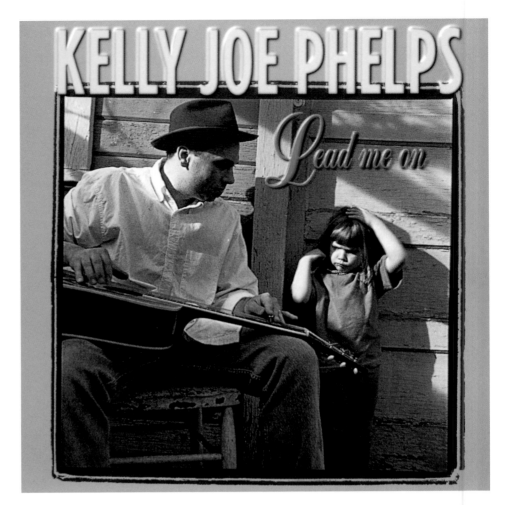

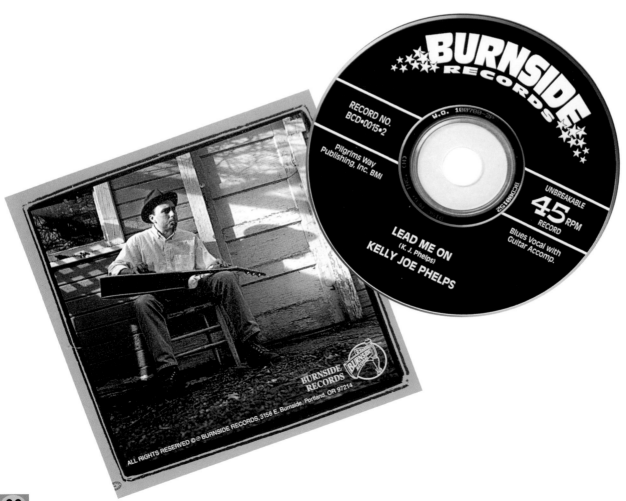

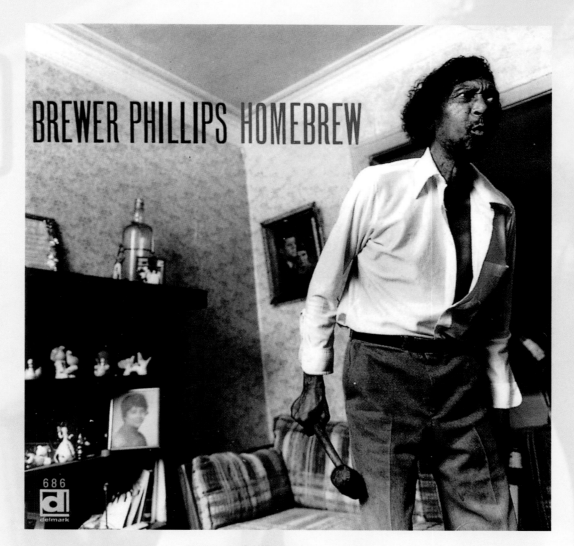

Brewer Phillips
Homebrew *(Delmark Records)*
Toward the end of this CD, former Hound Dog Taylor guitar accompanist Brewer Phillips makes a remark about getting hassled by a policeman, and considers rectifying the matter with a hammer. Let's hope Brewer's got a "Get Out of Jail Free" card tucked into one of his pockets.

designer
Al Brandtner

photographer
Marty Perez

Jimmy Rogers
Blue Bird
(Analogue Productions Originals)

The most common blues CD cover is a man with his instrument. But this straight-ahead black and white image is appropriate for the era the CD aims to evoke: the 1950s, when Jimmy Rogers was an influential figure in Chicago's developing electric blues scene. On these tracks, he's joined by other players of that period, including pianist Johnnie Johnson and harp master Carey Bell.

designer
Liz Knaus

designer
and photographer
William Claxton

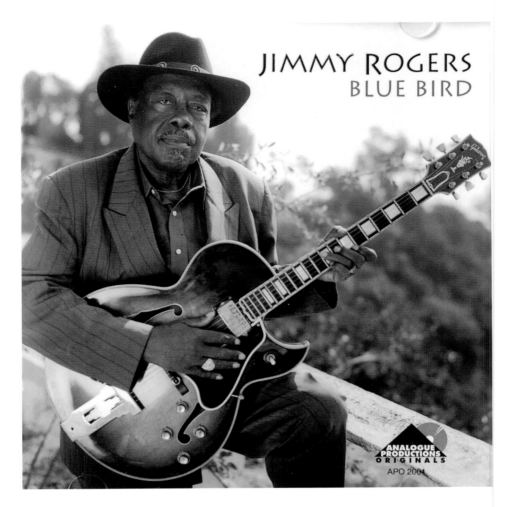

Ernie Johnson
Just in Time *(Ronn Records)*

Cheesy? You bet! Get a load of that red vinyl outfit, worn shirtless. This is vocalist Ernie Johnson's idea of hip. And he's not alone. On the hard-core, down-home southern R&B circuit he plays, this is hip, baby. Check out that cocksure smile, too. Johnson's telling us it's party time, and your host is a smooth loverman who's always in control.

designer
Don Logan

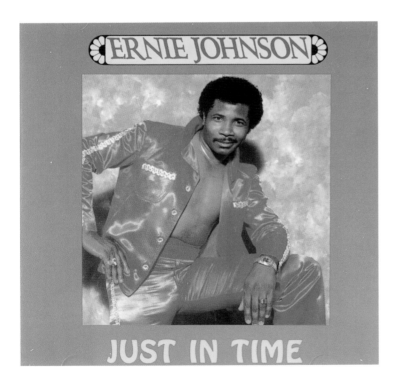

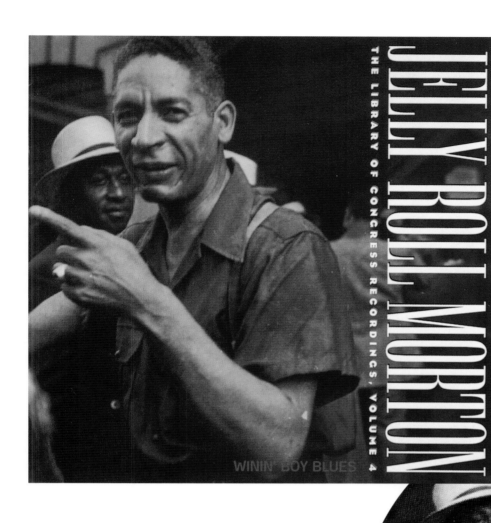

Jelly Roll Morton
Winin' Boy Blues: The Library of
Congress Recordings, Volume 4
(Rounder Records)
In the mid-1930s, the great jazz piano
innovator Jelly Roll Morton was living in
Washington, D.C., down on his luck. He
was persuaded by historian Alan Lomax to
perform solo and tell stories for the
Library of Congress recorded archives. The
result includes some of the most low-
down blues ever waxed. And this is a gor-
geous character shot of Morton.

designer
Nancy Given

photographer
Danny Barker

photos from the collection of
Frank Driggs

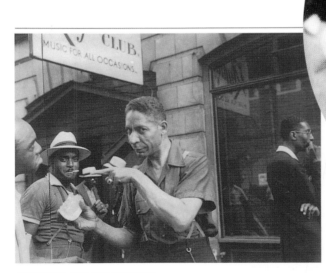

Jelly Roll Morton - piano, guitar, vocal, speech;
Alan Lomax - speech.
Tracks 1 - 3 probably recorded June 8, 1938; tracks 4 - 12 recorded between June 8 and June 12;
tracks 13 - 20 recorded June 12; tracks 21 and 22 recorded December 14 in Coolidge Auditorium,
Library of Congress, Washington, D. C.

Rounder CD 1094 ℗ © 1993 Rounder Records Corp., One Camp Street • Cambridge, Massachusetts 02140 USA.
Printed in Canada.

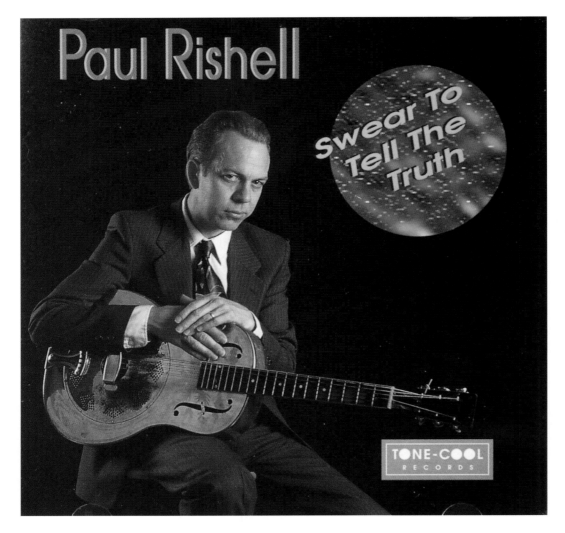

Paul Rishell
Swear to Tell the Truth
(Tone-Cool Records)
Looks like a class picture, doesn't it? But
one should never be put off by the simple
or inexpensive look of a blues CD, because
that often indicates a DIY approach as
down-home and personal as the music
inside. Here singer/guitarist Rishell offers
a very special style of country blues, per-
fected via years of careful study, but
played straight from the heart.

art director
Diane Menyuk, Artworks

photographer (front and back cover)
David Herwaldt

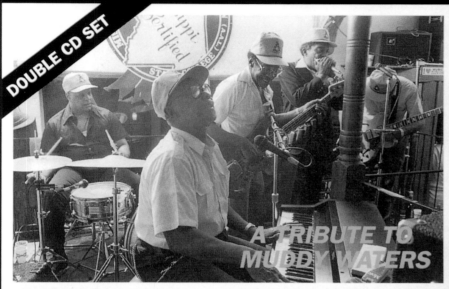

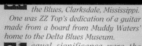

Reunion Blues Band
Back Home to Clarksdale
(Icehouse Records)

This double-disc set is billed as a tribute to Muddy Waters. It was cut live in a juke joint in Clarksdale, Mississippi, where he grew up, and it mainly celebrates the spirit of indefatigable piano man and former Waters' sidekick Pinetop Perkins. Recorded in 1988, it also captures the "anything goes" spirit of jukes, where musical and personal anarchy always contribute to the lively ambiance.

designer
Dale Franklin
for Street Level Graphics

the Blues, Clarksdale, Mississippi. One was ZZ Top's dedication of a guitar made from a board from Muddy Waters' home to the Delta Blues Museum.

01 equal significance were the incredible performances turned in by the "original" Muddy Waters Blues Band at John Mohead's Cotton Exchange Club.

10 overblown concert to mark the event, rather two authentic juke-joint shows by a special group of players, the likes of which invented the genre.

DISC TWO
1. I GOT MY MOJO WORKING
2. IDA VEE
3. CALEDONIA
4. LEND ME YOUR LOVE
5. CRYIN' SHAME
6. EVERYTHING'S GOING TO BE ALRIGHT
7. MOJO'S JOMO
8. GOING DOWN SLOW
9. HOW LONG
10. JUST A LITTLE BIT

2. I ALMOST LOST MY MIND
3. HI-HEEL SNEAKERS
4. MY LITTLE ALL IN ALL
5. HARP THANG
6. FOR YOU MY LOVE
7. BABY WHAT YOU WANT ME TO DO
8. AFTER HOURS
9. BLUES WITH A FEELING
10. HOLD IT

this two-CD set was distilled from those historic performances.

be warned! You'll hear crowd noise, clinking glasses, missed notes and feedback. You'll hear fade-ins and fade-outs, mainly because the original recording devices were not always operating at the right time.

but mostly what you'll hear is the real, visceral expression of blues masters in its most powerful, unadulterated form.
 Get ready to sweat!

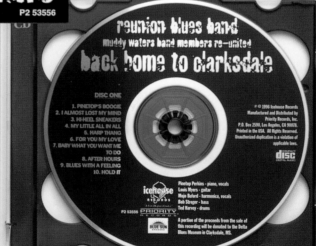

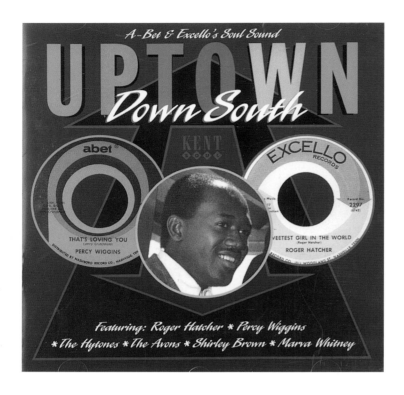

Compilation
Uptown, Down South
(Excello Records/Ace Records)
The 45 r.p.m. vinyl disc was music's indisputable hits medium. So this cover, which reproduces two actual 45 labels and borrows the color scheme from those labels for its title, promises just one thing: hits. In this case, the hits are from the mid-South-based Excello and A-Bet labels, and include an early regional chart-maker from Z.Z. Hill, before he became a million seller.

designer
David Farrow

photographer
Percy Wiggins

Sleepy John Estes
Broke and Hungry
(Delmark Records)
Except for the presence of blues guitar savant Mike Bloomfield, who's between John Estes and mandolinist Yank Rachell, isn't this what you'd imagine an early-1960s blues session looking like? It's literally the picture of down-home studio simplicity, with this foursome caught cutting live tracks. Thirty years later, the blues is nearly the only genre where they still sometimes make recordings this way.

designer
Zbigniew Jastrzebski

photographer
Ray Flerlage

Louisiana Red
Sittin Here Wonderin
(Earwig Music Company)

designer
Al Brandtner

photographer
Karen Atkins

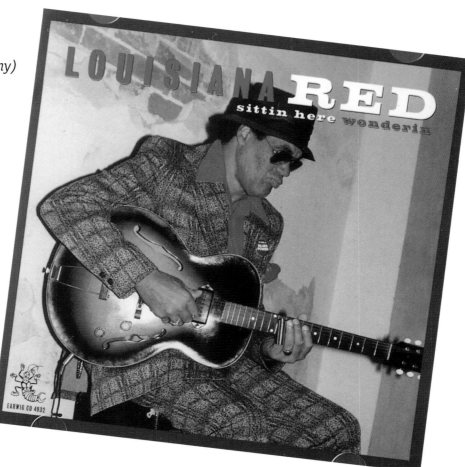

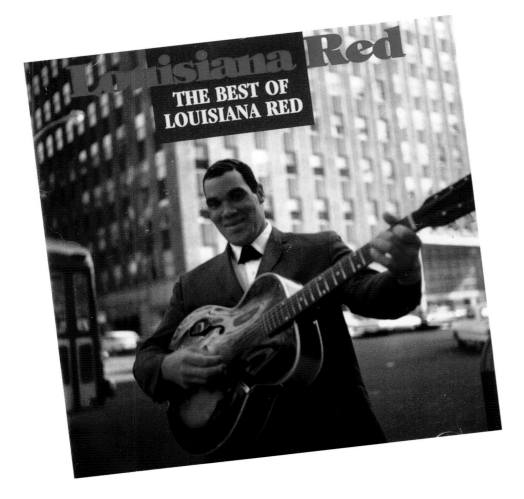

Louisiana Red
The Best of Louisiana Red
(Evidence Music)

Louisiana Red plays hard and direct blues. He was able to win his first acclaim from the tough-to-please factory workers who crowded the Detroit bars in the 1950s, then went on to become a darling of the festival circuit. Given to singing about Martians and beating up Khruschev, his own story is more somber. Red's mother died shortly after his birth, and his father was murdered by the Ku Klux Klan. By the time he turned 13, Red was playing guitar in the streets, where he learned the chemistry of crowds. That lesson's reflected in these covers. *The Best of Louisiana Red* features festival Red: the clean-cut bluesman ready for his white, folk-bred listeners. *Sittin Here Wonderin* depicts jukin' Red, dressed sharp on a Saturday night.

art director
Rothacker Advertising & Design

photos courtesy of
Herb Abramson

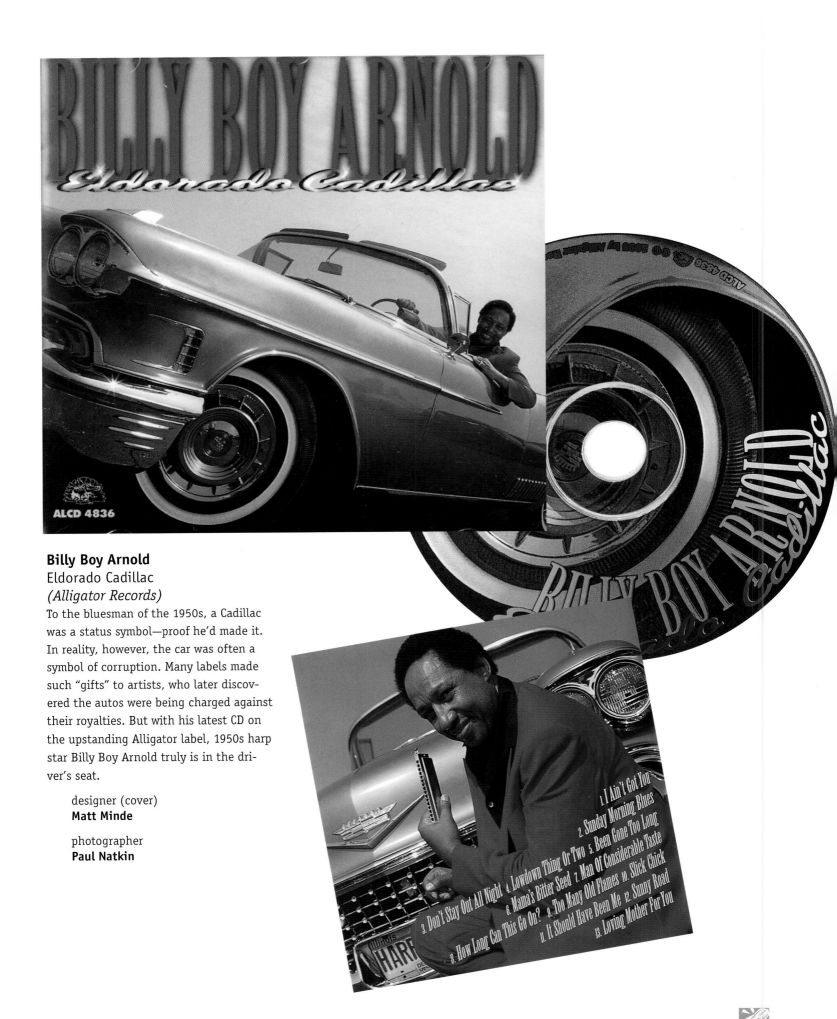

Billy Boy Arnold
Eldorado Cadillac
(Alligator Records)
To the bluesman of the 1950s, a Cadillac was a status symbol—proof he'd made it. In reality, however, the car was often a symbol of corruption. Many labels made such "gifts" to artists, who later discovered the autos were being charged against their royalties. But with his latest CD on the upstanding Alligator label, 1950s harp star Billy Boy Arnold truly is in the driver's seat.

designer (cover)
Matt Minde

photographer
Paul Natkin

ALCD 4836

1. I Ain't Got You
2. Sunday Morning Blues
3. Don't Stay Out All Night
4. Lowdown Thing Or Two
5. Been Gone Too Long
6. Mama's Bitter Seed
7. Man Of Considerable Taste
8. How Long Can This Go On?
9. Too Many Old Flames
10. Slick Chick
11. It Should Have Been Me
12. Sunny Road
13. Loving Mother For You

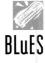

Igot involved in the art because at a small company, you have to do a little of everything yourself. We started with a photo session, with lots of different poses. It was my idea to use a border, to have that African feel. Her outfit on the back inspired it, but I didn't think Deborah lying down was the right cover image. So we matched the border to that outfit, then colorized her clothes on the cover to match the border."

—Randy Friel, owner, New Moon Blues

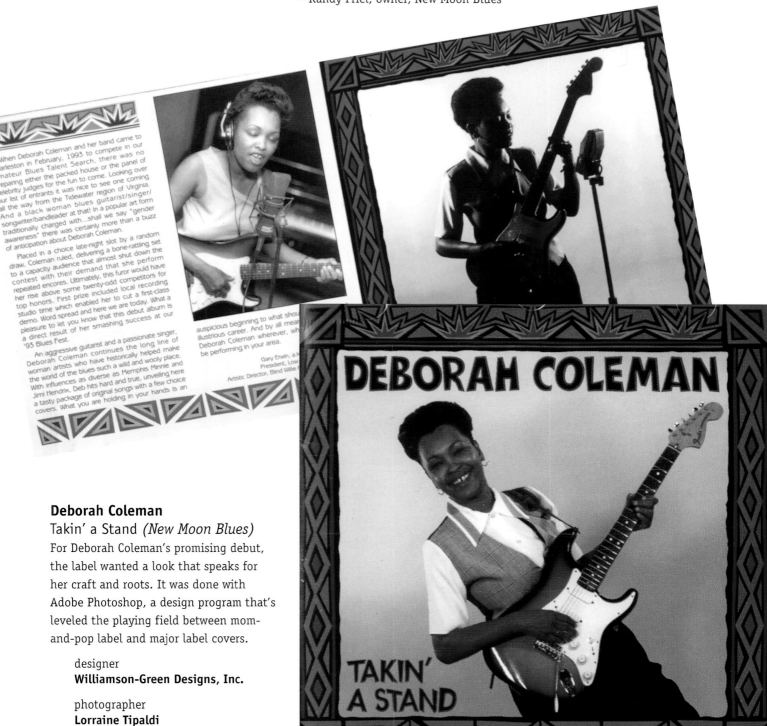

Deborah Coleman
Takin' a Stand *(New Moon Blues)*
For Deborah Coleman's promising debut, the label wanted a look that speaks for her craft and roots. It was done with Adobe Photoshop, a design program that's leveled the playing field between mom-and-pop label and major label covers.

designer
Williamson-Green Designs, Inc.

photographer
Lorraine Tipaldi

The Best Music CD Art+Design

Originally I wanted to shoot the cover at a zoo, with a nice-looking lady holding a little monkey. The monkey would be running away, but my eyes wouldn't be on the monkey. They'd be on the good lookin' lady, of course. You know, if one person or one monkey leaves, you still got to keep your thing goin' on. Heh-heh."

—Bobby Rush

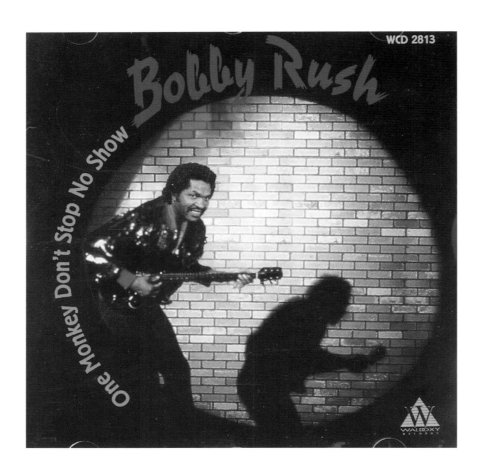

Bobby Rush
One Monkey Don't Stop No Show
(Waldoxy Records)
Although he's just crossing into the blues mainstream, singer/multi-instrumentalist Bobby Rush's over-the-top concerts— built around his sly-fox stud persona— have made him a top draw on the chitlin' circuit. For Rush, the show is everything. Hence this photo of Rush in the spotlight, shot live during a TV taping of "Blues Going On" in Chicago.

graphic designer
Dennis J. Heckler

art director
Paul H. Lee

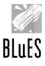

Pop Art

R. L. Burnside

A Ass Pocket of Whiskey
(Fat Possum/Matador Records)

Derek Hess is one of country's top rock poster illustrators and a fine artist trained in stone lithography. He's making the transition from the underground to mainstream galleries. His drawing for R. L. Burnside's album is the hippest blues CD cover of 1996.

illustrator
Derek Hess

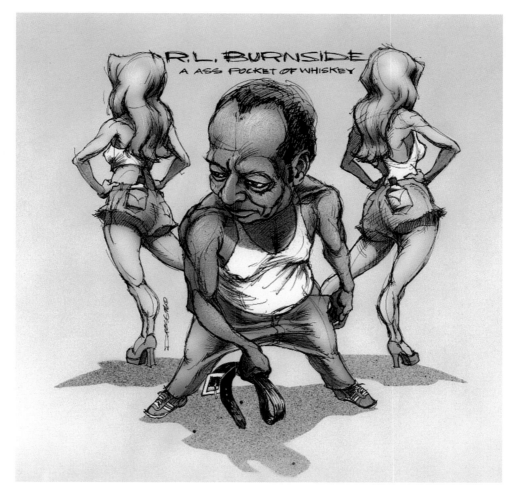

have my own method for pen and ink. I work spray paint into it, and then I photostat it. Then I work color into it with markers, but the markers are laid down like an airbrush, using this little compressed air gun attached to the tip of the markers. Once I'm satisfied with the color saturation, I can scratch into it with an X-Acto blade—like the lines in R. L.'s forehead—because it's on photographic paper."

—Derek Hess, illustrator

Swamp Dogg
Best of 25 Years of Swamp Dogg... or F**k the Bomb, Stop the Drugs
(Pointblank/Virgin Records)

Swamp Dogg, a.k.a Jerry Williams, has been performing his own idiosyncratic blues since 1970. He's taken on everything from the miracles of love to the burdens of protest. This cover, which touches on the latter and reveals the real Dogg in its lower right corner, captures the spontaneity and anything-goes attitude of his music. The Cold War-era motif continues throughout the CD's twelve-page booklet.

designer
Jeff Lyons

art director
Len Peltier

artwork
Greg Jensen

photographers
Greg Jensen and Jeff Lyons

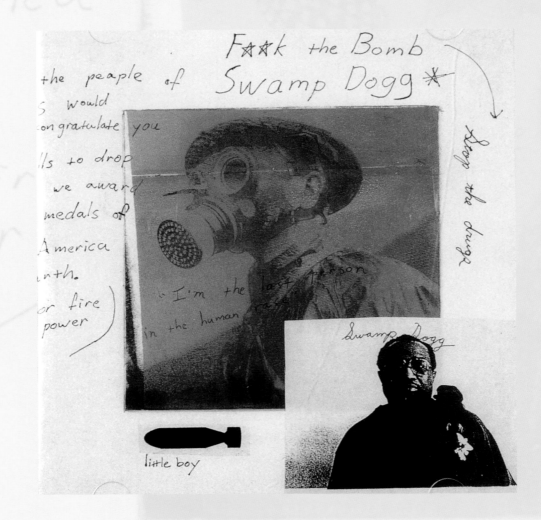

Compilation
Essential Blues *(House of Blues Music Company)*

This first offering from the House of Blues label is a two-disc sampler of post-World War II tracks. The liner notes comprise a generous booklet full of historical notes and colorful illustrations, such as the one on this cover, the House of Blues logo. It's a beautiful design: the band of thorns and bleeding heart symbolize the music's spirituality, while the eternal flame represents its undying nature and vitality.

designers and art directors
Kav DeLuxe and Kurt DeMunbrun

I got into the idea of the title. These are famous American blues artists. I took the idea of the 1960s...the use of the flag in the dress of the hippie culture. I thought of the Vietnam era and the use of the American flag in protests. This became my poster for all of that. [Evidence president Jerry Gordon] asked me to use the black and white photographs by Raeburn Flerlage that are inside the booklet on every CD. So then we have the artists' photos and their names, which bring it all into the blues."

—George Rothacker, designer/art director, Rothacker Advertising & Design

Compilation
American Folk Blues Festival: 1962–1965 *(Evidence Music)*
This striking package contains recordings from the festival that took modern blues to Europe. The design fits hand-in-glove with the seventy six classic live performances on this five-CD set.

designer and art director
George Rothacker, Rothacker Advertising & Design

photographer
Raeburn Flerlage

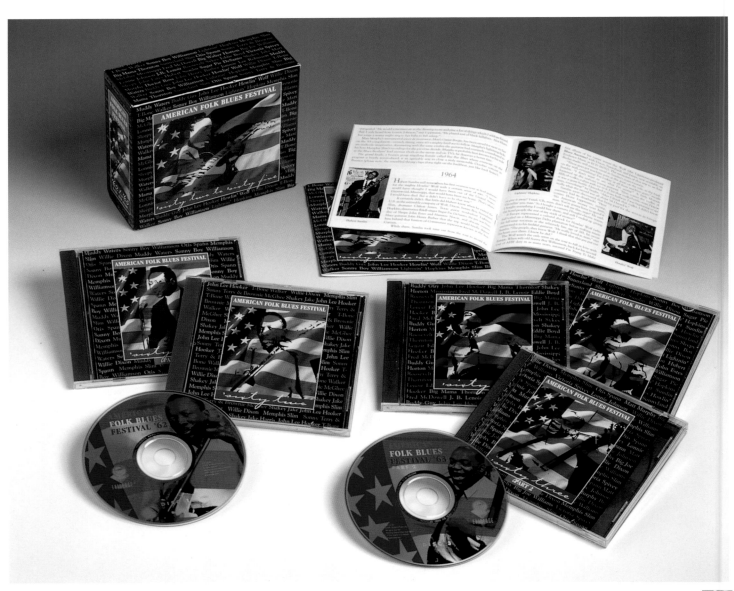

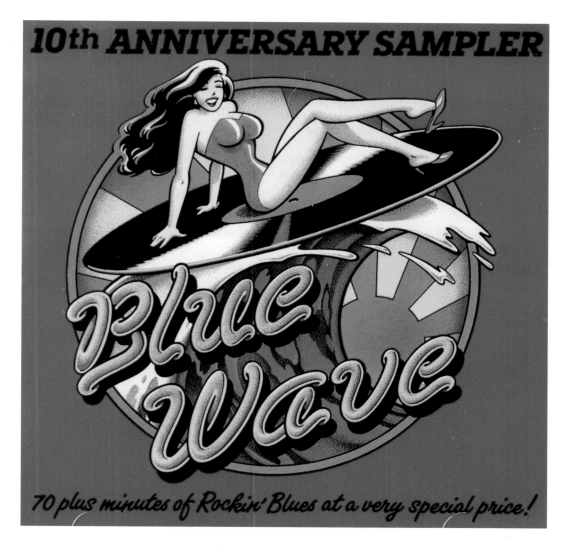

Compilation

Blue Wave 10th Anniversary
Sampler *(Blue Wave Productions)*
There's plenty of rockin' blues on this 16-song sampler from the small label in Baldwinsville, New York. And this illustration, borrowing the Varga girl concept and substituting an LP for a surfboard, is an accurate and playful signpost for what's inside. The broad details and bright, upbeat colors also make this CD a real stand-out on the shelves of record stores.

designer and artist
Stephen T. Eckhardt

Robert Cray
Some Rainy Morning
(Mercury/PolyGram Records)

Southern American rural folk art is in vogue. At one time you could only see it in shacks, jukes, and barbecue joints. Now it appears in galleries, museums, books, and upscale restaurants and bars like the House of Blues—who pattern their logo on a folk-art style. It's also on Robert Cray's last album, where illustrator Keith Graves perfectly tapped the genre's backwoods magic realism.

designer
Jeffrey L. Schulz

art director
Michael Bays

illustrator (cover)
Keith Graves

photographer
Jeff Katz

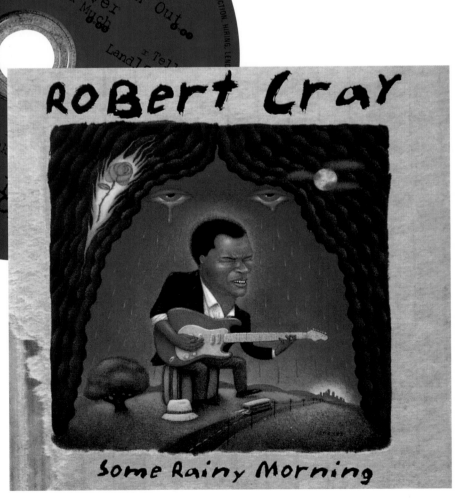

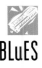

I got the idea from something [southern freak-rock guru] Bruce Hampton said while we were making the record. I used his quote—'If Mount Rushmore is a natural phenomena, why isn't CeDell's face on it?'—inside as well. I thought to just put his face on Mt. Rushmore would be too predictable, so I found an old etching and superimposed him on it. Same with the plantation on the back. I wanted it to really attract attention." —Flournoy Holmes, designer/photographer

CeDell Davis
The Best of CeDell Davis
(Fat Possum/Capricorn Records)
Flournoy Holmes has specialized in provocative album designs for decades, including the Allman Brothers' classic *Eat a Peach*. Here, he's inflated CeDell Davis's expressive face on the cover, rewritten history by placing him in plantation-era Mississippi on the back, and made him a national institution inside.

designer and photographer
Flournoy Holmes

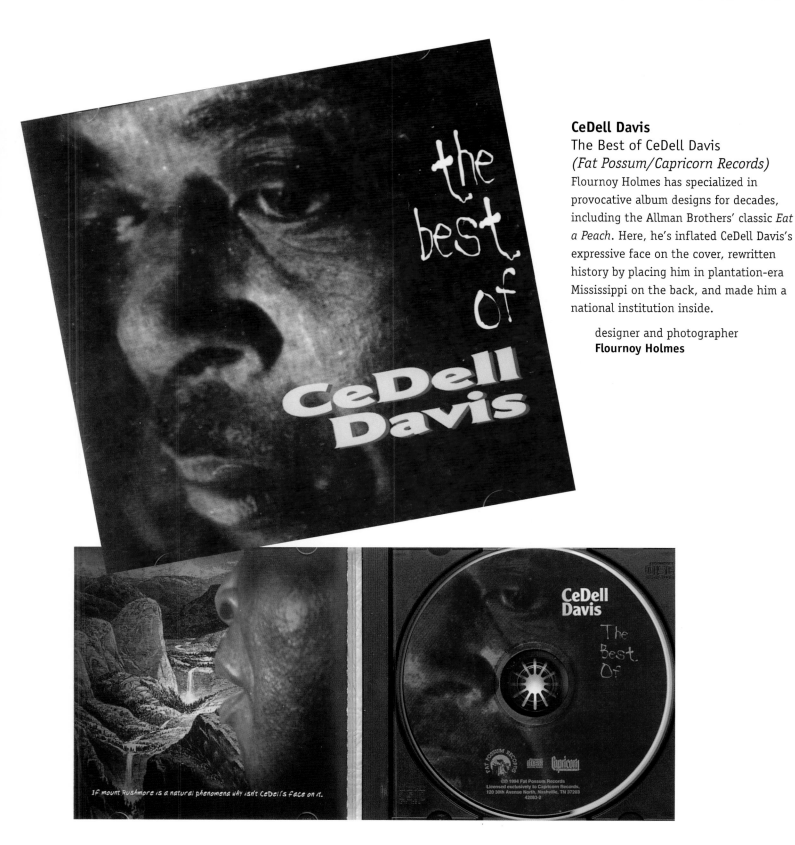

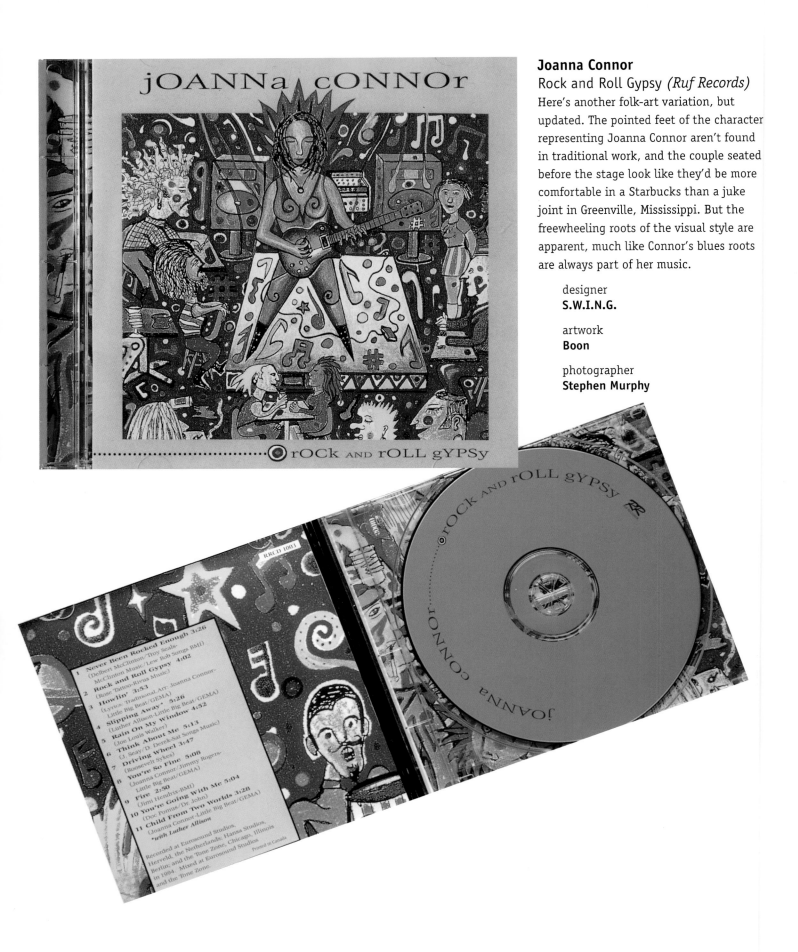

Joanna Connor
Rock and Roll Gypsy *(Ruf Records)*
Here's another folk-art variation, but updated. The pointed feet of the character representing Joanna Connor aren't found in traditional work, and the couple seated before the stage look like they'd be more comfortable in a Starbucks than a juke joint in Greenville, Mississippi. But the freewheeling roots of the visual style are apparent, much like Connor's blues roots are always part of her music.

designer
S.W.I.N.G.

artwork
Boon

photographer
Stephen Murphy

'm a fan of old black and white cartoons, Betty Boop and all that stuff, but I have a disability: I can't draw worth a damn. One of the many jobs that I had when I was trying to become a musician was working at a place that raised laboratory rats and mice. I had 750 mice and 1,500 to 2,000 rats to feed and water every day."

—Dave MacKenzie

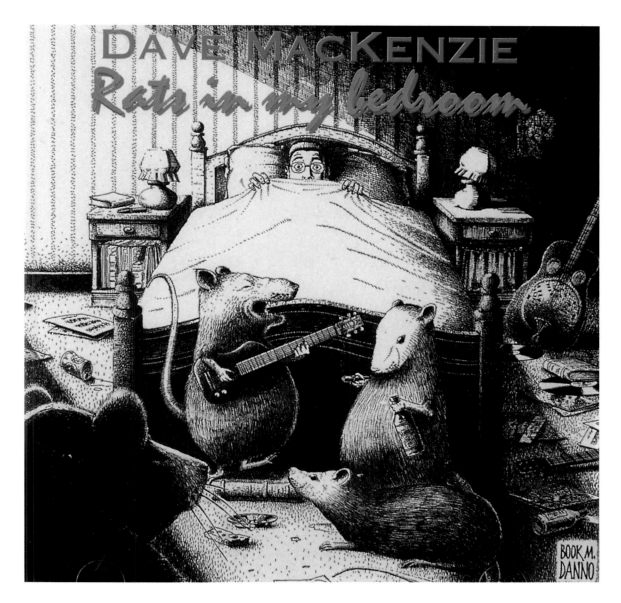

Dave MacKenzie
Rats in My Bedroom
(Hey Baby! Music)
Dave MacKenzie's cover concept, executed by illustrator Daniel Marmignon, is the rats' revenge. For the leering wolf that's the Hey Baby logo, the cartoon aficionado told the illustrator to "think Tex Avery." He got it.

illustrator
Daniel Marmignon

graphic layout
Grey Graphics

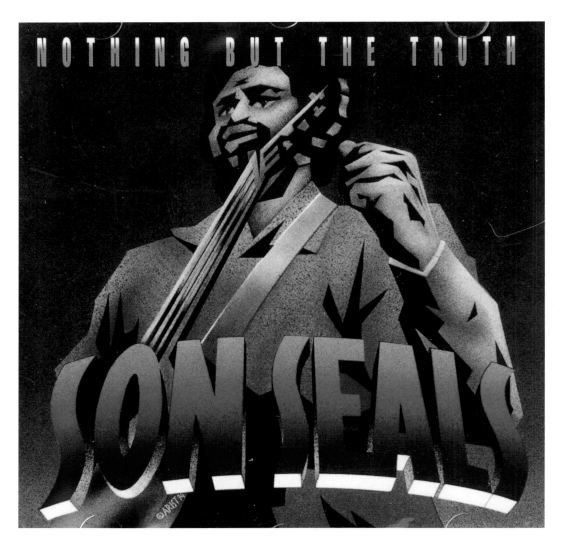

Son Seals
Nothing But the Truth
(Alligator Records)
Chicago blues giant Son Seals seems to bear a striking resemblance to the Zig-Zag rolling papers logo guy in this drawing. The bold lettering as well as his Mt. Rushmore-sized likeness make the singer/guitarist appear to be some sort of mythic, comic book superhero. It's a nice homage to one of Alligator's veteran performers.

designers and producers
D. Dominick Forte and Matt Minde

illustrator
Arist Kirsch

Solomon Burke
Live at the House of Blues
(Black Top Records)

This is a stylized and flattering image of rockin' soul king Solomon Burke, who's not quite so young or thin anymore. The cover of this delightful album recorded in New Orleans during Jazz Fest '94 has one foot in poster art and another in the folk camp, thanks to the homespun decorations that line the "wooden" frame— including the House of Blues logo—and the rough script of the lettering.

designer and cover artist
Diane Wanek, Zigzag

photographer
Rick "Rico" Olivier

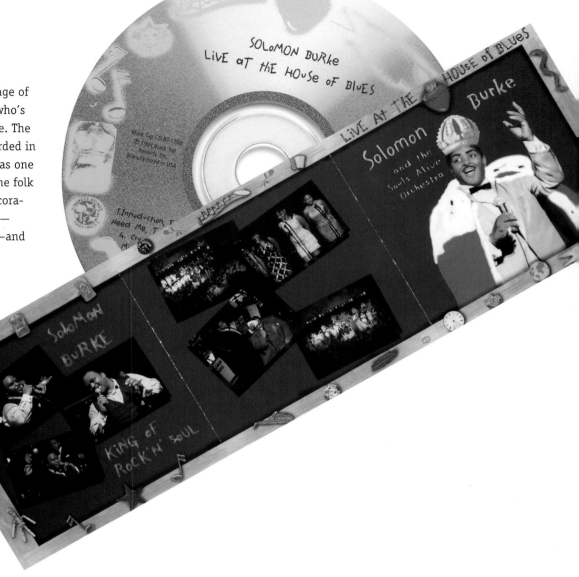

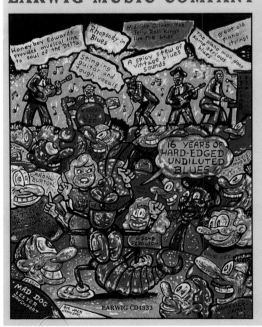

Compilation
Earwig Music Company 16th
Anniversary Sampler
(Earwig Music Company)

Famous San Francisco cartoon artist R. Crumb (who now resides in France) is an obvious influence in illustrator George Hansen's cover drawing. Crumb's own work, in fact, has often had blues or old-time music themes. Here, note the earwig's fingers (pointing up), the rounded noses, the three-quarter moon eyes, and block-shaped teeth. They're all Crumb trademarks, and Hansen's work on this compilation of Earwig classics is a marvelous tribute—at least as funky as what's inside.

designer
Terran Doehrer, Earth Star Graphics

illustrator
George Hansen

The Best Music CD Art+Design

Michael Hill's Blues Mob
Bloodlines *(Alligator Records)*

This dramatic cover straddles spray-paint art and photo-realism in its melange of resonant African-American images that tell the story of Michael Hill's songs and stinging guitar style. Hill developed his technique in the urban watering holes of New York City, with the support of the Black Rock Coalition, but his music has a roots consciousness that stretches back through the history of his people. A cutting-edge look for cutting-edge music.

designers
D. Dominick Forte and Matt Minde

illustrator
Blaize

photographer
Ebet Roberts

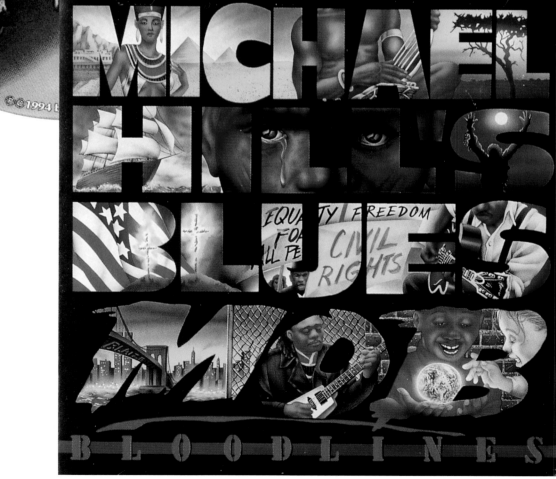

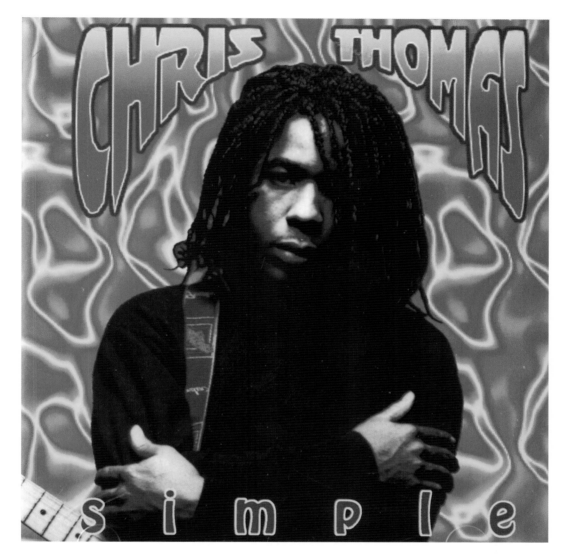

Chris Thomas
Simple *(Hightone Records)*
Louisiana's Chris Thomas is an aggressive
newcomer, a volatile singer and guitarist
whose playing is inspired more by Jimi
Hendrix than Robert Johnson, but who
nonetheless draws on the deepest blues
roots when required. Here he's playing to
his psychedelic edge, the "moving" color
lines behind him framing his photo in a
trippy backdrop. You can tell at first glance
that this isn't your average blues CD.

designer and illustrator
E Conspiracy

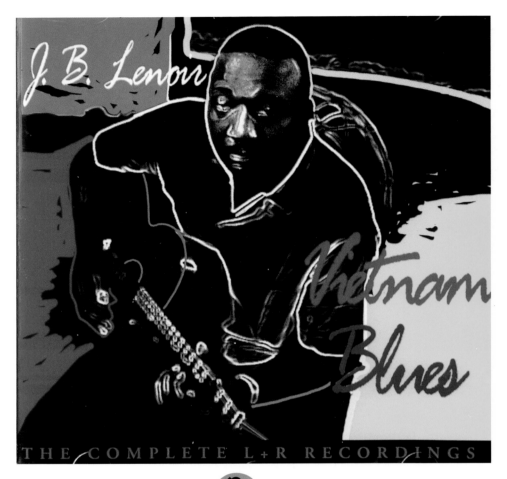

J. B. Lenoir
Vietnam Blues *(Evidence Music)*

art director
Rothacker Advertising & Design

photographer (cover)
Stephanie Wiesand

all other photos courtesy of
Jonny Meister

R eissuing a record by a dead person, it's hard to be creative. The photo was basic: J.B. sitting on a back porch, looking kind of dull but fine from a historical perspective. But I wanted some of the poster quality of the 1960s. This is *Vietnam Blues*; it merits the vivid coloring of the times, the Peter Max quality, the 1960s presentation. I started with the black-and-white photo, and turned it into an outline on the computer. I hand-painted the bright colors onto it, to give it a new look. When marketing blues, everyone asks, 'Do people recognize who the artist is?' I say make it fresh. The buyers don't want it to look like their grandfather's record."

—George Rothacker, art director, Rothacker Advertising & Design

Post Modern

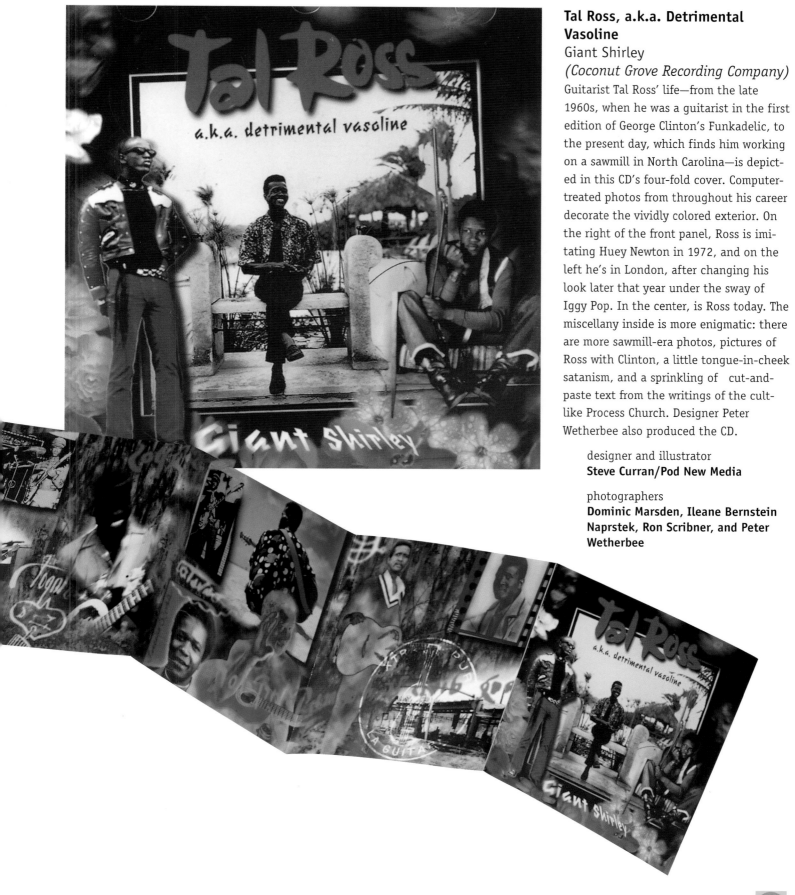

Tal Ross, a.k.a. Detrimental Vasoline
Giant Shirley
(Coconut Grove Recording Company)

Guitarist Tal Ross' life—from the late 1960s, when he was a guitarist in the first edition of George Clinton's Funkadelic, to the present day, which finds him working on a sawmill in North Carolina—is depicted in this CD's four-fold cover. Computer-treated photos from throughout his career decorate the vividly colored exterior. On the right of the front panel, Ross is imitating Huey Newton in 1972, and on the left he's in London, after changing his look later that year under the sway of Iggy Pop. In the center, is Ross today. The miscellany inside is more enigmatic: there are more sawmill-era photos, pictures of Ross with Clinton, a little tongue-in-cheek satanism, and a sprinkling of cut-and-paste text from the writings of the cult-like Process Church. Designer Peter Wetherbee also produced the CD.

designer and illustrator
Steve Curran/Pod New Media

photographers
Dominic Marsden, Ileane Bernstein Naprstek, Ron Scribner, and Peter Wetherbee

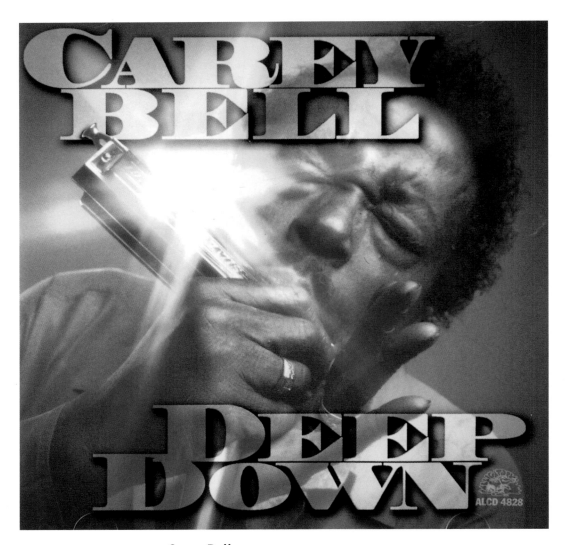

Carey Bell

Deep Down *(Alligator Records)*

The flash of light seemingly emanating from Chicago veteran Carey Bell's harmonica, the look of intense concentration on his face, and the ice-blue background all declare that something heavy is on the way. Taken with the title, this arresting graphic warns that this is serious blues, inspired and authentic, not only coming from deep down in Bell's soul, but from the bedrock of the music's tradition.

designers
D. Dominick Forte and Matt Minde

photographer
Peter Amft

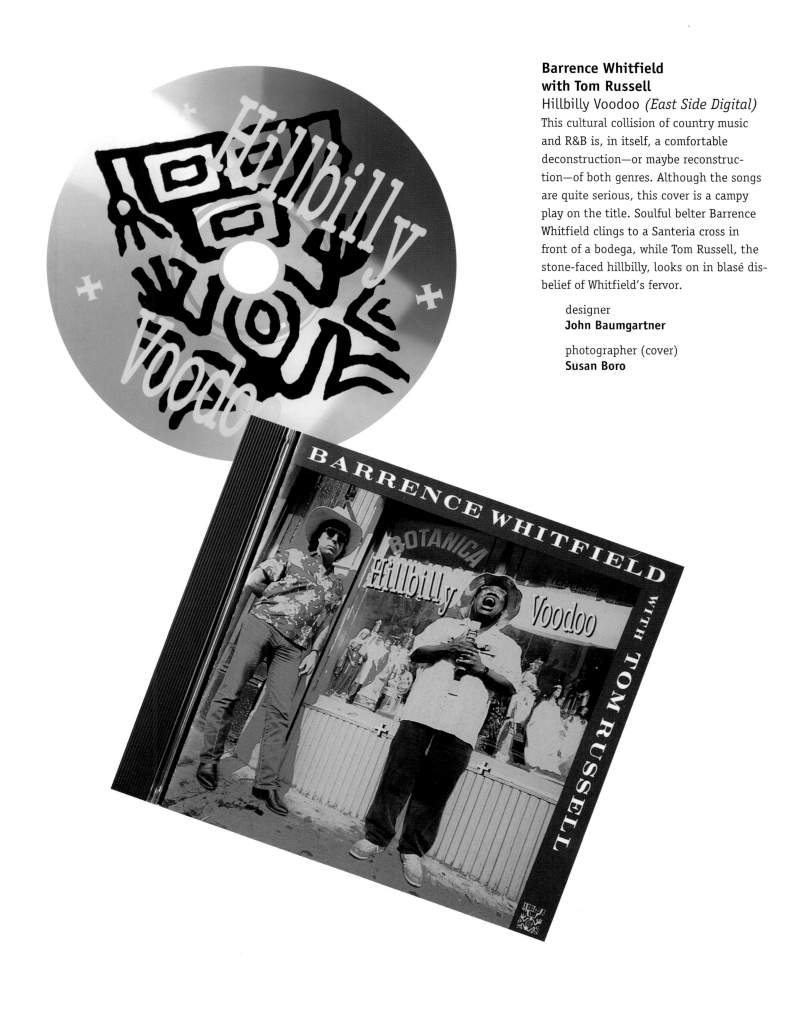

**Barrence Whitfield
with Tom Russell**
Hillbilly Voodoo (East Side Digital)
This cultural collision of country music
and R&B is, in itself, a comfortable
deconstruction—or maybe reconstruc-
tion—of both genres. Although the songs
are quite serious, this cover is a campy
play on the title. Soulful belter Barrence
Whitfield clings to a Santeria cross in
front of a bodega, while Tom Russell, the
stone-faced hillbilly, looks on in blasé dis-
belief of Whitfield's fervor.

designer
John Baumgartner

photographer (cover)
Susan Boro

Neal Black + the Healers
Neal Black + the Healers
(Deluge Records)
Young Texas guitarist Neal Black plays
with a brooding intensity more common
to rock'n'roll, and the look of Black's
debut CD captures his tightly wound,
dark-edged music. Nothing is crystal-
clear in this photo, but the downcast
angle of his head, the shadows, and the
lines that read like scars on his face sug-
gest volumes.

designer
Patrick Duffy for Attention

photographer
Murgett Roydd

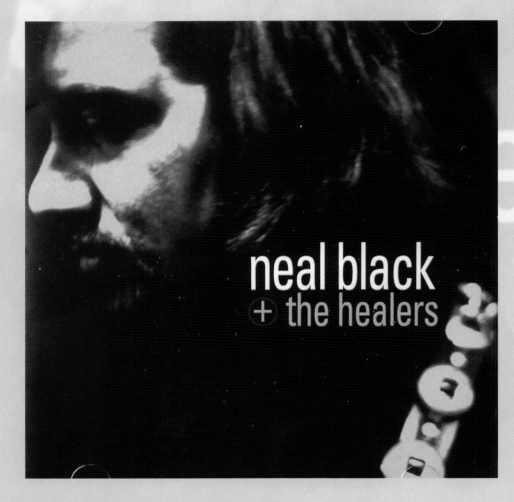

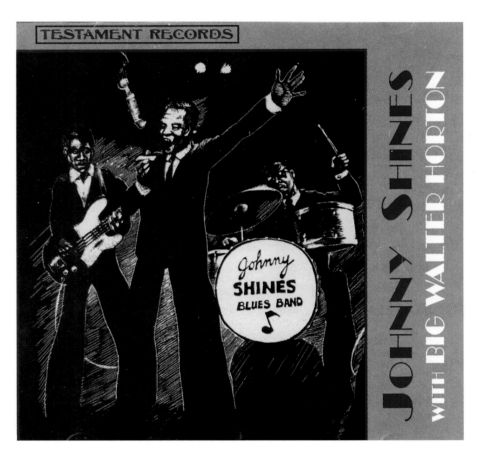

Johnny Shines
Johnny Shines with Big Walter
Horton *(Testament Records)*
A very cool representational drawing that
captures the high energy level often ema-
nating from the clubs of Chicago, the city
where Johnny Shines lived and worked for
decades before his death. But it's too bad
none of these striking figures actually
depict Shines. The huge-voiced singer
who was a running buddy of Robert
Johnson in the 1930s played neither har-
monica nor bass, but guitar. It's still nice
work, though.

art director
Brian Walls at E Con

illustrator
Warren Hughey

photographer
Brad Barrett

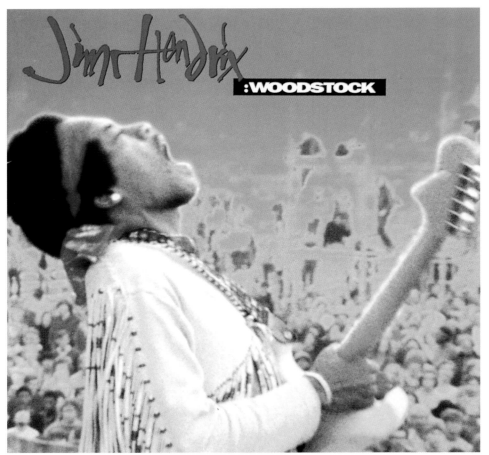

Jimi Hendrix
Woodstock (MCA Records)
At Woodstock, Jimi Hendrix fully evinced the spirit of his electric church, rapping with the crowd and playing his festival-capping set as the sun drove away the torrential rain and streaked the sky with dappled purple psychedelic light. This cover does the same, as the distorted audience and rolling grassy hills behind Hendrix blur into an acid-tinted frame for the exploratory, volume-fueled blues-rock within.

designers
John O'Brien and Jeff Smith, Cimarron/Bacon/O'Brien

design consultant
Vartan

photographer
Allan Koss

electronic imager
Adrian Boot/Exhibit-A

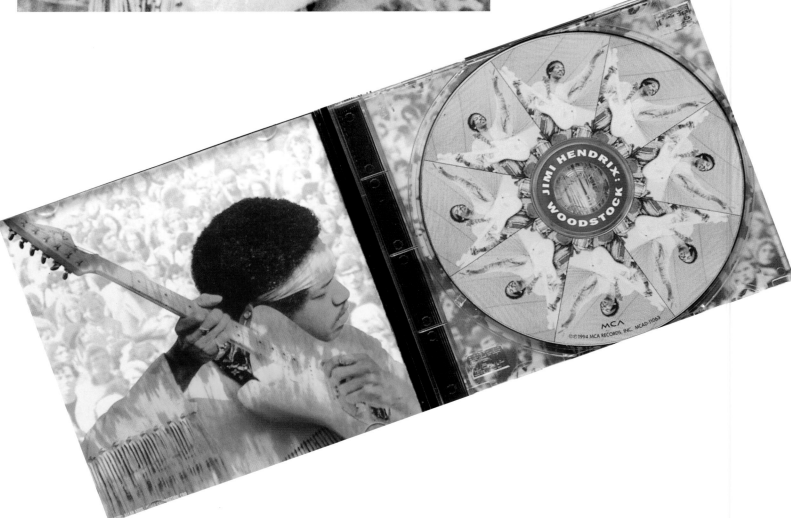

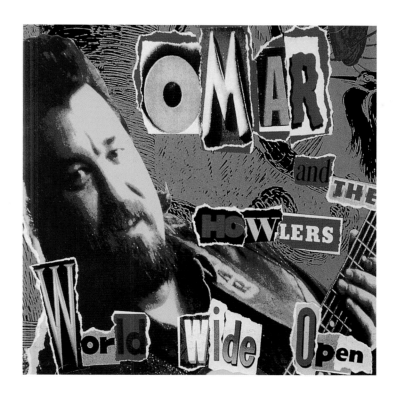

Omar and the Howlers
World Wide Open
(Watermelon Records)
Never mind the bullocks, it's Omar and the Howlers. Actually, this cover is more than a homage to the ransom-note–style cut-and-paste artwork of the Sex Pistols' first album; it depicts leader Omar Dykes' face, too, which means it hasn't strayed too far from blues-album design customs.

designers and art directors
**Dick Reeves Design with
Heinz Geissler and Kevin Wommack**

photographer
Jennifer Jaqua

collage and cover concept
Melissa Grimes

Luther is very photogenic. I wanted something that said 'high-power, explosive.' The title came first; we decide on titles in a marketing meeting. The lights in the photo were already there. And I used technology to get the words to streak like the photo. [Alligator president] Bruce Iglauer really wants a photo of the artist and their instrument, so buyers can instantly see what they're getting. Ninety-five percent of the time you have the same type of photo: a guy with a guitar. Harmonica players are worse. How many ways can you play a harmonica? So my challenge is, 'How do you make it unique?'"

—Matt Minde, art director, Alligator Records

Luther Allison
Blue Streak *(Alligator Records)*

designers
Matt Minde and D. Dominick Forte

photographer
Paul Natkin/Photo Reserve

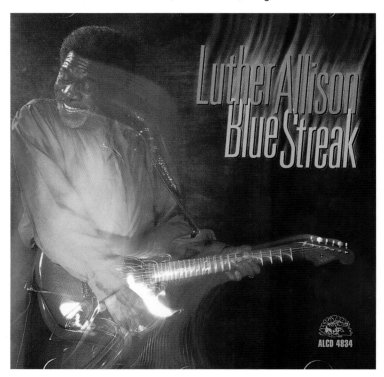

The Best Music **CD** Art+Design

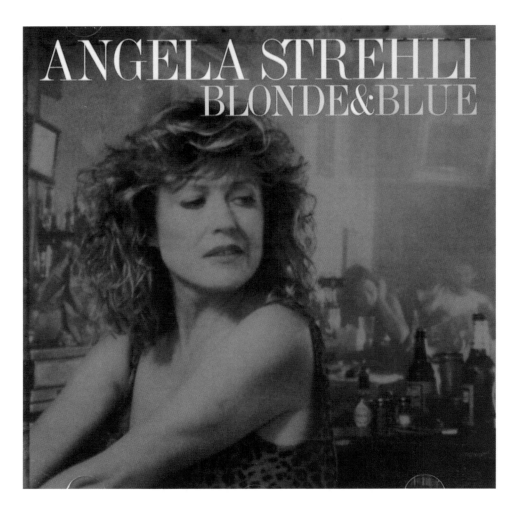

ANGELA STREHLI
BLONDE&BLUE

Angela Strehli
Blonde & Blue *(Rounder Records)*
In this photo, the Austin-based singer just looks blue. Everything does. But the message is clear: this is the blues. And for Strehli, the cantina setting—which comes into focus after we notice the artist herself—is right for the mix of hard-livin' romance and Texas border stories that are the meat of her songs. This is straight-ahead, no-frills music, as advertised.

designer
Nancy Given

photographer
E. K. Waller

Sherman Robertson
I'm the Man *(Code Blue/Atlantic)*
Here's a hip, post-modern scenario: a photo shoot of a photo shoot. The face of the artist, Louisiana-raised bluesman Sherman Robertson, is in shadow—seemingly irrelevant to his own cover, which is telling: this slick-sounding CD has no relationship to the swamp-fired, dynamic blues this virtuoso player has performed in the past, yet his posture makes him seem lost in his music. An interesting contrast.

photographer
Gary Compton

photo concept
Tony Engle

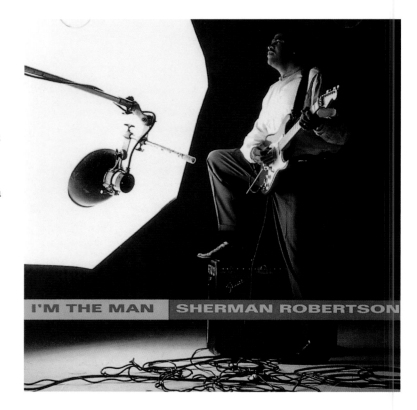

I'M THE MAN SHERMAN ROBERTSON

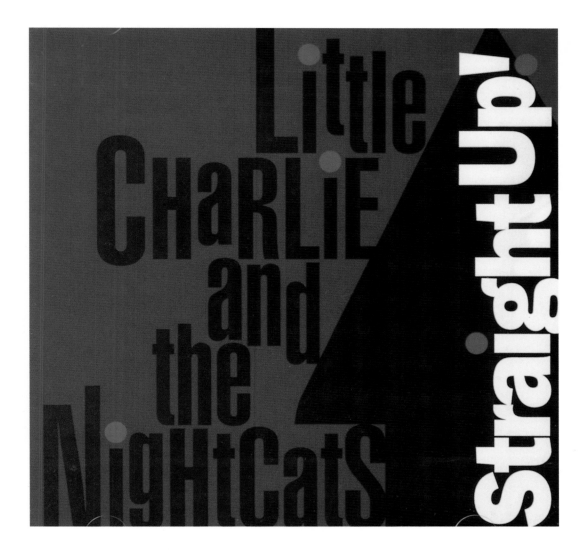

Little Charlie and the Nightcats
Straight Up! *(Alligator Records)*
This cover is another example of the artist
being subordinated to the look of the CD.
Here, cover designer Matt Minde is
depending on the well-known band's rep-
utation to sell copies. But the typeface
and the arrow graphic also have their
virtues: a cleanliness and simplicity of
design that allows Little Charlie and the
Nightcats' name easy visibility on record
store shelves.

designer
Matt Minde

Blues Queen Sylvia
Midnight Baby *(Evidence Music)*

If singer/bassist Sylvia Embry looks like a ghost on this cover, perhaps it's because she was one by the time this collection of 1983 sessions was released. It's been said that God is in the details. But perhaps here God is in the vagaries. Shortly after these recordings were made, the late Embry's marriage broke up. She then found religion, and gave up playing the blues.

art director
Rothacker Advertising & Design

cover photo courtesy of
Jimmy Dawkins

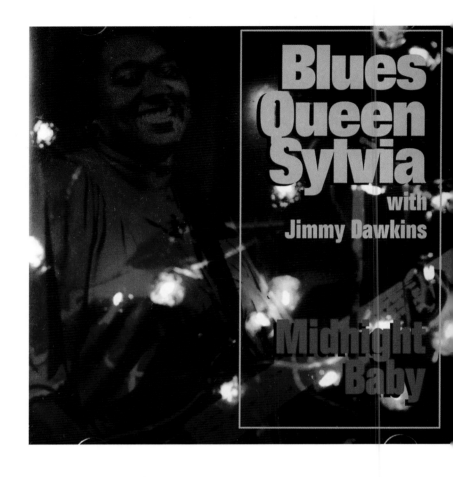

Compilation
Rare Chicago Blues, 1962–1968
(Bullseye Blues)

This collection embraces more than a dozen artists—including such greats as Otis Spann and Robert Nighthawk—caught live in the streets and homes of Chicago in the 1960s. A single photo of just one of them would have been inappropriate for this CD of rare recordings. But this distorted, sepia-tone image of an outdoor setting aptly evokes the tone of these informal but red-hot performances.

designer
Nancy Given

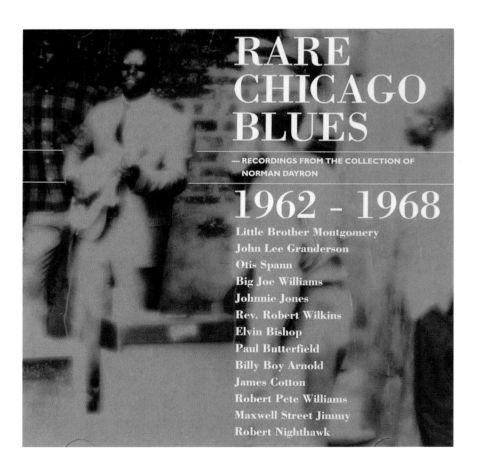

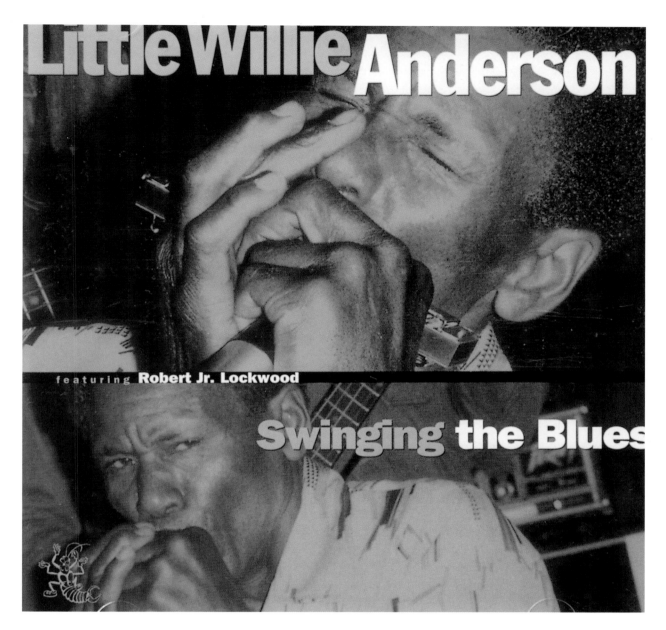

featuring **Robert Jr. Lockwood**

Little Willie Anderson

Swinging the Blues

Little Willie Anderson
Swinging the Blues
(Earwig Music Company)
A cinematic split-screen approach gives us
two views of Little Willie Anderson in
action. Both tell us volumes about his tra-
ditional approach to playing harp. His
closed eyes, tilted head, and that sly side-
ways glance indicate his vitality as a per-
former. And on the tracks inside, we find
that this unsung Chicago blues hero keeps
the flames ignited by Little Walter glow-
ing bright.

designer
Al Brandtner

photographer
Jim O'Neal

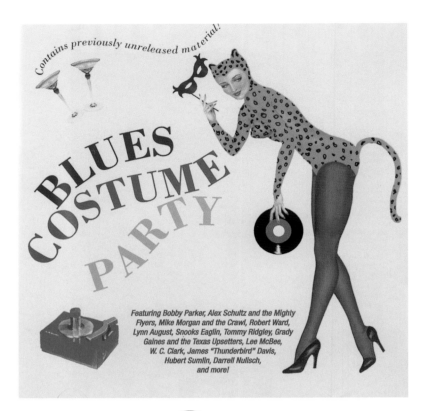

Compilation
Blues Costume Party
(Black Top Records)
In the kitschy spirit of late-1950s/early-1960s bachelor-pad instrumental LPs by the likes of Juan Garcia Esquivel, these costumed women appeal to the blues' largely male fan base.

designer and illustrator
Diane Wanek, Zigzag

We wanted a very un-PC image, to sell the CDs. We liked the cat idea—feline and feminine, sexy. It was fun, like a costume party. In [New Orleans], it is pretty common for women to dress like this. Not just at Mardi Gras; there are costume parties all year. We also wanted retro—a cool 1950s/1960s feel that gave the music, even though it's contemporary, a sense of another era. The Santa's Helper costume was more obvious."

—Diane Wanek, designer, Zigzag

Compilation
Blues, Mistletoe, & Santa's
Little Helper
(Black Top Records)

designer
Diane Wanek, Zigzag

photographer
Bryce Lankard

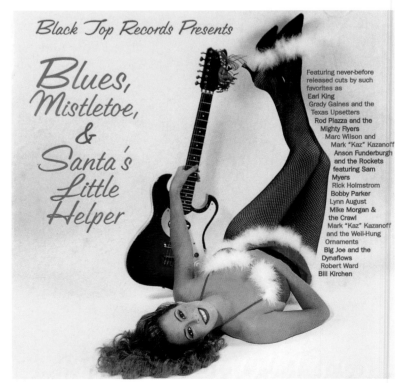

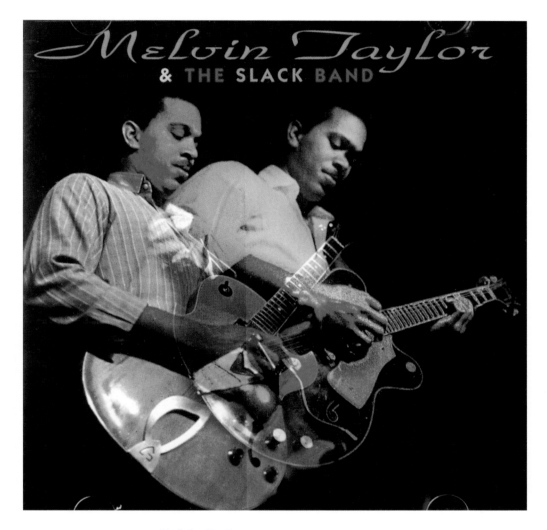

Melvin Taylor
Melvin Taylor & the Slack Band
(Evidence Music)
This multiple-image photo is evocative of
Jimi Hendrix and the psychedelic 1960s.
It's a trippy banner for a CD loaded with
rip-it-up guitar licks that spiral like
Alice's tumble through the keyhole.
Taylor's dizzying speed and distortion-
tinted sound would have been comfort-
able echoing off the walls of the old
Filmore, maybe teamed with Big Brother
& the Holding Company...or Jimi himself.

art director
Rothacker Advertising & Design

photographer
Laura Byes

Sunnyland Slim

Sunnyland Train *(Evidence Music)*

Reissue specialists Evidence produce some of the best-looking blues CDs on an independent label budget. There's rich detail in this photo—the cigarette and hat on the piano displaying a life's worth of comfort on stage, the battered piano wood and the 1960s-era amplifier summoning an old Chicago speakeasy. And at the ivories, Sunnyland Slim himself, a living icon of the blues in 1983 when this recording was originally made.

art director
Rothacker Advertising & Design

photographer
Clark Dean

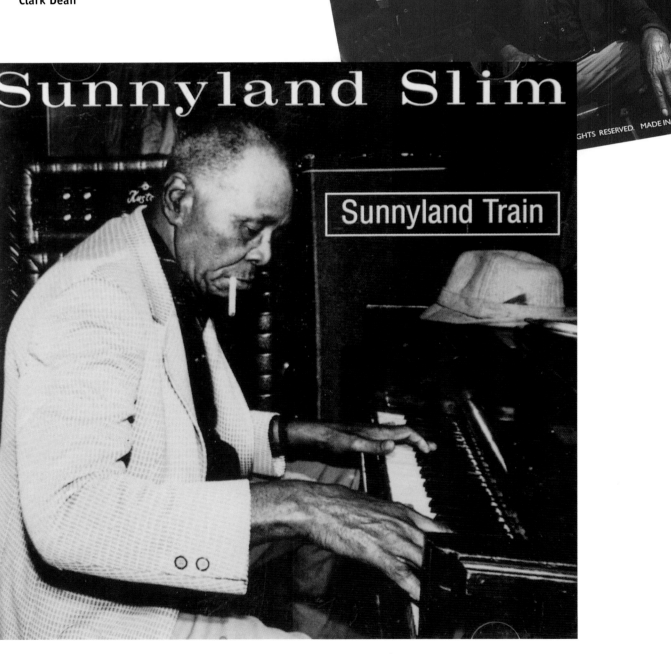

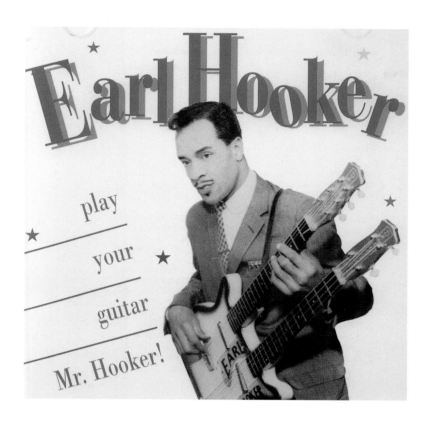

Earl Hooker
Play Your Guitar Mr. Hooker!
(Black Top Records)
The 1960s poster-style presentation, complete with a starred yellow background, brings us back to the era when Hooker was one of the greats of American blues. Outside a cult of guitar players, few know of Hooker's sophisticated and savage string-slinging, which is captured and presented so compellingly here—fitting for a blues genius who set a standard for other Chicago sessionmen.

designer
Kelly Richards

cover photo courtesy of
Sebastian Danchin

Alvin Youngblood Hart
Big Mama's Door *(Okeh/550 Music)*
Singer/guitarist Alvin Hart may be a youngblood, but his heart's in a very old place. This ramshackle shack puts his music right in the middle of the plantation-era South, although one would hope Hart's own Big Mama was lucky enough to never live in one of these. A similar place on Stovall farm outside Clarksdale, Mississippi, was once home to Muddy Waters and his kin.

graphic artist
Craig Wong

photographer
Rory Earnshaw

childhood photos courtesy of
Alvin Youngblood Hart

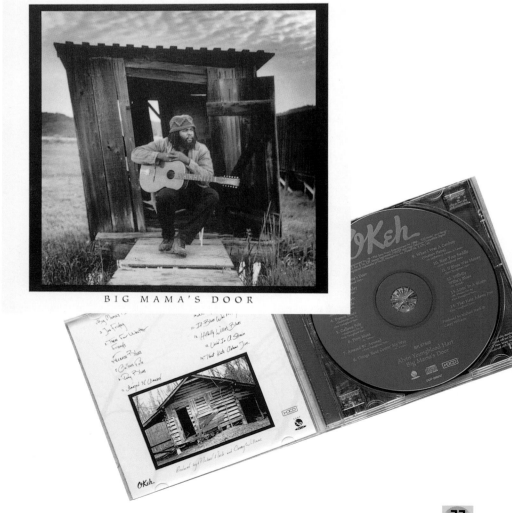

The Best Music **CD** Art+Design

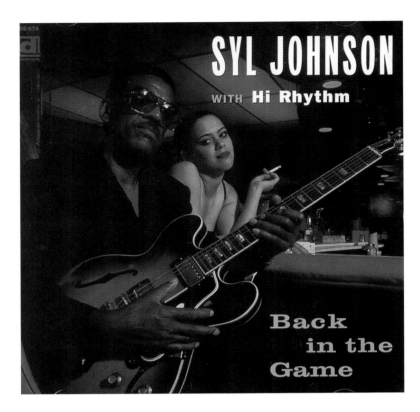

Syl Johnson with Hi Rhythm
Back in the Game
(Delmark Records)
It's the 1970s again, complete with red dance-floor lights, dropped ceilings, and a disco lady. That's when Syl Johnson's sophisticated funk was selling hits for the Hi label. This return to the studio after a 12-year absence puts him right back in his element. Night time is the right time, baby. And this is adult party music for the moonlight hours.

designer
Al Brandtner

art directors
Kate Hoddinott and Pete Nathan

photographer
Marty Perez

cover art assistance
Paul Taylor

All my other records have a picture of my face on them; this looks a bit more inspirational. The photographer, Jean Hangarter, came out to my house and took a bunch of pictures with the intention that it was going to be a full shot of me. But the Rounder art department found a picture she took of just my hands and the guitar, and thought it would look nice. I suggested sepia tone. I love sepia tone. I like old pictures of ball players and stuff. Plus, I was getting tired of looking at me. That Stratocaster has become my favorite guitar; it's a 1962 in Fiesta Red." —Ronnie Earl

Ronnie Earl & the Broadcasters
Grateful Heart: Blues & Ballads
(Bullseye Blues)

designer
Nancy Given

photographer
Jean Hangarter

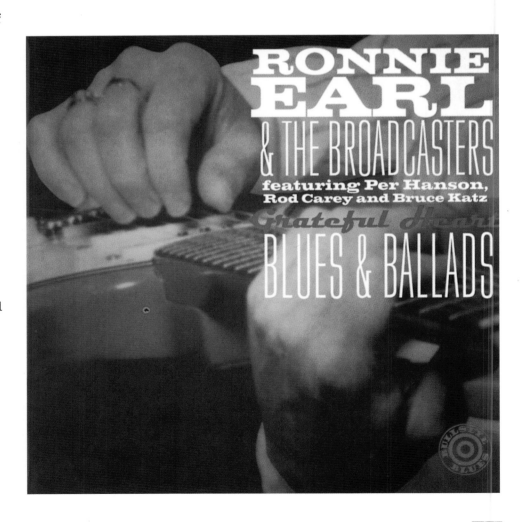

Eddie Taylor
Long Way From Home
(Blind Pig Records)

designer
Al Brandtner

photographer
Kazumi Okuma

One of the coolest looks of 1960s jazz records was the tinted action-photo covers of the classic LPs on the Blue Note label. Wes Montgomery springs to mind when seeing these guitarists. Taylor, who died 14 years ago, was one of the more influential instrumental voices around Chicago during the 1950s and 1960s, when the modern electric blues style was being defined. As a sideman, Taylor's mud-deep, chunky rhythm guitar became known as the "Jimmy Reed sound." Earl, as a player, has a gift closer to the subtly pyrotechnic abilities of Montgomery. But like Taylor, Earl is carving his own distinctive path through the legacy of the blues, mixing highly emotional playing and an encyclopedic knowledge of guitar styles with his own melodic, soul-informed take on jazz.

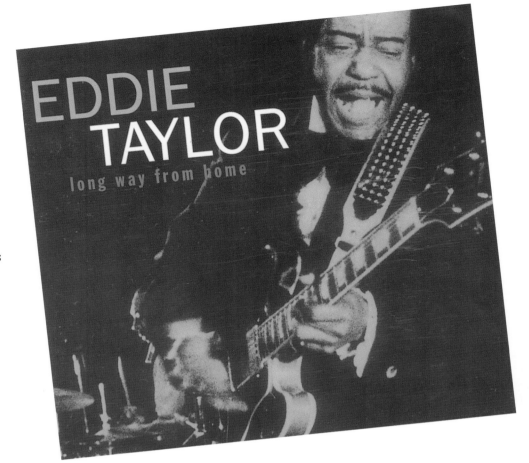

Ronnie Earl & the Broadcasters
Language of the Soul
(Bullseye Blues)

designer
Scott Billington

photographer
Jerry Berndt

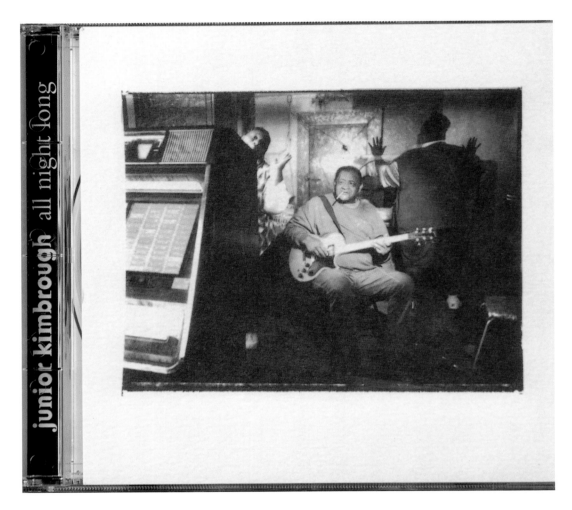

Junior Kimbrough
All Night Long
(Fat Possum/Capricorn Records)
This photo was snapped in 1995 in
Kimbrough's North Mississippi hill country
juke joint, but with that old Gibson guitar
in his hands, it could be the 1960s. Being
inside Junior's place is like stepping back
a few decades, save for the paintings of
contemporary African-American heroes
like Oprah Winfrey. If you've never been
to a juke, rest assured Kimbrough's music
is the real deal.

designers
**Gina R. Binkley and Janice Booker,
Alter-Ego Design**

art director
Diane Painter

photographer
Ron Keith

Rick "L.A. Holmes" Holmstrom
Lookout! *(Black Top Records)*

Also from the Blue Note school, but with a difference. Unlike Ronnie Earl or Eddie Taylor, ex-Mighty Flyers guitarist Holmstrom's own look—rock'n'roll black with a 1950s haircut—tells us that his instrumentals owe as much to rock's early picker-kings like Duane Eddy and Dick Dale as to the hotter electric bluesmen of that era. State-of-the-art twang.

designer
Diane Wanek, Zigzag

photographer
Stephen Taylor Hodges

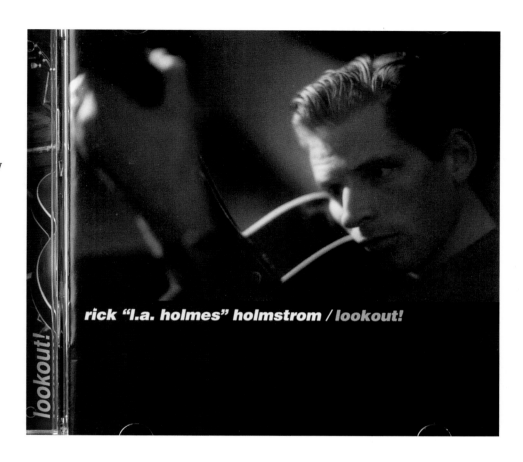

Dr. Isaiah Ross
Call the Doctor
(Testament Records)

There was a time in the Delta when a player had to do everything for himself. Hence the rhythmic, low-string droning that the great country bluesmen used to accompany the changes and melodies of their songs. Isaiah Ross took that to an extreme, simultaneously playing guitar, harp, and drums. When was the last time you saw a one-man band?

art director
E Conspiracy

photographer
Pete Welding

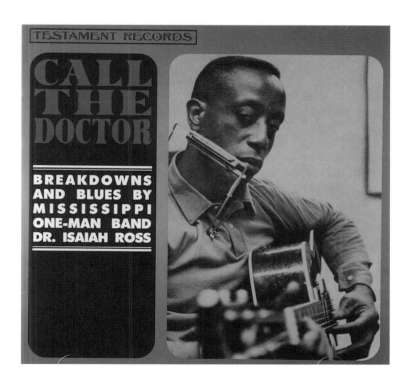

The Best Music CD Art+Design

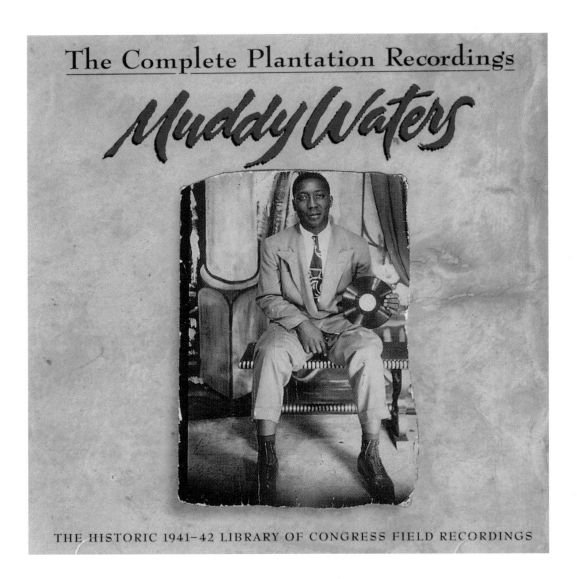

The Complete Plantation Recordings

Muddy Waters

THE HISTORIC 1941–42 LIBRARY OF CONGRESS FIELD RECORDINGS

Muddy Waters
The Complete Plantation
Recordings: The Historic 1941–42
Library of Congress Field Recordings
(Chess/MCA Records)
The nattily attired Muddy Waters himself
appears on the cover with one of his first
records, but these tracks pre-date even
those by nearly a decade. They were cut
around the Waters cabin by historian Alan
Lomax as he drove through the South,
preserving musical culture for the
Smithsonian. The cover signals this is
something special, old, historic—appeal-
ing to both the die-hard blues fan and the
music scholar. But even before he began
casting the modern electric blues sound,

Muddy Waters made music that transcend-
ed scholarship with his rich, dark-butter-
scotch voice and buzzing slide guitar.
Inside are more historic photos of Waters
and the very cabin on Stovall Plantation
where these recordings were made, as well
as Mary Katherine Aldin's informed and
intelligent liner notes.

designer
Junie Osaki

art director
Vartan

photo courtesy of:
the Estate of McKinley Morganfield

Introduction

by Jason Fine

The first jazz album I remember is a beat-up copy of John Coltrane's *Blue Train* that I found stacked amid the Beatles and Beethoven records in my parents' collection. I was eight or nine at the time, and though it was several more years before I got around to actually playing *Blue Train*, I recall being fascinated by the cover-its moody, blue-tinted photograph of a pensive Coltrane, saxophone reed close to his mouth, with the neat small type at the top of the jacket that was a trademark of the influential Blue Note label. I didn't know then that *Blue Train* was a famous cover, or that other jazz labels of the'50s and '60s—Contemporary, Riverside, Prestige, Impulse—were also designing record jackets that stand up to the finest pop art of the era. But I did know it was cool.

Of course, vinyl records are a thing of the past now. And while the large LP format, the old-fashioned liner notes, and stylish gatefold designs are mostly gone along with them, the CD age has bred some new innovations in the packaging of jazz. Working with restrictive six-inch-square jewel cases, designers at companies from the large Columbia and Warner Bros. labels to the tiny Homestead and CIMP have found ways to convey the same sense of personality and spirit in their covers that drew new listeners (like me) to the great artistry of Coltrane, Monk, Bird and other jazz giants of the past. Perhaps the most significant innovation has taken place in the area of multi-disc anthologies and box sets, where designers at labels like the venerable Blue Note and the relatively new Rhino have found creative ways to package old music—not simply by shedding historical light on the careers of legendary artists, but by recreating the same sense of excitement and intrigue that surrounded the music the first time around.

Take a look at the covers inside this book: From the neo-'50s sleeve that adorns San Francisco guitarist Charlie Hunter's *Bing! Bing! Bing!* to the brilliant, book-like designs for the six-disc Ornette Coleman *Beauty Is A Rare Thing* and the four-disc Clifford Brown *Complete Blue Note and Pacific Jazz Recordings* box, these CDs represent the best album design of the past five years.

And while CD art may never match the golden age of jazz vinyl, while flipping through these pages you can see there's still plenty of innovative artists keeping the tradition of innovative cover art alive.

Roscoe Mitchell

Hey Donald *(Delmark Records)*

Marking the thirtieth anniversary since reed master Roscoe Mitchell first recorded for the Delmark label, the sepia-toned cover for *Hey Donald*—an album that also features Mitchell's longtime collaborators Tootie Heath, Malachi Favors, and Jodie Christian—captures the warmth, spontaneity, and deep musical spirit that has always been at the core of Mitchell's music.

designer
Julia Simmons

art director
Kate Hoddinott

photographer
Todd Winters

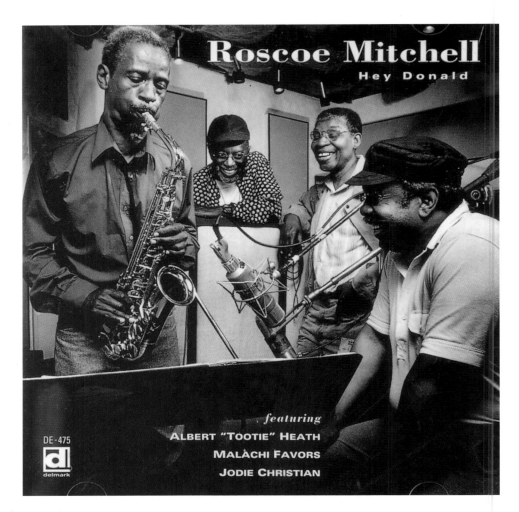

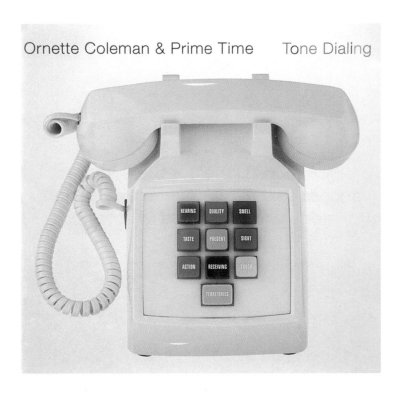

Ornette Coleman & Prime Time

Tone Dialing
(Harmolodic/Verve Records)

The title of free jazz pioneer Ornette Coleman's latest album—and his first for his own Harmolodic imprint—is an oblique reference to the notion that in the age of communication, real connections are harder to come by than ever. And for this brilliantly simple cover, designer Mike Mills took the concept one step further—creating a telephone that connects straight to the senses.

designer and art director
Mike Mills

photographer
Joe Wittkop

"I wanted to keep the integrity of the original work and at the same time create something that substantial on its own. This is music that's so important to our culture, so I wanted to make sure we designed this collection to stand the test of time."

—Geoff Gans, designer

"When we worked on the Coltrane book *Heavyweight Champion*, it took us about a month to do the remastering and sequencing of the music; it took us about a year to do the book and the graphics."

—Joel Dorn, compilation producer

John Coltrane
The Heavyweight Champion
(Rhino Records)

One of the most impressive collections ever put together by Rhino Records, this seven-disc box set comprises the explosive early 1960s sessions that produced such albums as *Giant Steps* and *My Favorite Thing*. A meticulous study of one of modern jazz's greatest musicians at the height of his creativity, *The Heavyweight Champion* comes with photographs from the sessions, a stunning, 70-page booklet featuring notes from critics and colleagues, and a discography of Coltrane's Atlantic recordings.

designer (cover)
Geoff Gans

"he muted tones of this photo invoke in me a memory of Chicago's historic State Street during the heyday of jazz. In contrast, the vibrant yellow of the cab symbolizes the intensity and immediacy of the city today."

—Gerald Wilson

The Gerald Wilson Orchestra
State Street Sweet
(MAMA Foundation)
Los Angeles–based bandleader Gerald Wilson has had a love affair with Chicago since he first visited the city as a child during the 1934 World's Fair. On this album, compositions like the title track and "Lakeshore Drive" pay tribute to the Windy City with all the warmth and sophistication of his best work.

designer
Rhion Magee/Objects of Design

photographers
Walter Mladina, Jay Van Pelt, Josefina Wilson, and Nancy Jo Wilson

cover photograph
©Archive Photos

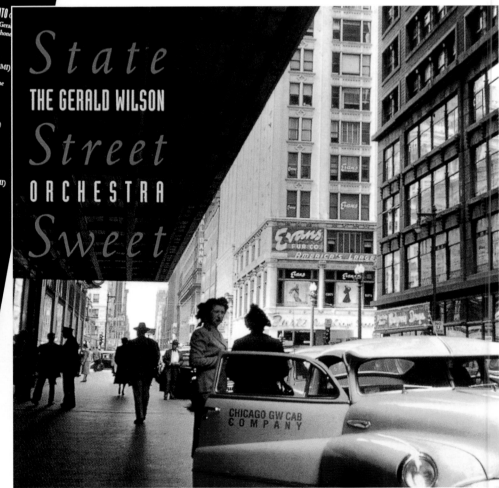

¹ STATE STREET SWEET (2:46)
Gerald Wilson (Brynhurst Music/BMI)
Randall Willis - Alto Saxophone

² LAKESHORE DRIVE (6:04)
Gerald Wilson (Brynhurst Music/BMI)
Brian O'Rourke - Piano
Randall Willis - Alto Saxophone
Anthony Wilson - Guitar

³ LIGHTHOUSE BLUES (7:48)
Gerald Wilson (Amestoy [Coast Music]/BMI)
Eric Otis - Guitar (1st and 3rd choruses)
Anthony Wilson - Guitar (2nd and 4th choruses)
Bobby Shew - Trumpet
Louis Taylor - Tenor Saxophone

⁴ COME BACK TO SORRENTO
Ernesto DeCurtis (arrangement by Gera
Plas Johnson - Tenor Saxophone

⁵ THE SERPENT (4:03)
Gerald Wilson (Jowil Music/BMI)
Bobby Shew - Trumpet
Carl Randall - Tenor Saxophone
Anthony Wilson - Guitar

⁶ THE FEATHER (5:54)
Gerald Wilson (Jowil Music/BMI)
Brian O'Rourke - Piano
Louis Taylor - Soprano Saxophone
Anthony Wilson - Guitar

⁷ CAPRICHOS (6:28)
Gerald Wilson (Amestoy [Coast Music]/BMI)
Eric Otis - Guitar
Anthony Wilson - Guitar
Carl Randall - Tenor Saxophone

⁸ JAMMIN' IN C (8:47)
Gerald Wilson (Brynhurst Music/BMI)
Brian O'Rourke - Piano
Snooky Young - Trumpet
Louis Taylor - Tenor Saxophone
Anthony Wilson - Guitar
Trey Henry - Bass

⁹ CARLOS (6:35)
Gerald Wilson (Coast Music/BMI)
Ron Barrows - Trumpet

¹⁰ NANCY JO (2:21)
Gerald Wilson (Jowil Music/BMI)
Tony Lujan - Trumpet
Randall Willis - Alto Saxophone
Anthony Wilson - Guitar

Total Playing Time: (56:25)

State Street
THE GERALD WILSON
ORCHESTRA
Sweet

CHICAGO GW CAB COMPANY

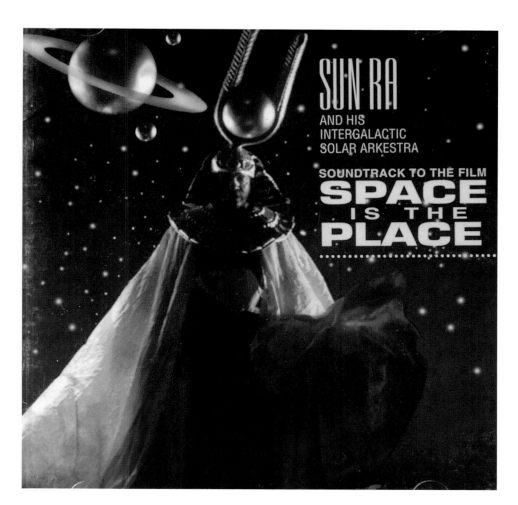

Sun Ra and his Intergalactic Solar Arkestra
Space is the Place
(Evidence Music)

Recorded in 1972 but not released until 1993, *Space is the Place* is the soundtrack to a rarely viewed film in which bandleader Sun Ra plays an alien from another planet who lands in Oakland, California, to save African Americans from the plight of ghetto life. Mixing space-age mysticism and disciplined musicality, Sun Ra is one of the most eccentric figures in modern jazz. Pictured here dressed in robes and floating in space, the cover captures him in all his otherworldly glory.

art director
Rothacker Advertising & Design

photographers
Alan Nahigian and Jim Newman

Clifford Brown
The Complete Blue Note and Pacific Jazz Recordings *(Blue Note)*

Even if the music contained in this four-disc set chronicling the 1953–54 recordings of trumpeter Clifford Brown wasn't some of the most brilliant jazz of the era, *The Complete Blue Note and Pacific Jazz Recordings* of Clifford Brown would be worth owning for its design quality alone. With its space-efficient, book-like layout, extensive liner notes, and stunning sepia-toned photographs by Francis Wolff, this package captures all the immediacy and magic of the music within—which, in the case of the great jazz trumpeter, is no small feat.

designer and art director
Darcy Cloutier-Fernald

photographer
Francis Wolff

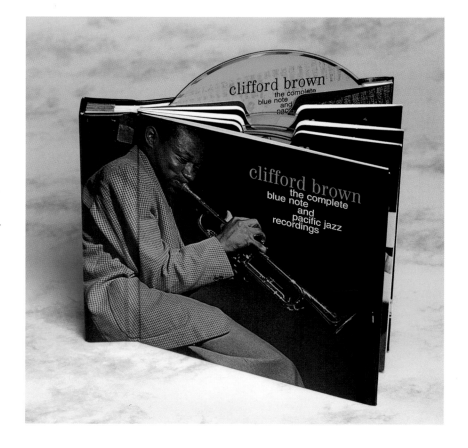

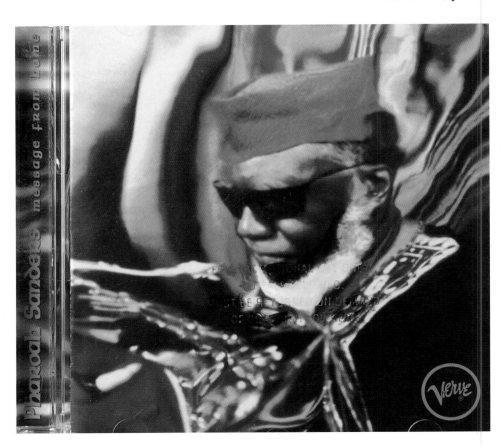

Pharoah Sanders

Message From Home
(Verve Records)

Since he came of age playing with John Coltrane in the mid-1960s, tenor saxophonist Pharoah Sanders has continued to pursue the fiercely independent, spiritually driven course of his mentor. On *Message From Home*, Sanders evokes the spirit of Africa in songs that combine traditional jazz themes with funk grooves and African percussion and chanting. With his long white beard and rugged features, Sanders possesses one of the most striking visages in jazz, and as shown here amid a swirling pattern of primary colors, designer Aldo Sampieri effectively evokes the kaleidoscopic range of styles and textures that contribute to Sanders' musical vision.

designer
Aldo Sampieri

photographer (Mylar)
Ira Cohen

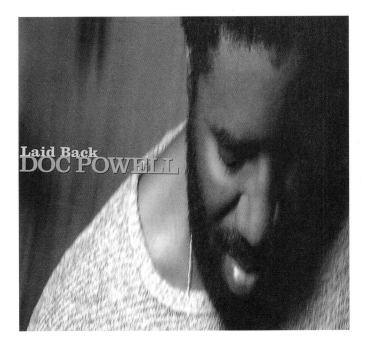

Doc Powell

Laid Back *(Discovery Records)*

Doc Powell may be "laid back," but the stylish guitarist is joined by some of the most ferocious talent in jazz-fusion on this radio-friendly outing that features guest artists including Stanley Clarke, Kirk Whalum, Gerald Albright, and even Sheila E. Both the cover photo and the inside sleeve shots offer testament to Powell's cool confidence and deep humility—the very qualities that make his music so special.

designer
DZN

photographer
Dennis Keeley, Artrouble

JaZZ

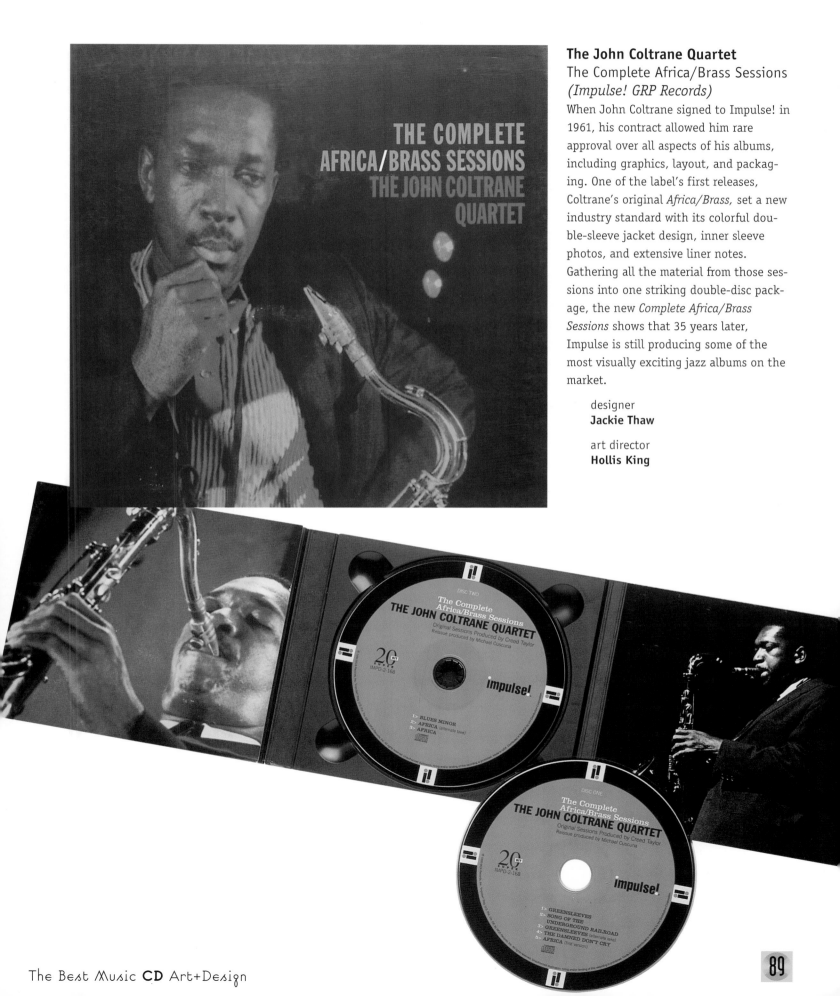

The John Coltrane Quartet
The Complete Africa/Brass Sessions
(Impulse! GRP Records)
When John Coltrane signed to Impulse! in 1961, his contract allowed him rare approval over all aspects of his albums, including graphics, layout, and packaging. One of the label's first releases, Coltrane's original *Africa/Brass,* set a new industry standard with its colorful double-sleeve jacket design, inner sleeve photos, and extensive liner notes. Gathering all the material from those sessions into one striking double-disc package, the new *Complete Africa/Brass Sessions* shows that 35 years later, Impulse is still producing some of the most visually exciting jazz albums on the market.

designer
Jackie Thaw

art director
Hollis King

The Best Music **CD** Art+Design

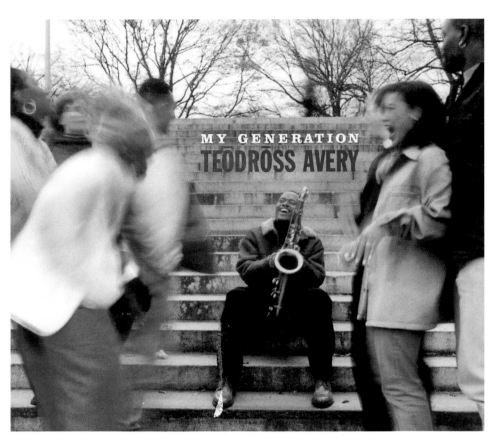

Teodross Avery

My Generation *(Impulse!)*
As a leader of the new crop of young jazz lions, saxophonist Teodross Avery combines tradition with his own decidedly 1990s approach to the music. Defying perceptions that jazz has lost its youth audience, this album design—with its bold title and casual street scene on the cover—demonstrates the Impulse label's attempt to draw in a new generation of jazz fans.

designers
Hollis King and Freddie Paloma

art directors
Robin Lynch and Freddie Paloma

photographer
Danny Clinch

Here we had a new fellow who had not had any exposure before. One of the things we were concerned with at the label, was that the label was very old and [Avery] was very new. The label was an old label, but it hadn't been functioning at all. So I had come up with a new packaging system. I looked at the old Impulse art that was done in the 1960s. It had a very distinct, personal kind of way the colors were done and I thought the design of the '60s held up very well today. As a matter of fact we're finding a lot of people trying to copy the style of the old record covers. So here we had a legitimate design thing from the past and a new artist.
"I thought since nobody knew him, even though he was quite a good player, that I needed to show him up close and personal so people would get an idea of what he looks like, so he doesn't get lost in the shuffle. So that cover was an attempt to pay tribute to the old, and pay tribute to the new, the new artist."

—Hollis King, designer, Impulse

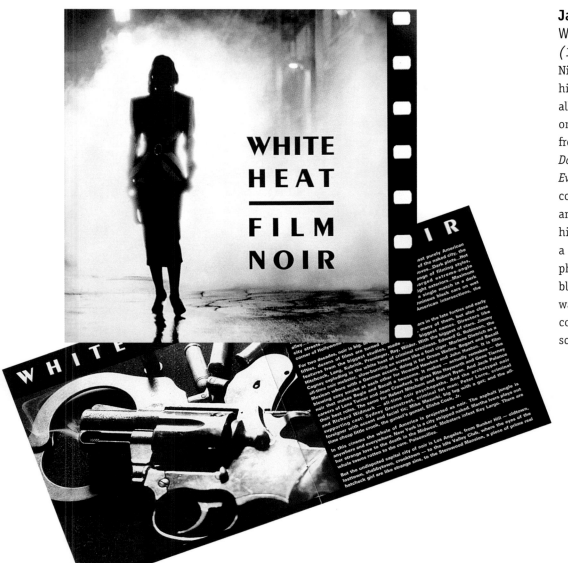

Jazz at the Movies Band
White Heat/Film Noir
(1996 Discovery Records)

Nightclub jazz and film noir have a long history together, and for this concept album, the Jazz at the Movies Band takes on some of the classic noir theme tracks from movies including Billy Wilder's *Double Indemnity*, Orson Welles' *Touch of Evil*, and Raoul Walsh's *White Heat*. The cover design beautifully evokes the dark and moody musical atmosphere, with a high-heeled woman in silhouette against a steamy street scene, and the inside photos—an old-fashioned typewriter, a blond woman in a black dress, smoke wafting around the barrel of a gun—could have come straight off the big screen.

designer
DZN

photographer
Dennis Keeley, Artrouble

Christian McBride
Number Two Express
(Verve Records)

Bass player Christian McBride is one of the leading instrumentalists of his generation, an accomplished band leader and soloist whose style—like this album cover—is all about motion. From the blurry image of the subway in the background to the hands superimposed on the bass at the center of the photo, you can almost hear the propulsive drive and elegant swing so characteristic of McBride's playing.

art director/designer
Giulio Turturro

photographer
Michael Grecco

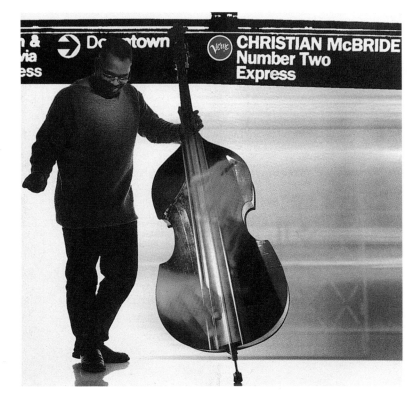

"We looked really hard for just the right image. We wanted to get just the right feeling, of elation and optimism, feelings that time really represented."
—Charlie Haden

Charlie Haden & Quartet West
Now is the Hour *(Verve Records)*

For the past 10 years, bassist Charlie Haden's Los Angeles–based Quartet West has devoted itself to recreating the nostalgic sounds of post-WWII Hollywood jazz and film music. On this, their sixth album, Haden sets his sights on music associated with New York after the war, and he couldn't have introduced the shift more dramatically than with this classic *Life* magazine photo of a soldier kissing a nurse in Times Square. The disc's foldout sleeve features several additional historical photographs, including one of Charlie Parker hugging Quartet West drummer Larance Marable and the back cover photo of soldiers gathering to celebrate peace.

designer
CB Graphics

art director
Patrice Beauséjour

photo (cover)
archival photo taken by Navy photographer named Jorgensen

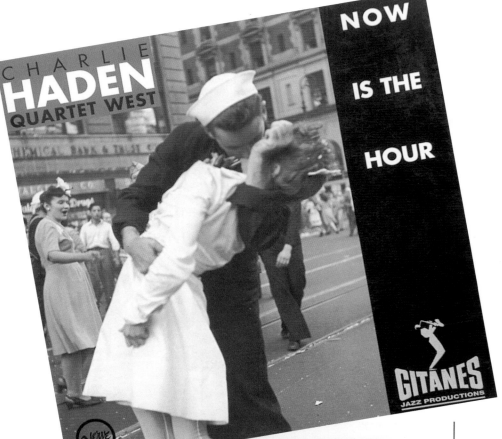

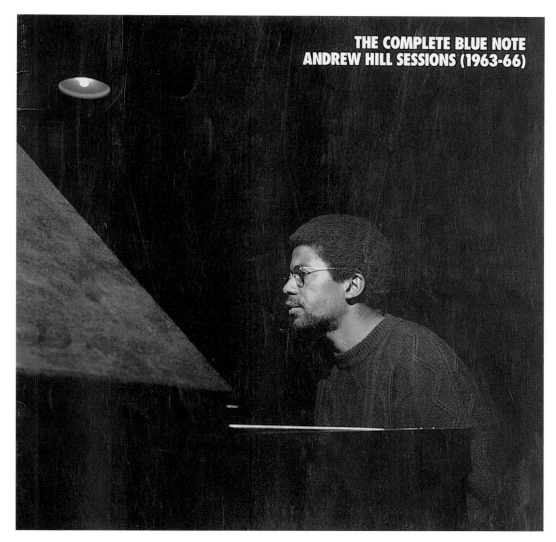

**THE COMPLETE BLUE NOTE
ANDREW HILL SESSIONS (1963-66)**

Andrew Hill
The Complete Blue Note Andrew
Hill Sessions (1963–66)
(Blue Note)
Pianist Andrew Hill was one of the most
sophisticated, esoteric instrumentalists
to emerge from the legendary Blue Note
Records talent stable of the early 1960s.
Full of sharp angles, subtle shadings, and
brilliant contrasts, Francis Wolff's cover
shot for this seven-disc retrospective per-
fectly captures the musical spirit of this
serious, scholarly jazz innovator.

art director
Richard Mantel

photographer
Francis Wolff

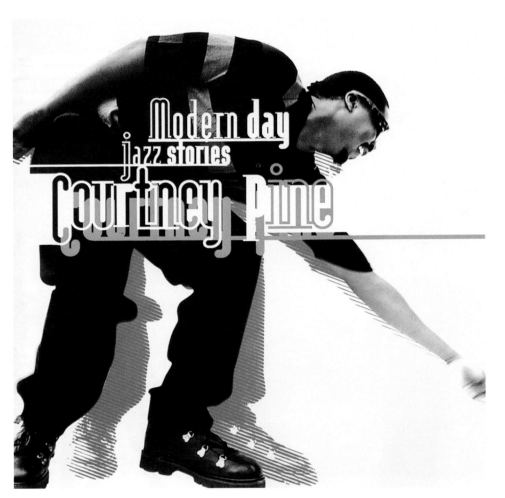

Courtney Pine
Modern Day Jazz Stories
(Verve Records)

Jazz musicians have a hard time competing with the flashy high-profile hip-hoppers who dominate today's music scene. But rather than abandoning the youth market for the more conservative, upscale audience of many of today's leading jazz figures, Courtney Pine makes a direct appeal to young listeners with his 1996 release, *Modern Jazz Stories*. Smiling on the day-glow–shadowed cover and dressed in hiking boots and wraparound shades, the saxophonist looks more like a rap star than a jazz musician, underscoring the title's insistence that jazz still has plenty of its own new stories to tell.

designer and art director
Patricia Lie

photographer
Eric Johnson

Splatter Trio & Debris Play Anthony Braxton
Jump or Die *(Music & Arts Programs of America)*

This simple, low-budget cover works brilliantly on two levels. For one, it evokes the deconstructionist sensibility that informs these musicians' approach to the complex music of Anthony Braxton. It also comments on the fact that although certain celebrated jazz innovators finally have earned their place on postage stamps—such as Charlie Parker, John Coltrane, and Jelly Roll Morton—others, like Braxton, remain woefully overlooked.

cover image
Robert Horton

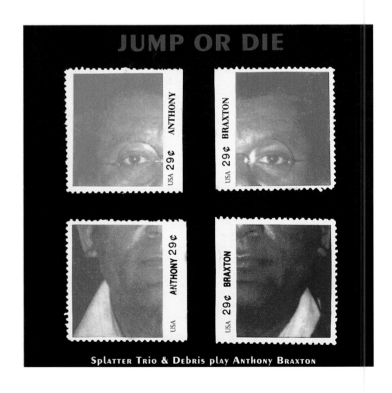

o many people this picture represents the Golden Age of bebop. It wasn't easy to get all the gangling six-feet-two of him into the frame. When he sat down, every available corner was full of Dexter! As he smoked nonstop, he was ideal for the dramatic back-lighting effects."

—Herman Leonard, photographer

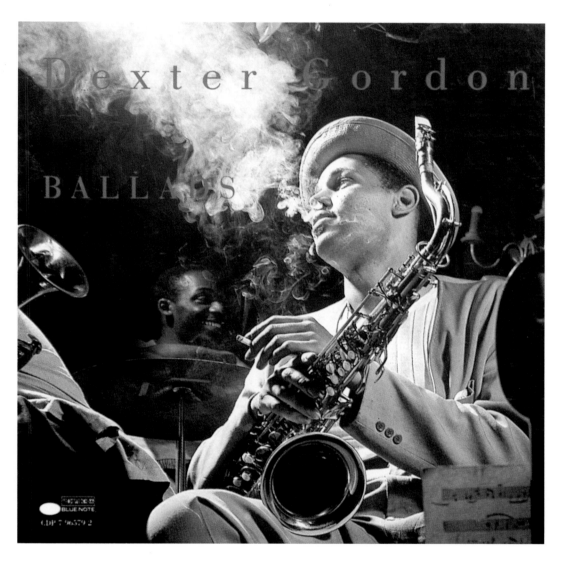

Dexter Gordon

Ballads *(Blue Note)*

The photograph of saxophonist Dexter Gordon used for the cover of this CD retrospective was taken by Herman Leonard at New York's Royal Roost in 1948. It stands as one of the most stunning examples of the smoky jazz-joint portrait so popular in the post-WWII era of bebop.

art director
Carol Friedman

photographer
Herman Leonard

T he cover image is actually from a video we took of Mahmoud when we were in Morocco with Pharoah. It made sense to give the package an Arabic look, with the border and the writing on the bottom, because the Gnawa music has roots in those traditions. I gave the basic idea to designer Aldo Sampieri and turned him loose from there."
—Bill Laswell, producer

Maleem Mahmoud Ghania with Pharoah Sanders
The Trance of Seven Colors
(Axiom/Island Records)

designer
Aldo Sampieri

photographers
Bill Laswell and Eric Rosenzveig

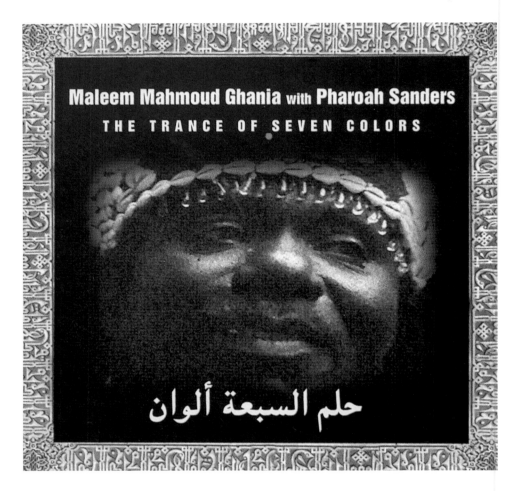

Charlie Parker
The Essential Charlie Parker
(Verve Records)
This CD is part of a series chronicling the Verve recordings of modern jazz greats, including Ella Fitzgerald, Louis Armstrong, and Sarah Vaughan. Artist Laura Levine's colorful rendering of Charlie Parker is playful and irreverent, yet it captures the grace and dignity of one of jazz's greatest all-time heroes.

designer
Patricia Lie

art director
Alli Truch

artwork
Laura Levine

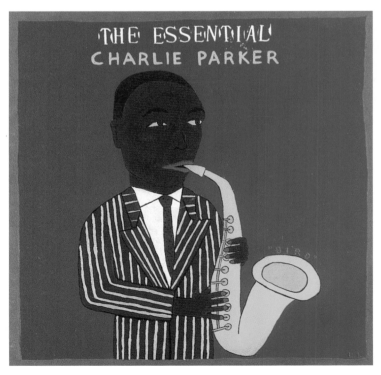

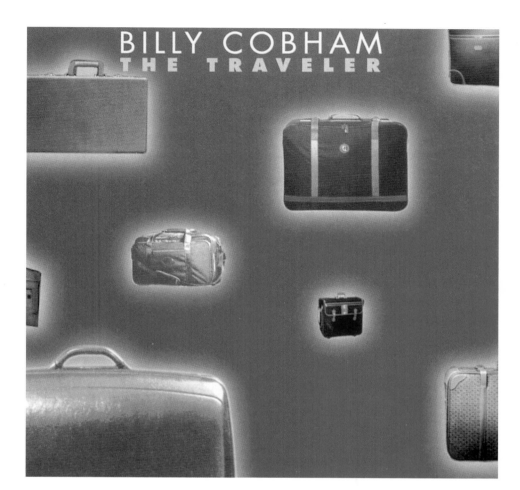

Billy Cobham

The Traveler *(Evidence Music)*
Some people count sheep when they sleep; others count luggage. At least that's the impression given by David Weil's design for the cover of drummer Billy Cobham's *The Traveler*. As both a metaphor for Cobham's far-reaching musical excursions and an allusion to the endless distances traveled by touring jazz musicians, the cover is a simple but highly effective design concept.

designer
David Weil

Ben Webster

Black Lion Presents Ben Webster
(Black Lion)
Simple, strong, and full of jazz flavor, this remarkable collection of recordings by the great pre-bop saxophonist Ben Webster is one of a series of stunning, compactly designed multi-disc collections released by the small Black Lion label. It's as much fun to look at as it is to listen to.

designer
Malcolm Walker

photographs
DF Photo Archives

"**I**t was a tribute album to *Cool Struttin'*. We couldn't just lift it, so we had to recreate it!"

—Jamie Putnam, designer, Fantasy

Ron Holloway
Struttin'
(Milestone Records/Fantasy)
A virtual reproduction of Sonny Clark's classic *Cool Struttin'* Blue Note cover, Holloway's version can be viewed either as a tribute to the pop-art brilliance of 1950s jazz cover design, or a mere copy-cat rendering. Either way, it works as a spare, evocative image that suits the saxophonists easy urban swing.

art director
Phil Carroll

photographer
Frank Lindner

"**T**his was done entirely digitally. As we transferred from paste-up to computers, we never knew what the photos would look like on the same surface until it had all been stripped together. For this, we were able to have everything scanned into the computer. It was the first time we'd ever been able to work all in color. It all came together much better because of that."

—Jamie Putnam, designer, Fantasy

Joe Henderson
The Milestone Years
(Milestone Records/Fantasy)
The definitive collection of long-underrated saxophonist Joe Henderson's '60s and '70s work, this impeccably designed eight-disc box is a treasure chest of stunning artwork, detailed liner notes, and, of course, some of the most commanding jazz of the period.

designers
Phil Carroll and Jamie Putnam

art director
Phil Carroll

photographer (box cover)
Katsuji Abe

JaZZ

I wanted something that reflected the complexity of Threadgill's music, and Shinro Ohtake's work seemed perfect. He's done a lot of three-dimensional pieces like this one, and they always have that feeling of movement, as if the image is still in the process of changing or growing."

—Bill Laswell, producer

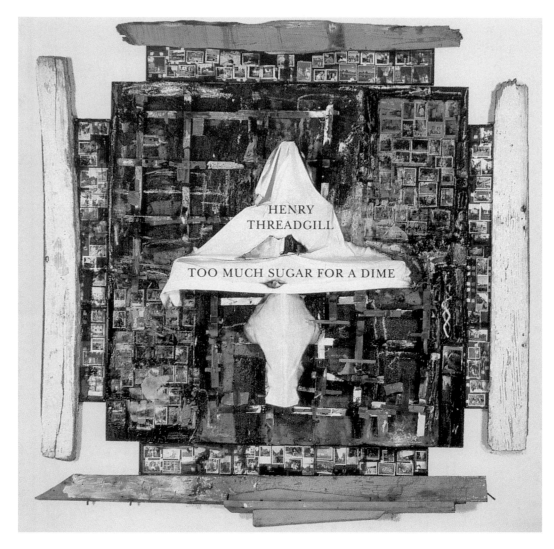

Henry Threadgill
Too Much Sugar for a Dime
(Axiom/Island Records)

designer
Aldo Sampieri

artist *Family Tree* (1986–1988)
Shinro Ohtake

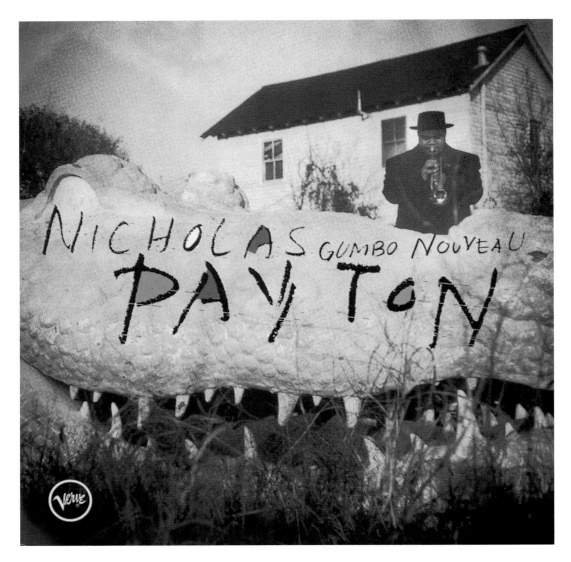

Nicholas Payton
Gumbo Nouveau *(Verve Records)*
Trumpeter Nicholas Payton takes a trip
through the music of New Orleans on this
1996 recording, and David Lau's striking,
hallucinatory cover design perfectly cap-
tures the heady, brooding mix of nostal-
gia and invention that is at the core of
Payton's work.

designer and art director
David Lau

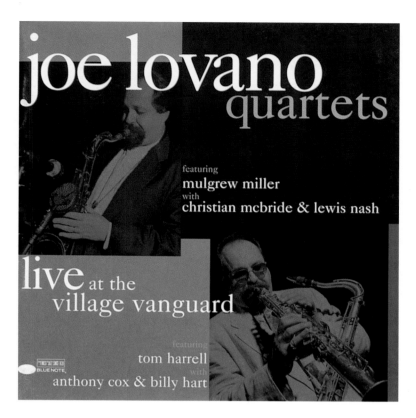

Joe Lovano Quartets
Live at the Village Vanguard
(Blue Note)
Recorded live during separate engagements at the Village Vanguard, this two-disc set captures two distinct sides of versatile reed player Joe Lovano—one with a straight-ahead post-bop quartet, the other with a more adventurous, avant-garde combo. Packaged to look similar to the classic Blue Note live albums of the '50s and '60s, art director Darcy Cloutier-Fernald and designer Patrick Roques employ contrasting performance photos and subtle shadings in blue and black to convey the different styles of music contained within.

designer
Patrick Roques

art director
Darcy Cloutier-Fernald

photographer
Jimmy Katz, Giant Steps

Ahmad Jamal
The Essence Part 1 *(Verve Records)*
Simple, clean, and casually elegant, the design for veteran pianist Ahmad Jamal's 1996 album conveys the fluid beauty of his music. More significantly, it captures the restless jazz innovator in motion, moving out of frame. This is important because at a time when shameless copycats dominate the marketplace, it's impossible to know just where Jamal will go next.

designer
CB Graphics

art director
Patrice Beauséjour

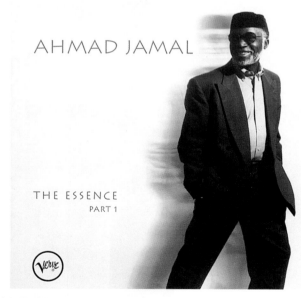

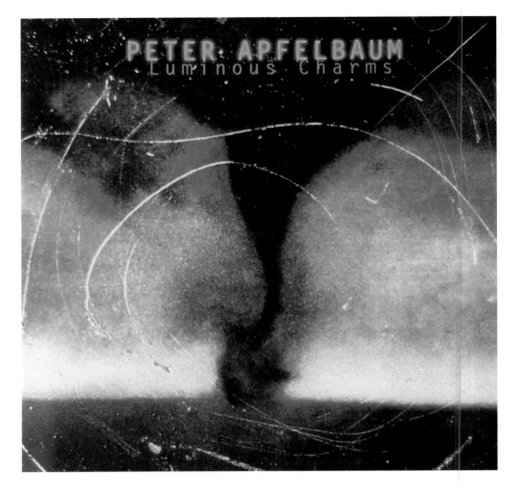

When [producer] Hans Wendl first sent me slides of Mark Gleason's work, I was knocked out. We originally chose another, quieter painting of Gleason's for the cover, before the recording sessions began. Once the sessions were over and the album had taken shape, we decided this one had more in common with the music, with all its turbulence. I really like the motion, the multidimensional quality and the intensity it has. I also like what [graphic designer] Steve Jurgensmeyer did with the type—he actually took some 'mist' from the painting and applied it to the letters.

"In album covers, as in titles, I look for a suitable parallel to the music, rather than a literal representation. Another record company might have responded to the title, *Luminous Charms*, by using a picture of some glowing jewels or something, which would have been hokey.

"I got teased about the fact that the cover looks somewhat like the ad for the movie *Twister*, which came out around the same time. Maybe some people will buy the CD thinking it's the soundtrack."

—Peter Apfelbaum

Peter Apfelbaum
Luminous Charms
(Gramavision/Rykodisc)

designer
Steven Jurgensmeyer

cover painting
Mark Gleason

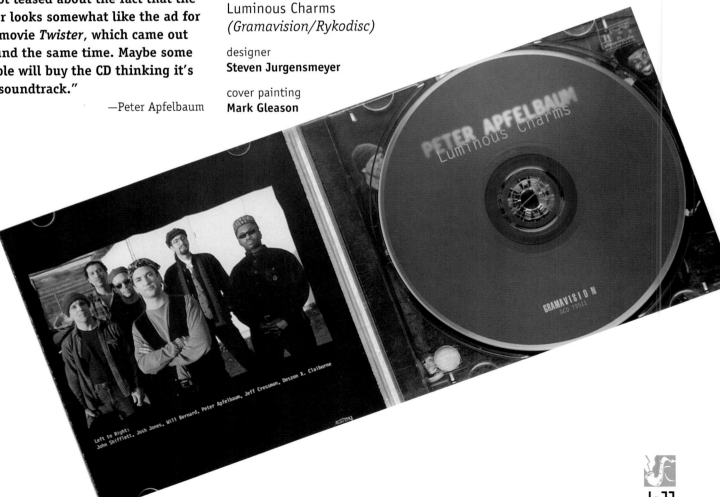

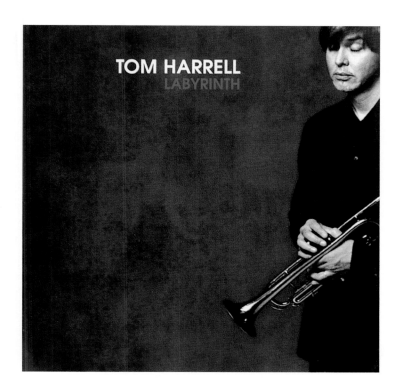

Tom Harrell
Labyrinth *(RCA/Victor)*

Brilliant trumpeter Tom Harrell has struggled with a schizophrenic disorder throughout his career. For this 1996 release, art director Scott Johnson evocatively employs an off-center photograph of Harrell set against a backdrop of rich, muted browns. It conveys both beauty and imbalance.

art director
Scott Johnson

photographers
Michael Ian and Carol Weinberg

The Roy Hargrove/Christian McBride/Stephen Scott Trio
Parker's Mood *(Verve Records)*

Recorded to coincide with the 40th anniversary of Charlie Parker's death, this tribute to Bird features three of jazz's top young lions performing some of the be-bop legend's best-known tunes. Far from an exercise in bland recitation, however, Hargrove, McBride, and Scott approach the material with fresh ideas and tremendous energy. It's that same energy that art director David Lau and designer Lisa Po-Ying Huang capture in their bold collage-style cover, which features cut-out photographs of the musicians set against a blur of text and fragmented line drawings. The rough feel of the cover contrasts nicely with the stark black and white photography that adorns the album's back sleeve.

art directors
David Lau and Lisa Po-Ying Huang

designer
Lisa Po-Ying Huang

photographer (Trio)
Jimmy Katz

photographer (Charlie Parker)
Herman Leonard

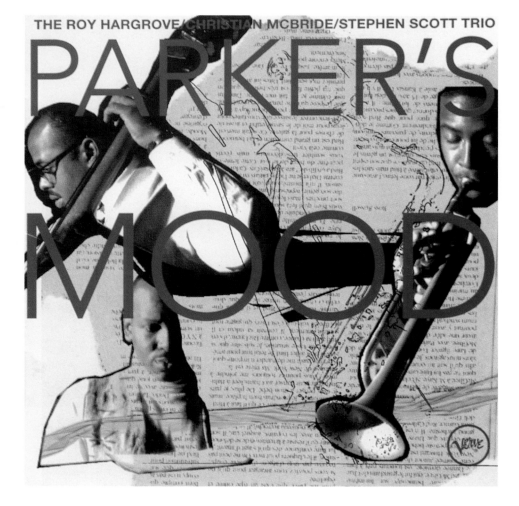

The Best Music CD Art+Design

The legendary American illustrator, Thomas Hart Benton, has long been a favorite of Bill's. For me, Benton's work certainly shares with Bill's a true fondness for cultural Americana with a sense of irony that is sometimes expressed impressionistically as opposed to a literal treatment with blind reverence.

"Gwen Terpstra, the designer of the package, picked out a few of his illustrations as possible cover solutions. But *The Boy* quickly rose to the top. In retrospect, as I look at this piece, it seems particularly appropriate since it portrays the subject starting off on a journey, waving farewell, etc. Although this was not a conscious decision at the time, now it strikes me as symbolic of the new direction Bill has taken with his quartet and the adventurous aspect of its unconventional, more orchestral instrumentation of guitar, violin, trumpet, and trombone.

"In the same spirit of respectful revisionism, Gwen Terpstra did the brilliant color treatment of what was originally a black and white print. We feel that this truly enhances the power of the original image for the purposes of being couple with Bill's music for a CD package."

—Lee Townsend, producer

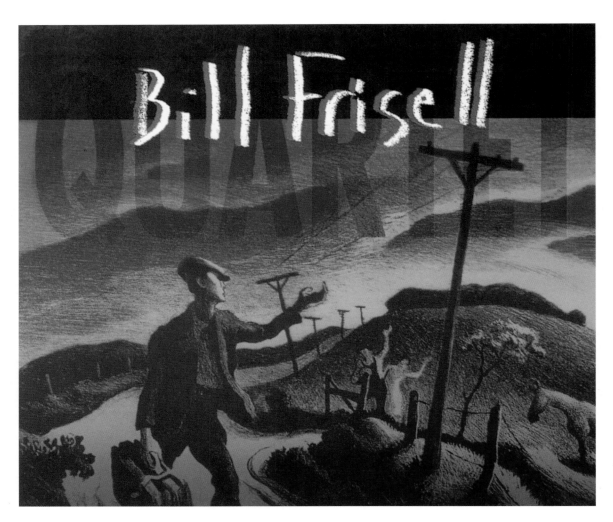

Bill Frisell
Quartet *(Nonesuch Records)*

designer
Terpstra Design

illustrator, *The Boy*
Thomas Hart Benton

The logo used on *Friday Afternoon in the Universe* is a symbol of the band. This was from a series of line drawings I have been developing. What does it mean? Whatever you want it to mean.

"Two musician/artists that I admire very much, Bob Moses and John Lurie, have been major influences on me. As well as touring and playing in their bands, drawing with them has been very encouraging."

—Billy Martin, drummer for Medeski, Martin, and Wood

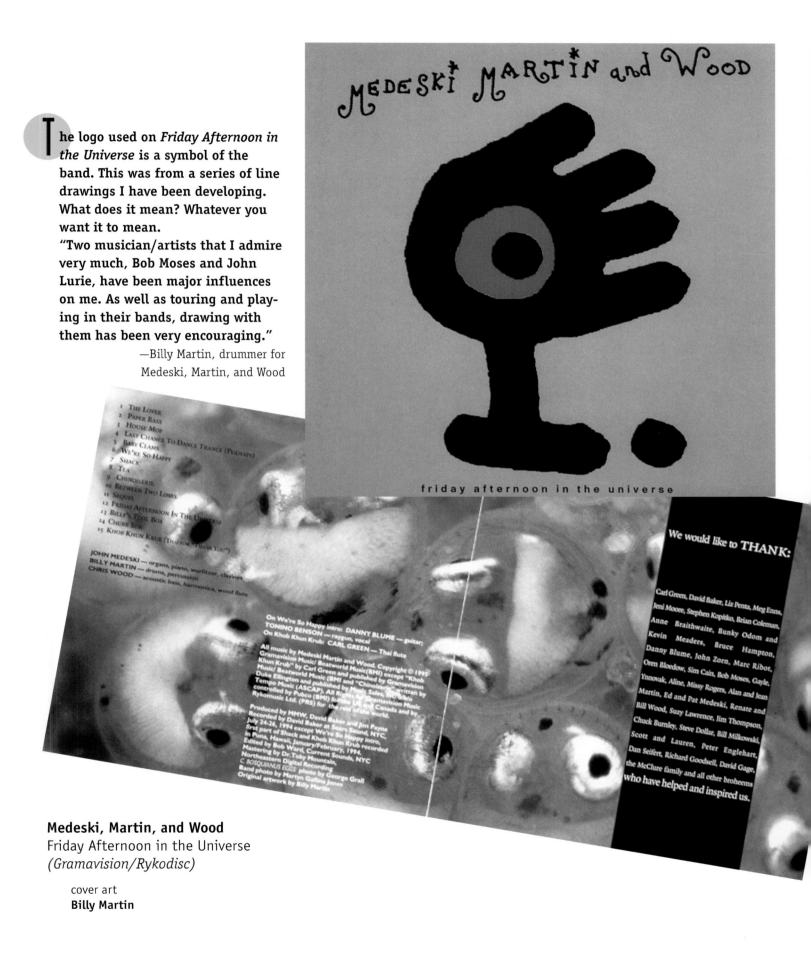

Medeski, Martin, and Wood
Friday Afternoon in the Universe
(Gramavision/Rykodisc)

cover art
Billy Martin

Clusone Trio
I Am an Indian
(Gramavision/Rykodisc)
Holland-based drummer Han Bennink has long been one of the most adventurous European exponents of American jazz, and for this album with his Clusone Trio, he takes the American mythology one step further with his own striking cover drawing—appropriately titled *I Am An Indian*.

designer
Steven Jurgensmeyer

cover art
Han Bennink

Lester Young

The Complete Aladdin Recordings of Lester Young *(Blue Note)*
With his sleepy eyes, dapper suits, and oddly tilted horn, Lester Young never carried himself with the swagger or menace of many of his jazz contemporaries. But as the beautiful archival photo of "The Prez" that adorns the simple cover of this 1995 compilation makes clear, no elaborate CD design concept was needed to convey the tremendous intensity and power that came through in his music.

photograph courtesy of
Colin Escott

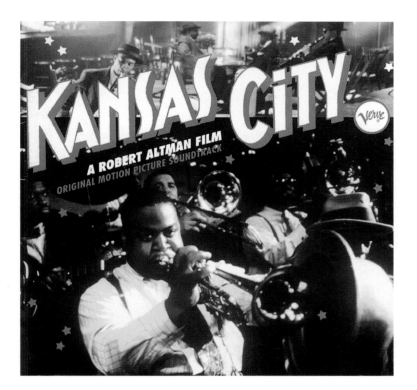

Original Motion Picture Soundtrack
Kansas City *(Verve Records)*
Set amidst the 1930s jazz bars and jam sessions of Kansas City, maverick director Robert Altman's 1996 film burns with the spirit of that era. For the excellent, all-star accompanying soundtrack, Verve designers used images taken from the film—note young saxophone star James Carter (in the role of Ben Webster) in the upper left—to convey the gritty, after-hours nightclub feel inherent in all of the music.

photographer
Eli Reed

I designed the outside of the box, and it was a woodcut. I actually made a linoleum cut based on a photo. I designed the font for all the headlines to make it look like woodblock type. It's based on another font and I just modified it. It's called 'Sonny Black.' We had always wanted to do a woodcut, and this was a perfect opportunity. We love Sonny. We love to make really special packaging for him."

—Jamie Putnam, designer, Fantasy

Sonny Rollins
The Complete Prestige Recordings
(Prestige Records/Fantasy)

designer (booklet)
Georgia Gillfillan

art director
Phil Carroll

cover art (block print)
Jamie Putnam (based on a photograph by Burt Goldblatt)

Charles Mingus
The Complete Debut Recordings
(Fantasy)
Stark, masculine, and full of style, Fantasy's anthology of Charles Mingus' recordings for his own Debut label stands out with all the verve and dignity that characterized the bassist's legendary persona.

designers and producers
Jerri Linn, Jamie Putnam, Deborah Sibony

art director
Phil Carroll

cover art based on a photograph by
Grover Sales

Don Byron
Music for Six Musicians
(Nonesuch Records)

> cover art *Barber Shop* (1946)
> **Jacob Lawrence**
>
> photographer
> **Anthony Barboza**

Ornette Coleman
Beauty is a Rare Thing
(Rhino Records)
Hailed as one of the first great jazz box
sets when it was released in 1993, *Beauty
is a Rare Thing* still stands as a hallmark
in the since-glutted field. It remarkably
compiles six discs of music along with
exhaustive notes, discographies, pho-
tographs (including reproductions of all
the original album covers), and personnel
information into a compact six-inch
square box so gorgeous to look at, you
might want to own it even if you've never
acquired a taste for Coleman's revolution-
ary free jazz.

> designer
> **Brigid Pearson**
>
> art director
> **Geoff Gans**

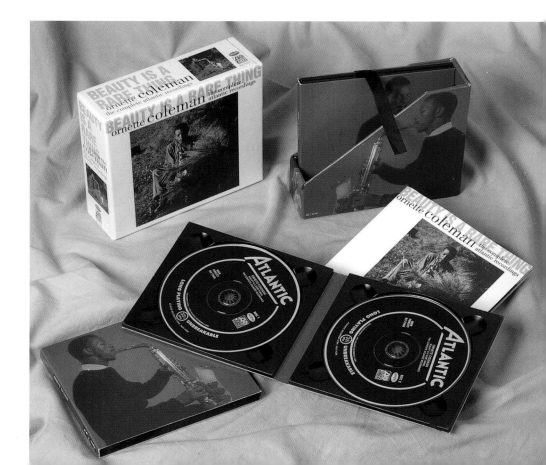

John Scofield Quartet
What We Do *(Blue Note)*

Using a technique often employed by magazines, the cover of John Scofield's 1993 album *What We Do* is simply a sepia-tinted contact sheet cut up and pasted together. It creates a beautifully effective composite of images that captures the band members both playing their instruments and hamming it up for the camera. Not all great covers require sophisticated concepts.

design concept
Susan Scofield

art director
Mark Larson Design

photographer
Les Morsillo

1 Little Walk (6:34)
2 Camp Out (8:01)
3 Big Sky (6:05)
4 Easy For You (6:41)
5 Call 911 (7:27)
6 Imaginary Time (6:08)
7 Say The Word (6:26)
8 Why Nogales? (8:15)
9 What They Did (7:09)

All compositions by John Scofield.

Scoway Music, BMI

1 Little Walk
2 Camp Out
3 Big Sky
4 Easy For You
5 Call 911
6 Imaginary Time
7 Say The Word
8 Why Nogales?
9 What They Did

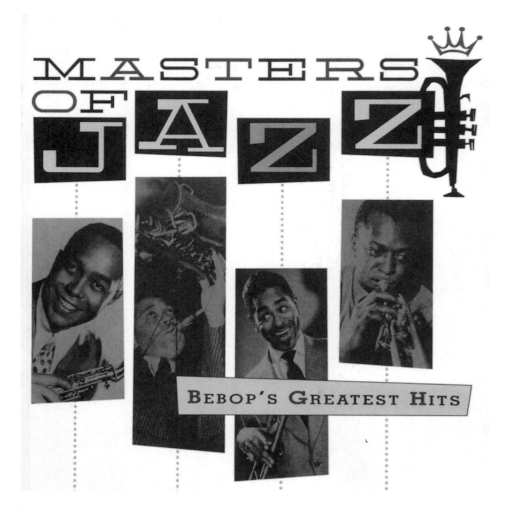

BEBOP'S GREATEST HITS

Compilation

Masters of Jazz: Bebop's Greatest Hits *(Rhino Records)*

Taking its look from old pop records of the '40s and '50s, Rhino's Masters of Jazz series highlights several distinct facets of the music in its heyday. Individual releases are devoted to male and female vocalists, big bands, and, in this example, jazz "hit singles." Featuring such stars of the past as Count Basie, Wes Montgomery, and Gene Ammons, among others, this compilation's dynamic design seeks to bring back the feel of a time when jazz was pop music. Listening to the music within, it's hard to imagine why jazz ever fell out of favor.

designer
Rachel Gutek

art director
Coco Shinomiya

photographer
Michael Ochs Archives

World Saxophone Quartet

Four Now *(Justin Time Records)*

A pairing of the World Saxophone Quartet with African drums is bound to create a fascinating hybrid sound. The cover design of *Four Now* takes as its inspiration this clash of styles. The quartet's horns are burnished and laid out in a design incorporating the instruments' curved shapes. Against this, several colorful sketches of drums float on a different plane, suggesting the musical journey that will bring together these disparate forces.

designer
**Karen Birdgenaw and
Reid Norris at Graphic Junction**

photographer
Fernando Natalici

Donal Fox/David Murray
Ugly Beauty (Evidence Music)
Pianist Donal Fox and saxophonist David Murray took the title of this CD from a Thelonious Monk tune. A striking mask, its features contorted and mouth pulled into gaping, pained grin, dominates the cover. The visage floats against a background of urban graffiti. The imagery captures the inherent contradiction of the title.

art director
Rothacker Advertising & Design

Sonny Stitt
Legends of Acid Jazz
(Prestige Records/Fantasy)
Seeking to capitalize on the renewed popularity of '60s and '70s soul jazz, reinvented in '90s nightclubs as "acid jazz," Prestige has released a series of vintage recordings by such soul-jazz masters as Melvin Sparks, Boogaloo Joe Jones, and, presented here, saxophonist Sonny Stitt. Designed with bright bursts of color and explosive hand-designed lettering, the package looks more like a psychedelic rock record than jazz—but that is what's helping draw in a whole new generation of listeners.

art director
Phil Carroll

photographer
Steve Schapiro

To play the bass implies a big responsibility, as you are the 'bottom' of the band. Everything you do influences the mood of the performance, the color of the music, and the communication between the people involved. What does the 'bottom' have to say? With this project, I didn't try to take over the top of the band, but to make music the way I like to hear it. The bottom's view."

—Joris Teepe

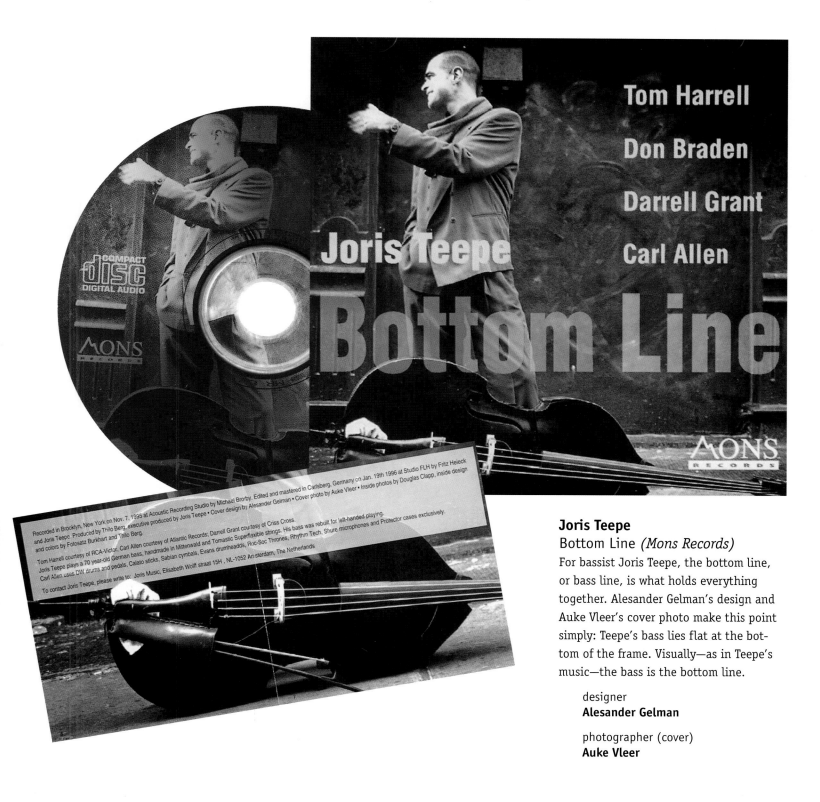

Joris Teepe
Bottom Line *(Mons Records)*
For bassist Joris Teepe, the bottom line, or bass line, is what holds everything together. Alesander Gelman's design and Auke Vleer's cover photo make this point simply: Teepe's bass lies flat at the bottom of the frame. Visually—as in Teepe's music—the bass is the bottom line.

designer
Alesander Gelman

photographer (cover)
Auke Vleer

Rahsaan Roland Kirk
I, Eye, Aye *(Rhino Records)*

designer
Bryan Rackleef

art directors
Bryan Rackleef and Coco Shinomiya

photographer
Giuseppe Pino

"**R**ahsaan's my passion in life. All of the photographs are from the archives of one of the greatest photographers in the world, Guiseppe Pino. He gave us access to his stash. Pino is a world-class photographer, one the great artists of Italy, and has been chronicling the Montreaux Jazz Festival since its beginning." —Joel Dorn, producer

Frank Lowe Trio
Bodies & Soul *(CIMP Ltd.)*
Part of a new series of recordings on the small Creative Improvised Music Projects label, this album was put together with a lot of love and dedication by a devoted family of jazz fans. *Bodies & Soul* was produced by Robert Rusch and engineered by his son, Marc. The cover painting, titled *Playtime*, was painted by Robert's daughter, Kara. The whole package proves you don't need the big-budget of a major label to put out great music and stunning design.

cover painting
Kara D. Rusch

typesetter
Hillary J. Ryan

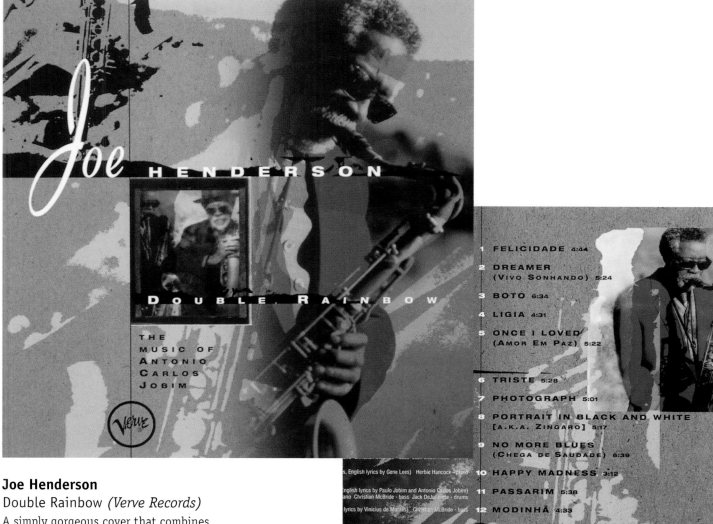

1 FELICIDADE 4:44
2 DREAMER (VIVO SONHANDO) 5:24
3 BOTO 6:34
4 LIGIA 4:31
5 ONCE I LOVED (AMOR EM PAZ) 5:22
6 TRISTE 5:28
7 PHOTOGRAPH 5:01
8 PORTRAIT IN BLACK AND WHITE [A.K.A. ZINGARO] 5:17
9 NO MORE BLUES (CHEGA DE SAUDADE) 6:39
10 HAPPY MADNESS 3:12
11 PASSARIM 5:38
12 MODINHA 4:33

Joe Henderson

Double Rainbow *(Verve Records)*

A simply gorgeous cover that combines graphics and photos to create a double image of Henderson. In the center, he appears as a tiny set of figures in a black and white photograph, a suggestion of a gloomy, cramped time. To the right, he appears out of the backdrop—a burst of color, horn to his lips—as a glorious precedent to the rainbow he brings whenever he blows the clouds away with his saxophone.

art directors
David Lau and Patricia Lie

photographer
James Minchin

Compilation
Antonio Carlos Jobim and Friends
(Verve Records)

Patricia Lie's art direction and Joel Nakamura's illustrations take the much-loved music of Jobim as its inspiration, just as the performers do with the music on this CD. They're creating something vibrant and fun: a swirling wash of images bob on a painted, textured piece of tin. The floating images of musical instruments and the celestial motif offer a buoyant visual counterpoint to the joyful music inside. The pastiche suggests the colorful beauty of Jobim's songs: The flowing circular motion represents the tune "Wave," for instance.

art director
Patricia Lie

illustrator
Joel Nakamura

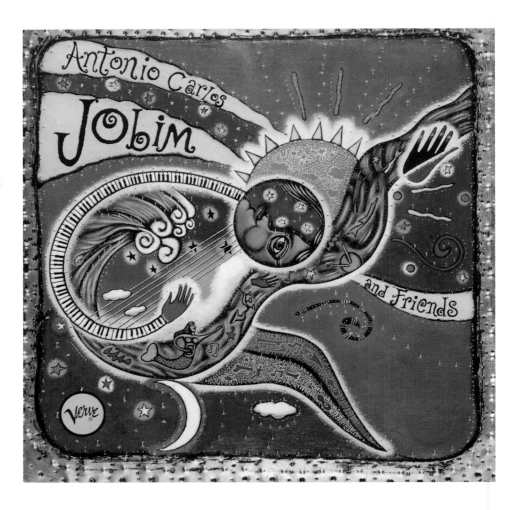

Ernie Krivda Trio
Sarah's Theme *(CIMP Ltd.)*

This cover was painted by Kara Rusch as part of a new series of recordings on the small CIMP (Creative Improvised Music Projects) label. The simple, evocative juxtaposition of red flowers against a cut-up, Matisse-like, blue-and-green background contains the same beauty and sense of bold purpose that fills the music by saxophonist Ernie Krivda and his trio.

cover art
Kara D. Rusch

typesetter
Hillary J. Ryan

avid Newman has always been my personal favorite saxophone player. We did 8 or 10 albums together. When I got to Atlantic, Fathead had left and I brought him back. Coincidentally, the first record he made for Atlantic when I got there was called *House of David*. And I loved the title so much that when we did the anthology I just said, 'Screw it, man, we're not gonna come up with a better title for this record than *House of David*.'"

—Joel Dorn, compilation producer

David "Fathead" Newman
House of David: The David "Fathead" Newman Anthology *(Atlantic/Rhino Records)*

designer
N. Kellerhouse

art director
Geoff Gans

photographer (color)
Lee Friedlander

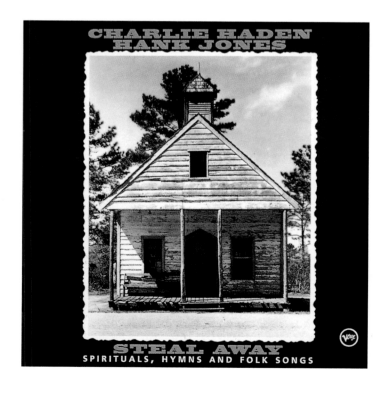

ank and I both have a real love for those old American folk songs and hymns, and I think the photograph on the cover is a kind of symbol of that music—that building is so old and weathered, but it's still so beautiful, kind of noble."
—Charlie Haden

Charlie Haden/Hank Jones
Steal Away: Spirituals, Hymns, and Folk Songs *(Verve Records)*

designer
Alain Frappier

photographer
Walker Evans

"The inspiration for the cover painting came directly through the music. The players on this recording are as follows: David S. Ware, tenor sax; Matthew Shipp, piano; William Parker, bass; and Whit Dickey, drums. The painting, by Ethiopian artist Wosene Kosrof, was hanging on drummer Whit's hall, above the fireplace. Its infinite depth, cryptic language, and feel for an ancient African village lent itself perfectly for usage on this project. Like the music, the painting unfolds itself; the more time the listener/viewer spends, the greater the reward. Three quadrants of the painting were utilized. The booklet unfolds to show one per panel, revealing a reproduction of the full painting on the fourth panel."

—Steven Joerg, label manager, Homestead Records

David S. Ware Quartet
Tao/Dao *(Homestead Records)*

cover painting
Wosene Kosrof

photographer
Michael Galinsky

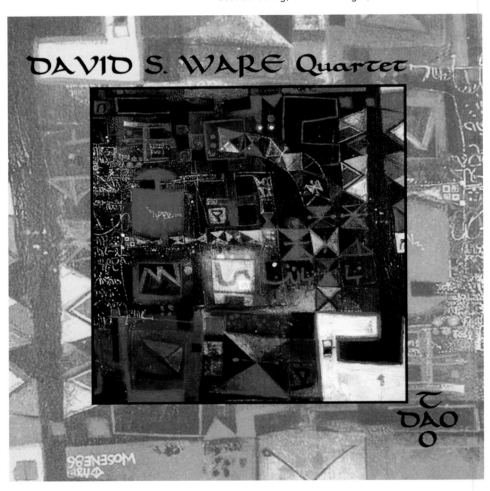

(continued from back cover) They can shadow Ware with the softness of a feather or undergird his roar with rumbling thunder. Of course, the group is rarely reactive; they engage in a perpetual four-way conversation. *Dao* proves to be no exception.

Ripping away from the tether that can paradoxically straitjacket free jazz's theoretically boundless options, the group has continually finetuned its distinctive modus operandi; whether hewing closely to the changes of a standard like "Autumn Leaves" or drifting free of any harmonic moorings at all, the quartet, whether bulldozing ahead or tiptoeing gently, moves as a unified whole. Four voices lovingly knotted together with single-minded determination, but traveling with restless curiosity, careful probing, thoughtful questioning, thorough investigation, and a throbbing sense of adventure. A strain of the Taoism referred to in the album's title has been a concern of the group for years. As Ware explains, "There's an underlying intelligence in the music, and that's what structures the music, provides the sequence, everything. It's important to be attuned to that, the intelligence that orders everything in life, sequences it all. It all comes through me, yes, but in a sense it's not mine; it has its own intelligence. If you try to keep your personality out of it enough just enough to get at it, you can come up with something good." In Taoism this concept is known as wu wei, which translates loosely as "creative quietude." The body serves as the conduit for an untainted pre-cognitive creativity. Through intense relaxation and that near-impossible determination to shutdown the cognizant mind, the music ideally flows forth with a rare purity, unfettered by everyday distractions. Of course, the level of expression produced by the David S. Ware Quartet is hardly a primal howl; while rooted in deep emotional cries, the means of expression are devastatingly sophisticated, the content liberated by astonishing technical facility. The key, in this case, is to exploit technique as nothing more than a means to an end. While the listener may gasp at Ware's mind-bending swirl of caustic circular breathing on "Dao," it's fundamentally only a residual reward, albeit a rather substantive one. The message that extended technique puts forth is the real meat of the matter.

This Taoist tenet conflates with another familiar concern of David S. Ware; the simple melodic motif. Ware and company thrive on dissecting a small nugget; breaking it down and closely examining every component from every possible angle by every available method. The same idea was expressed in words by the leader in the unique liner notes to his last Homestead release *Cryptology*; a long series of images and ideas linked primarily by abstract tendrils of concept and sound. "Awareness / acceleration / heat / embrace /

manifesting / self / think / neuter," runs but a small chunk of Ware's piece, but as a snippet it reveals both the Taoist ideas discussed above as well as the associative methodology at work in the music. In "Motif Dao," for example, Ware delivers a catchy little riff with typically sharp, precise ferocity, which is then grabbed by Shipp who splinters the melody with provocative embellishments. The pianist never relinquishes the motif, but he chops it up, beats it around, and reconstructs it. The entire group excels at this process of deconstruction and rebuilding. Particularly rewarding in this process is the tactile qualities the musicians offer. Dickey's drumming is fiercely rhythmic, but he rarely serves as a mere timekeeper. His playing prods, reacts, and interacts. His chunky three-dimensional trades with Ware's blustery tenor, his poignant fills, and the skating textures he places beneath Ware and Shipp attract constant notice without distraction.

The quartet engages in some new approaches on *Dao*. As Ware offers, "We're dealing with a full spectrum and each given approach is equally valid. My only goal was to make it different than anything else we'd ever done. That's always my goal." Especially striking is "Rhythm Dao," which calls upon Shipp,

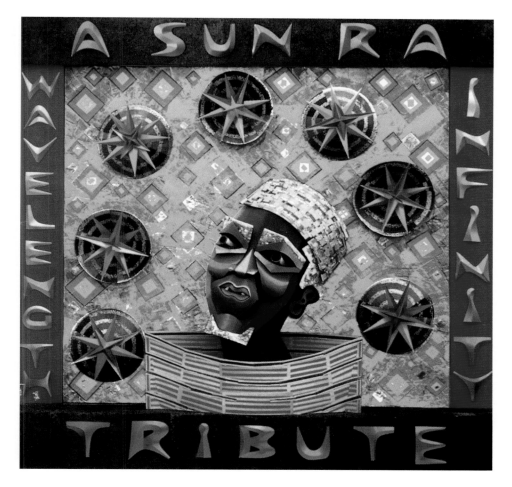

Compilation

Wavelength Infinity: A Sun Ra Tribute *(Rastascan Records)*

Sun Ra was one of jazz's most enigmatic, avant-garde figures. For this brilliantly eclectic tribute to him, artist Ronald Davis has created a beautifully skewed cover that combines a totemic African motif centered around an almost space-age-looking array of sparkling stars and colorful boxes. It beautifully represents both Ra's powerful, rooted Afrocentric message as well as his fascination with the possibilities of exploring the vast expanses of outer space.

designer
Hilary Davis and Ronald M. Davis

artwork
Ronald M. Davis

William Parker

In Order to Survive:
Compassion Seizes Bed-Stuy
(Homestead Records)

cover art
Jeff Schlanger

nspiration for the artwork of this album comes directly from the music itself. *In Order to Survive* is the name of William Parker's small ensemble group; the name comes from the words, 'in order to survive we must sometimes die many, many times in one lifetime.' On this recording the group was: Rob Brown, alto sax; Susie Ibarra, drums; Cooper Moore, piano; and William Parker, bass. The painting was done live during the recording of the album. Mr. Schlanger's painting/design work has also appeared on William Parker's two previous albums (all three of which combine to form a *Sound Trilogy*), as well as on albums by Charles Gayle, Julius Hemphill, and the World Saxophone Quartet."

—Steven Joerg, label manager, Homestead Records

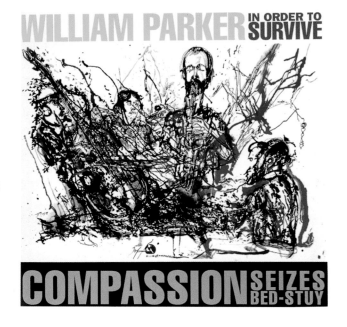

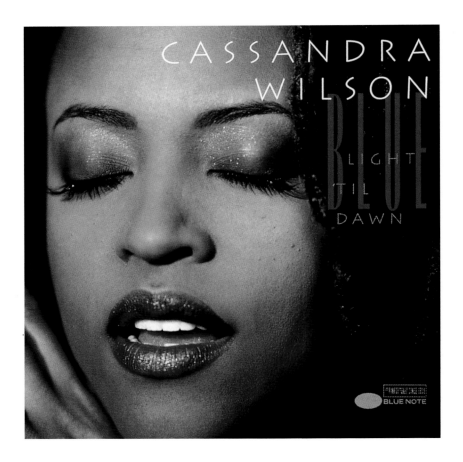

Cassandra Wilson
Blue Light 'Til Dawn *(Blue Note)*

The record that made Wilson the jazz singer into Wilson the star features a simple design by Mark Larson and excellent pictures by Chris Callas that highlight the recording's greatest asset: Wilson herself. A close-up of the lovely singer, her lips slightly parted and eyes closed, suggests qualities of her music: uncommon beauty, emotional closeness, and a sensual melancholy, all of which make her one of jazz's most unusual and compelling singers.

designer and art director
Mark Larson

photographer
Chris Callas

Billie Holiday
Lady in Autumn: The Best of the Verve Years *(Verve Records)*

This classic photo by Herman Leonard is used so often it's almost a jazz cliché. The bright lipstick, shiny pearls, and hair full of flowers instantly identify the great Billie Holiday. But the pained expression, the intense concentration, and the sheer power of her presence prove that this image—employed here for a compilation of Holiday's later recordings—is as vivid today as the day it was shot.

art director
Alain Frappier

photographer
Herman Leonard

Art Pepper

Live at the Village Vanguard
(Contemporary/Fantasy)

When Art Pepper appeared for a week's engagement at the famous Village Vanguard in New York, it was a monumental occasion for jazz. As Peter Keepnews points out in his perceptive liner notes, "some might say that the mere fact that Pepper was 'alive' in 1977 was noteworthy in itself." Yet after years of drug abuse, prison stints, and a lack of the professional recognition he'd long deserved, the Los Angeles–based alto saxophonist finally made it to his first New York gig—and the results show him in brilliant form. Not only does Mitsushiro Sugawara's striking cover photo show the intensity in Pepper's face, but the inside notes by Keepnews, accompanied by Pepper's own notes on the various songs he chose to play, give this package wonderful insight into one of hard bop's most talented—and often overlooked—saxophone heroes.

designer
George Kershaw

photographer
Mitsushiro Sugawara

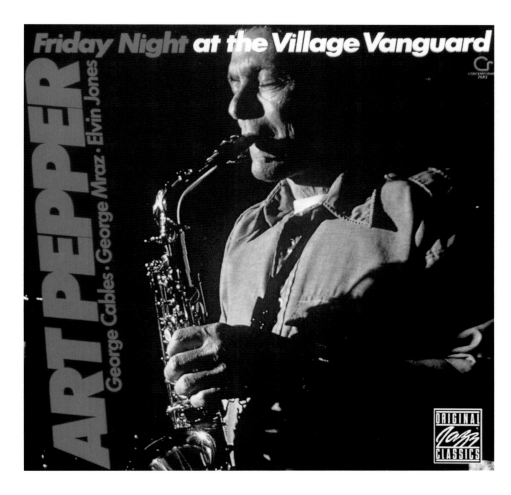

NRG Ensemble

This Is My House *(Delmark Records)*
The multilayered cover demonstrates the understanding that designer Sandy Sager and art director Kate Hoddinott have for the searing avant-garde jazz of the NRG Ensemble. The photos of the musicians mingle with and are partly obscured by peeling playbills and posters pasted upon the walls of city streets. The effect underscores the often transient nature of the musician's place within the world: one minute you're on top, then you're covered over by the next new thing.

designer and photographer
Sandy Sager

art director
Kate Hoddinott

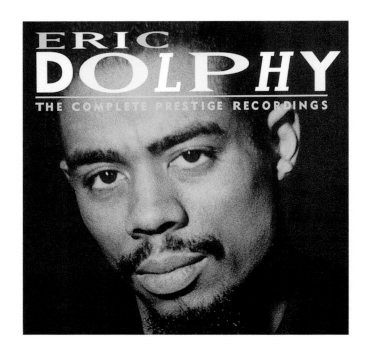

Eric Dolphy
The Complete Prestige Recordings
(Fantasy)
Simple, clean, and delicately shaded, Esmond Edwards' cover photo for this nine-disc retrospective of Eric Dolphy's Prestige recordings perfectly captures the L.A. saxophonist's quiet intensity and deep spirit. One of the leaders of the post-bop jazz avant-garde, Dolphy's greatest work is contained in this package, along with excellent liner notes, photographs, and a detailed bibliography of writings about the jazz giant.

designer
Jamie Putnam

photographer
Esmond Edwards

One of the main concerns here—whether it was Rahsaan or guys I was that tight with personally or had produced—was that they weren't what I call 'hometeam mentality reissues' of old material. This is a portrait of a human being who is an artist, so they all had to be different to reflect that. "If we did that properly in the anthology stage, then people would want to go buy the [original] titles also, because if you liked the tune "Black and Crazy Blues," then you might want to go buy the album it came from, which was *The Inflated Tear*. So it was set up to knock over dominoes, you know. The boxes were the first domino and the titles were the second."

—Joel Dorn, compilation producer

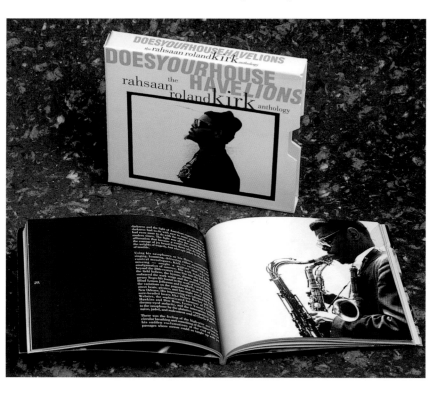

Rahsaan Roland Kirk
Does Your House Have Lions: The Rahsaan Roland Kirk Anthology
(Rhino Records)

designer
N. Kellerhouse

art director
Geoff Gans

photographer
David Gahr

Introduction

by Kim Gordon

Record covers always held a fascination for me. As a child, I used to pull out each record from my father's collection and examine it. It was only after thoroughly studying the LP jacket that I'd throw the record on to check out the music. I would place the LPs in a row, arranging them first according to musical preference and then to make a visual story sequence. If the cover image was too melancholy and/or creepy I wouldn't play it until last. What to do with the Chet Baker LP jacket which showed a topless woman holding two Lambchop puppets in front of her breasts?!

When I was a teenager, these records still held room for fantasy, being the only source for more than a fleeting glimpse of a band and an indication of how cool they were. Oily finger marks smudged the covers after hours spent poring over the pictures and texts, trying to garner as much information as possible. Information spoken through the semiotics of art-as-portrait. From the soft, air-brushed gooeyness of a Bing Crosby LP to the zipper front of the Stones' *Sticky Fingers* LP, the art told a traditional story.

Music video seems to have replaced the LP cover as the premier medium for pop images today, and CD cover art has taken on its own distinction. Major labels tend to give most of their artists bare-bone budgets with which to produce CD cover art, creating a generic mainstream standard. Often a package will be a single strip of gloss paper with color on one side and black-and-white on the other. Sometimes intriguing surprises emerge from the art departments of the big-league labels, but more often the medium is best utilized by independent artists and labels—especially those working in the artful arena of ambient/noise music.

Within the span of a single generation the LP cover has been bustled into the realm of limited editions and specialty packaging, and designers have had to confront the limitations of a six-by-six-inch plastic square. Many of them have grappled with it admirably, maximizing the medium, but perhaps it isn't wise to settle too comfortably (or grudgingly) into any format. My two-year-old daughter, attracted to the small, shiny objects, loves the sound of the clashing plastic as she hurls them into the trash.

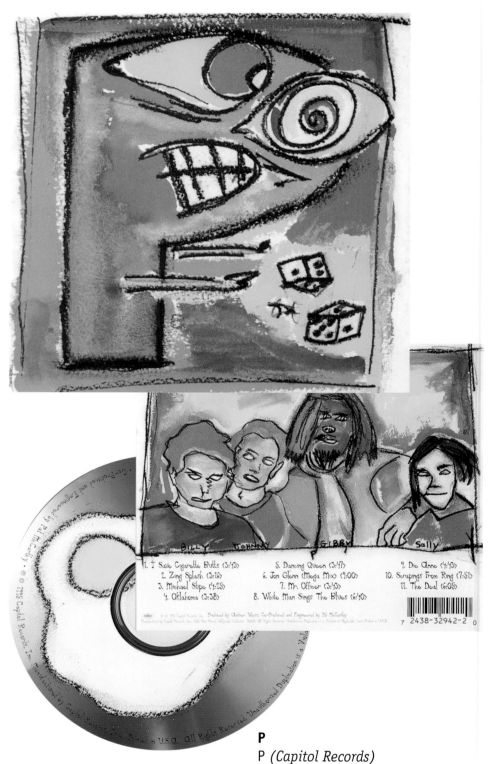

"I did a lot of painting in college. It was funny—I was president of the student art association. It was something I was elected to after I did this goofy, controversial sculpture thing. I wasn't an art major—I was a basketball jock/stoner—but it was such a white bread school that when I'd put my paintings up, those would get more attention than the art students' work. I've got pretty decent compositional skills, but I can't do something big and shrink it down and make it look good. To me, that's what destroyed album cover art. When CDs came out people still did their original artwork on twelve-by-twelve-inch [paper] and then they'd send it to the CD [manu-facturer] and they'd shrink it down, and it looked like shit. Early CD covers really suck. To me, still, it's too small. Like, the ulti-mate CD cover would be a pink background with a big green dot on it—just something to catch your eye—because you can't put artwork on something that small."

—Gibby Haynes, P

"Gibby brought in his work and we thought, 'This is going to be great.' He painted in fluorescent colors, so we ended up printing in fluorescent colors trying to match his art as closely as possible. It's actually a four-color process using four fluorescent inks to accomplish that. I think the effect was pretty appropriate for the band, and true to his art work as well."

—Tommy Steele, vice president, art & design, Capitol Records

P
P *(Capitol Records)*

designer and art director
Wendy Dougan

art director
Tommy Steele

artwork
Gibby Haynes

print production
Christina Bookman

RoCK

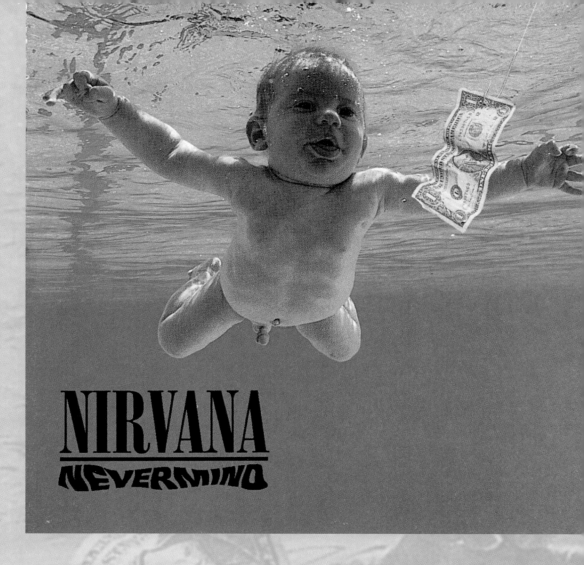

Nirvana
Nevermind *(DGC)*

Nirvana's success not only altered the face of mainstream rock, but it left an indelible mark on the band's hometown of Seattle. A certain innocence that underpinned the obscurity of the Pacific Northwest music scene was lost as clueless A&R scouts began to bob around the tight-knit milieu like the baby in the picture lured by the pretty greenback.

designer and art director
Robert Fisher

photographer (cover)
Kirk Weddle

photographer
Michael Levine

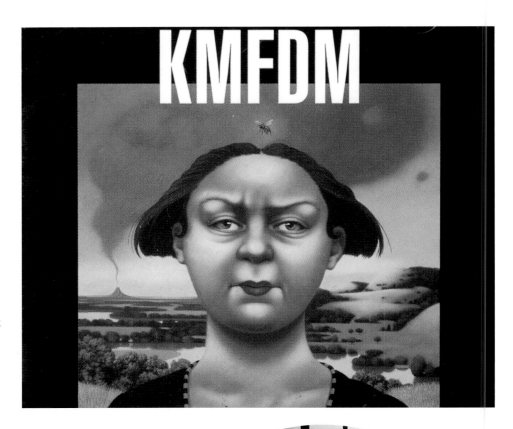

K MFDM was already familiar with my work, and when they asked me to do the painting, they already had the title, *Nihil*, and that was sort of the theme behind that painting—which I was planning on doing anyway. Actually I did two versions of the painting. They both have the volcano in the background, and it's the same face, but the colors are different. I was doing one for them and one for a show I was having in San Francisco. They turned out somewhat different, but it surprised me how similar they were."

—Francesca Sundsten, artist

KMFDM
Nihil (Wax Trax!/TVT Records)
After years of bold cover art designs by renowned graphic artist Brute, KMFDM opted for this invitingly surreal, Bosch-like image that is both foreboding and funny—a visual pun alluding to the dark post-modern cloud hovering over our heads.

artist
Francesca Sundsten

type designer
Chris Zander

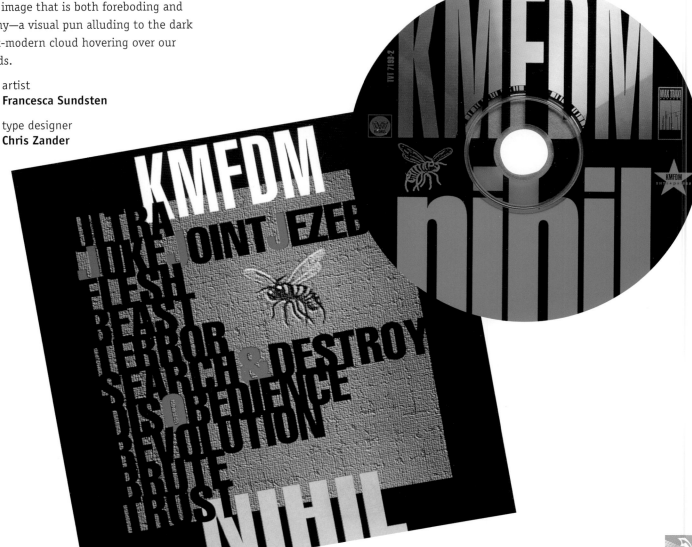

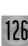

"The girl in the snapshot is the drummer Glen's older sister Georgia. It was taken, I think, in the late '50s or early '60s—a vintage photo from the family album. They were showing us a lot of stuff and we just said, "God, that's a great image." There's something about an image that naive that's wonderful. You know, we all have this design sense, and a lot of times we try to un-design things to make them look real, and this one worked out that way to begin with."

—Tommy Steele, vice president, art & design, Capitol Records

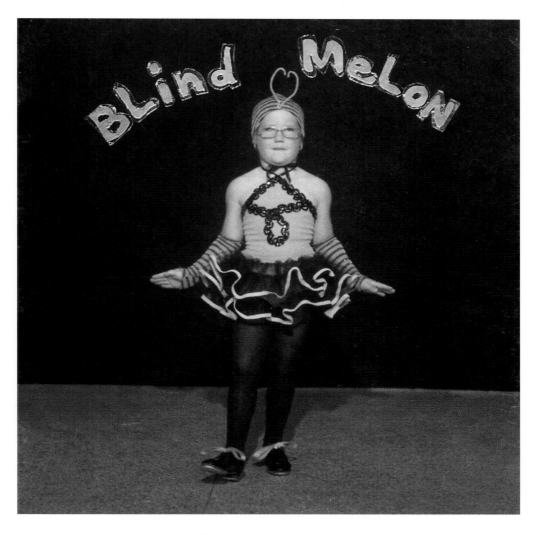

Blind Melon
Blind Melon *(Capitol Records)*

art director
Tommy Steele

cover
Georgia Graham

photographer and collage
Heather Devlin

Aerosmith
Pump *(Geffen)*

Pump was Aerosmith's big comeback album, and remains the band's greatest album to date. The songs on it somehow combined everything that the band had been in the past with a fresh, more incisive attitude. Their signature sexual innuendo gyrated alongside songs that addressed such daunting issues as kicking drugs and child abuse.

art directors
Kim Champagne and Gabrielle Raumberger

photographer
Norman Seeff

photographer (truck)
© American Stock Photography

logo rendered by
Andy Engel

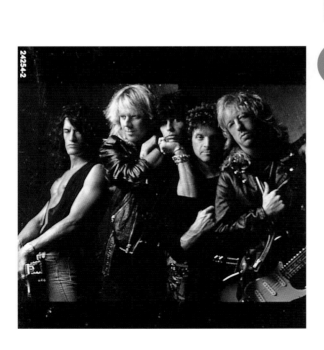

came up with the title shortly after our *Permanent Vacation* tour had ended and we were having a business meeting. As usual I was daydreaming, looking around at the titles of our previous albums which adorn our manager's office and I'm going, 'Oh we've gotta do another one of these now.' You know, another album, another title and that's really where *Pump* originated, at that meeting, because I thought the Aerosmith logo reminded me of the old Flying A gasoline sign and I started going with the whole gasoline station theme. I started working with one of the guys at the office, Keith Garde. I told him about my idea and it just became *Pump* and we thought it was great. Everybody thought it was great—except the guys in my band but *Pump* did win out. I thought it was such a good title because it said so many things. It was sexual, it was musical, it was '90s."

—Brad Whitford, guitarist

RoCK

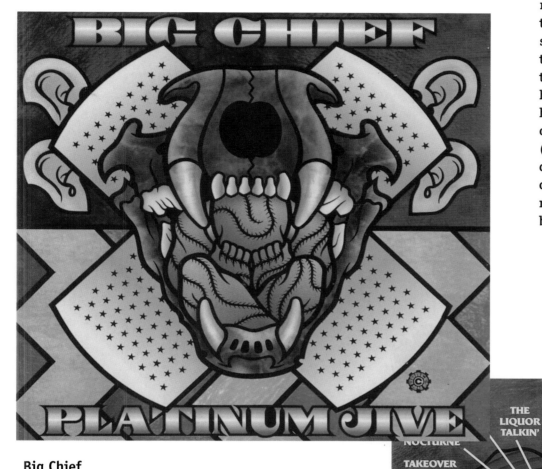

Big Chief's move to a major label was like the lion tamer sticking his head into the lion's mouth—Ta Daa!—a corny stunt that's been done before but is still potentially dangerous. On the cover our battle-scarred little man has put himself in harm's way and is about to get himself chewed up and spit out, much like Big Chief itself! (John Hill is responsible for the colors. I used photos of discolored skin from my brother's medical textbook to provide the background.)"
—Mark Dancey, guitarist

Big Chief

Platinum Jive *(Capitol Records)*
Big Chief formed out of the staff of *Motorbooty*, a humor magazine in the tradition of *Mad*. Guitarist Mark Dancey is also the chief illustrator of *Motorbooty*, and his assertive illustrations have graced the covers of all of Big Chief's albums.

cover art
Mark Dancey

graphic assistance
John Hill

When I first started work for KMFDM in 1986, I was pretty much tied to the musical content to base my work around and this sometimes led to problems—namely artistic block. However, as time went on, Sascha Konietzko gave me more freedom to come up with my own themes, unrelated to the music. The result, *Money*, was based upon my disillusionment with the street lifestyle I was experiencing at the time, and the art carries with it the implication that no matter what temptation lies in your path, you still gotta pay! Incidentally, the guy with the shotgun is a self-portrait.

—Aidan Hughes ("Brute"), artist

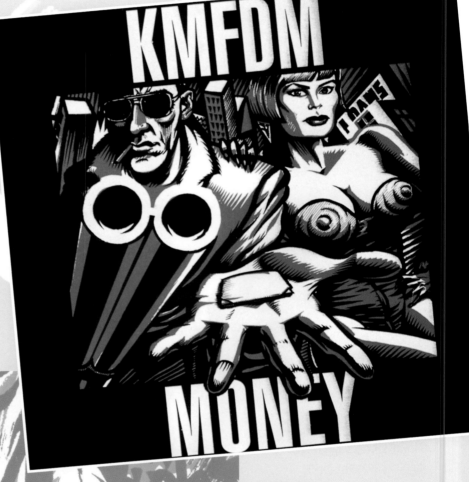

KMFDM
Money *(Wax Trax!/TVT Records)*

artist
Brute

typesetter
Chris Z

Megadeth
Youthanasia *(Capitol Records)*

designer and digital illustration
Hugh Syme

art directors
Tommy Steele and Hugh Syme

illustrator (logo)
Mick McGinty

photographer (band photos)
Richard Avedon

photographic elements
Tony Frederick

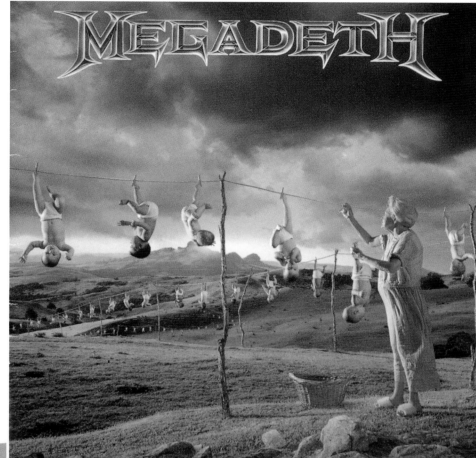

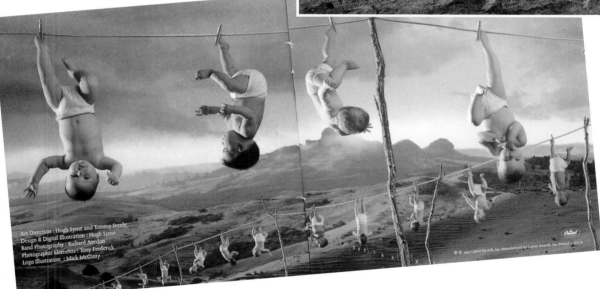

For the first part of their life as a band, Megadeth had been utilizing an illustrator who did a lot of their T-shirt art and we wanted to elevate their imaging a little bit beyond that level. We'd gotten a fellow named Hugh Syme who'd worked with the band once before. This was the next collaboration with Hugh. *Youthanasia* was Dave Mustaine's concept and it was all about how youth is the resource we should be embracing and we're just kind of killing off our youth. The play on words meaning killing off our youth, not the aged." —Tommy Steele, vice president, art & design, Capitol Records

Cocteau Twins
Milk & Kisses *(Capitol Records)*

Ever since their early days with 4AD, the Cocteau Twins have always managed to complement their opulent, softly surreal music with impeccable cover art imagery. This album and the two remix EPs that preceded it make for a perfect triptych that combines the hard and sharp with the soft, vibrant, and muted textures that comprise the English trio's music.

photographer
Spirol Politis, A Blue Source Sleeve

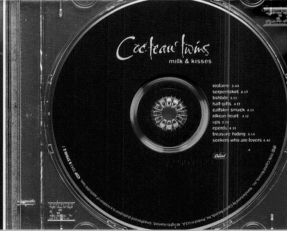

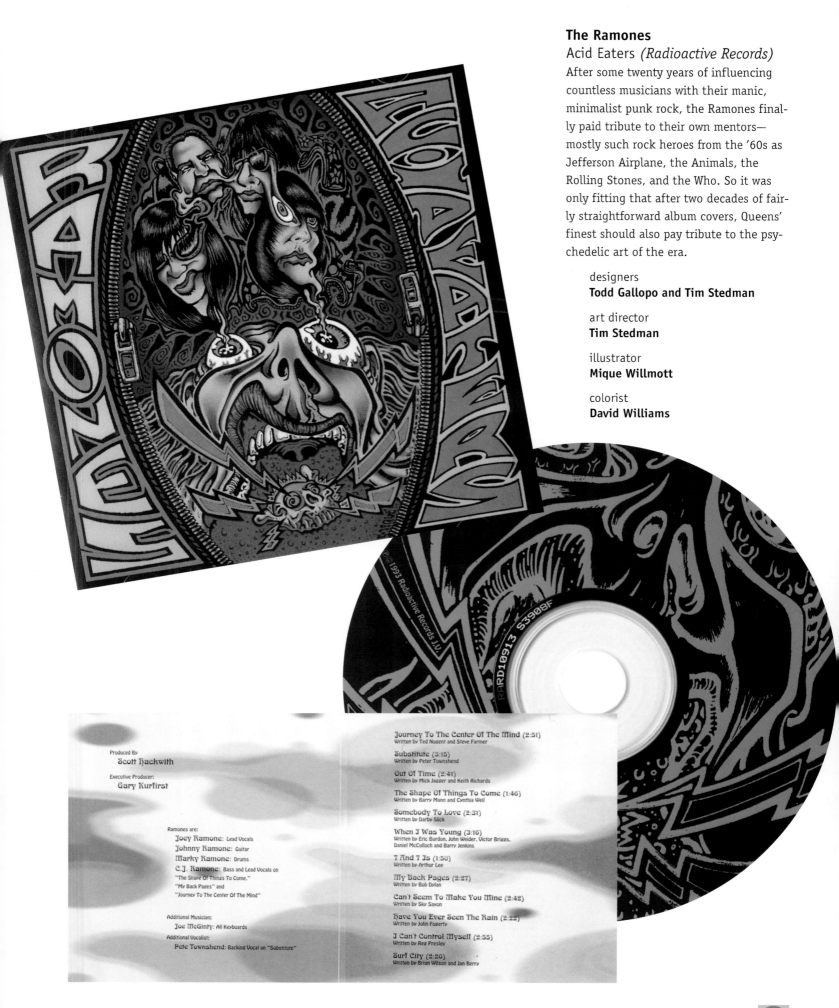

The Ramones
Acid Eaters *(Radioactive Records)*

After some twenty years of influencing countless musicians with their manic, minimalist punk rock, the Ramones finally paid tribute to their own mentors—mostly such rock heroes from the '60s as Jefferson Airplane, the Animals, the Rolling Stones, and the Who. So it was only fitting that after two decades of fairly straightforward album covers, Queens' finest should also pay tribute to the psychedelic art of the era.

designers
Todd Gallopo and Tim Stedman

art director
Tim Stedman

illustrator
Mique Willmott

colorist
David Williams

Produced By
Scott Hackwith

Executive Producer:
Gary Kurfirst

Ramones are:
Joey Ramone: Lead Vocals
Johnny Ramone: Guitar
Marky Ramone: Drums
C.J. Ramone: Bass and Lead Vocals on
"The Shape Of Things To Come,"
"My Back Pages" and
"Journey To The Center Of The Mind"

Additional Musician:
Joe McGinty: All Keyboards

Additional Vocalist:
Pete Townshend: Backing Vocal on "Substitute"

Journey To The Center Of The Mind (2:51)
Written by Ted Nugent and Steve Farmer

Substitute (3:15)
Written by Peter Townshend

Out Of Time (2:41)
Written by Mick Jagger and Keith Richards

The Shape Of Things To Come (1:46)
Written by Barry Mann and Cynthia Weil

Somebody To Love (2:31)
Written by Darby Slick

When I Was Young (3:16)
Written by Eric Burdon, John Weider, Victor Briggs,
Daniel McCulloch and Barry Jenkins

7 And 7 Is (1:50)
Written by Arthur Lee

My Back Pages (2:27)
Written by Bob Dylan

Can't Seem To Make You Mine (2:42)
Written by Sky Saxon

Have You Ever Seen The Rain (2:22)
Written by John Fogerty

I Can't Control Myself (2:55)
Written by Reg Presley

Surf City (2:26)
Written by Brian Wilson and Jan Berry

Tool

Undertow *(Zoo Entertainment)*

An undertow is a current or a force that runs counter to that which is apparent. The bizarre image on the cover, an abstract red object on a black background, suggests tentacles, curling fingers, a bracelet, a ribcage—and behind the shifting allusions and ambiguity lurks the ominous suspicion that it could be something worse.

art director
Adam Jones

art concept
Tool

creative director
K. Lee Hammond

3D art
Len Burge III, Paul, and Adam

photographer
Dean Karr

welders
Armando "Grande" Gonzalez and Rob Ramsdell

RoCK

We do all our own artwork all the time. With this one Leslie wanted something simple 'cause we always have pretty crazy, intense artwork. She was like, 'What about black-and-white?' And then Kerry came up with just having our faces on the front of it and I came up with the cutout across the eyes part, 'cause I used to work doing children's pop-up books. You can pick whoever you want to be on the cover—you can change it every week. You walk into Tower Records and there's like tens of thousands of CDs and everyone sort of uses the same format— that's why I always push to do something different because we have the ability to do it and everyone in the band is supercreative and artistic."

—Terri, guitarist

Red Aunts
Saltbox *(Epitaph Records)*

designers and art directors
Red Aunts and Nick Rubenstein

photographer
Danny Hole

The Best Music **CD** Art+Design

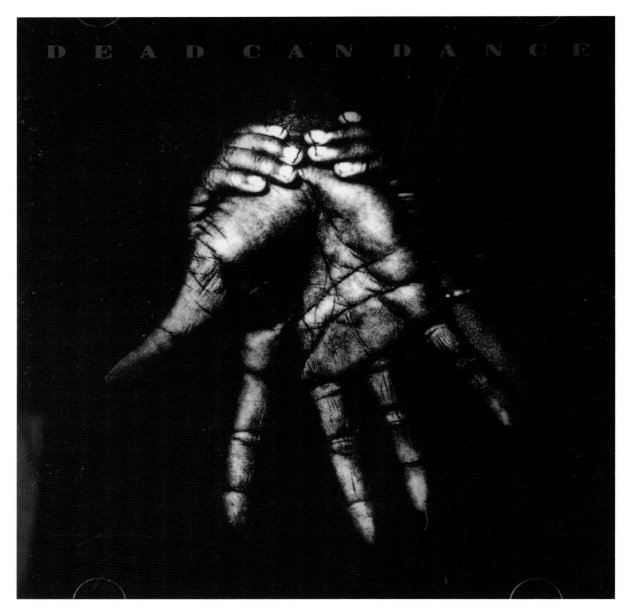

Dead Can Dance
Into the Labyrinth *(4AD Records)*
For well over a decade Lisa Gerrard and
Brendan Perry have experimented with
traditional music from around the world,
often melding different traditions into
exciting, new, and mesmerizing combina-
tions. Touhami Ennadre's beautiful pho-
tograph—with its deep textures, rich
tonality, and the symbolism of the tiny
young hand grasping the larger, older
hand—is quite moving.

designers
Chris Bigg and Brendan Perry

photographer
Hands of the World
Touhami Ennadre

RoCK

The Raspberries came out of Cleveland in 1972 with a sound that was already brilliantly homogenous—'Go All the Way' and 'Tonight' (their first two singles hits) were ringers for Paul McCartney, thanks to Eric Carmen's vocals, and the songs that followed lived up to a similar standard. Such romanticism and nostalgia had no great depth, but it was great entertainment."

—Dave Marsh, *The Rolling Stone Record Guide*

The Raspberries
The Raspberries Greatest Hits
(Capitol Records)
This cover is distinguished by its utter lack of ambiguity. What you see is what you get: a colorful, literal representation of the music inside. Like the Raspberries hits it contains, this packaging is bright, simple and to the point.

designer
Dyer/Mutchnick Group

art director
Tommy Steele

illustrator
Dale Sizer

E l Vez, the Mexican Elvis, wanted a parody of Paul Simon's *Graceland* album. So I did the painting and laid it out exactly like *Graceland*. Where *Graceland* has that African painting on the front, I did almost the same painting but with El Vez riding on a horse instead of the warrior guy. It's really funny when you put the two together. I don't know what Paul Simon thinks about this. The thing is, Paul Simon took so much flack for ripping off the poor African musicians. I don't think he could complain much about the poor Mexican musicians ripping him off."

—Jon Bok, cover artist

El Vez
Graciasland *(Sympathy for the Record Industry)*

cover artist
Jon Bok

photographer (El Vez)
Randall Michelson

photographer (collage)
Pablo Prietto

concept and typesetter
El Vez

logo
Virtu

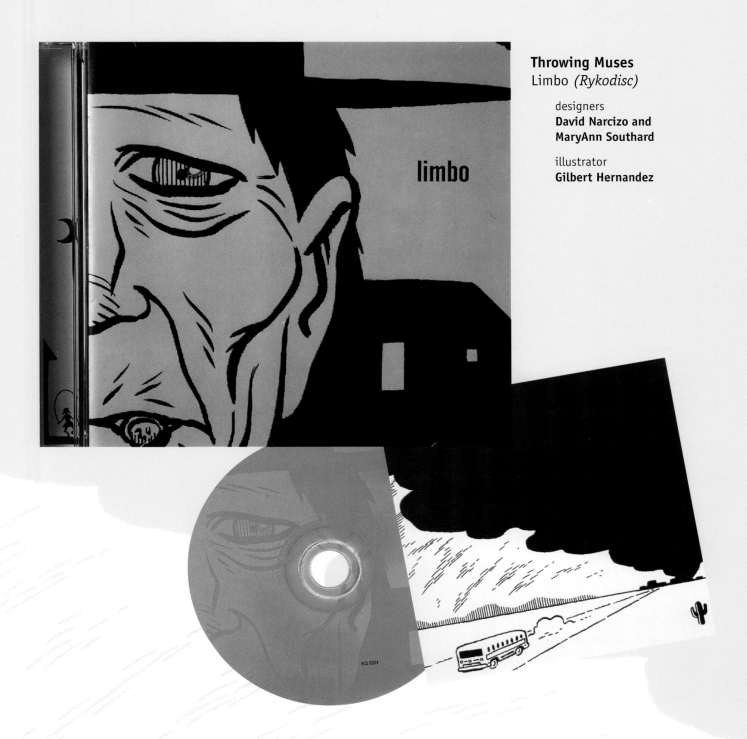

Throwing Muses
Limbo *(Rykodisc)*

designers
**David Narcizo and
MaryAnn Southard**

illustrator
Gilbert Hernandez

The band members were fans of my work in *Love + Rockets* and they basically asked me if I would do a cover for them and I said, 'Only if you tell me what you want.' They said 'Oh, basically what you do,' and I go, 'You've got to be more specific.' So I had them look through the *Love + Rockets* collection to see what images they liked and I would alter them enough to make them theirs and they did and the rest was pretty simple. Just getting the work out to them. They didn't really talk about it. They just basically said, 'We like this one' and pointed to this picture, looking for that mood in the picture without really explaining it to me, and I understood. As soon as they'd showed me a picture that I've drawn, I know what they're looking for."
—Gilbert Hernandez, illustrator

Compilation
A Tribute to Bauhaus: The Passion of Covers *(Cleopatra Records)*
When most people think of vampires, Bela Lugosi comes to mind. But this print animation is from the progenitor of all vampire cinema, F.W. Murnau's 1922 film *Nosferatu*. It's an apropos choice for a tribute to a group that was the architect of the Gothic rock genre.

designer
Eunah Lee

We wanted to go with the over-the-top sort of vampire connection—you know like the Bauhaus song "Bela Lugosi's Dead"—but unfortunately, Bela Lugosi's image is copywritten and really overseen by his son, so any time it appears you get in trouble. So we went with the *Nosferatu* image. *Nosferatu* is so perverse for its time period. The only other person who ever came as close to that creepiness was Klaus Kinski."

—Athan Maroulis, Cleopatra Records

Slant 6
Inzombia *(Dischord Records)*
Although this cover certainly conjures up memories of the creepy camp of classic '50s horror flicks, the music this trio makes is neither creepy nor campy. It does, however, exude the same stark yet rich textures of this black and white homage.

photographer
Charles Steck

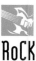

ast night *The Fly* was on TV, and the Misfits wrote a song called 'Return of the Fly,' which was about the sequel to that movie. That's the great thing: [the band] is very movie-oriented [with songs like] 'Astro Zombies' and 'She.' So it was great watching that movie and realizing this is exactly what the band is about. The words meet the absurdity of the way they dressed up on stage and their record covers, etc. I wanted to make sure I included not only the original artwork for all the records, but we also wanted to make them colorful. So we used duotones, like the blues and reds, and made sure we showed the old track listings underneath the song tracks in the front of the book, and the movie poster that's in the front and the one that's in the back. One of my favorite parts is the black cases—I just couldn't put *Static Age* on the other three discs. I wanted that separate, to have its own special packaging, because as far as I'm concerned it's one of the top five punk albums of all time. We wanted this to be special, not something that you just put away."

—Tom Bejgrowicz, Caroline Records

The Misfits
The Misfits *(Caroline Records)*
Considering the brevity of their existence, the Misfits certainly made a huge impact on both the punk rock and heavy metal music scenes. They themselves were like some strange mutant concoction of vintage '50s sci-fi flicks and the Ramones, blending an impeccable pop sensibility with edgy punk energy and over-the-top ghoulish imagery. There are a lot of bands who might be worthy of this coffin-as-boxed set idea, but the Misfits deserved a deluxe boxed-set, as many of their records are quite rare.

designer
Roger Gorman, Reiner Design, NYC

art directors
Tom Bejgrowicz and Roger Gorman

illustrator
Dave McKean

liner notes
Eerie Von

box set producer
Tom Bejgrowicz

packaging
AGI

enamel badge
T. J. Productions

The Best Music **CD** Art+Design

7 Year Bitch
¡Viva Zapata! *(C/Z Records)*

front cover painting
Scott Musgrove

back cover painting
Mia Zapata

photographer
Klaus Zach

photographer (photo of Mia)
Jackie Ransier

The idea for the album title and cover struck us all at about the same time. We were in a van on our way to Mia's wake and saw a billboard for the opera *Don Carlos* written in old Spanish lettering against sunset colors. Since the cry "Viva Zapata," borrowed from the Mexican revolutionaries, had been reborn among friends of Mia since her murder, it was obvious to us. In the end it turned out a bit different, but the idea was to show Mia Zapata as the beautiful, valiant, determined individual she was. I think we wanted to erase any nightmarish images we might have created in our minds of Mia in her last moments and replace them with a permanent one of her being serene and strong, looking forward, unafraid. Roisin and I were in the public library looking at art books to help us get an idea of what to tell whatever artist we hired. We were thinking seventeenth-century Flemish portraiture. A young man who happened to be an artist overheard us and said he'd like to give it a shot. Scott Musgrove had only two black-and-white photos of Mia to work off of, along with our comments. I think he did an excellent job portraying Mia in the traditional outfit of her distant cousin, Mexican hero Emiliano Zapata, who is the subject of Mia's own painting on the back cover. This album, inside and out, is a tribute to a woman who influenced us individually and as a band in so many ways. Her poetry and philosophy were humble yet proud, and melancholy but somehow celebratory too. In life she was as much a child as an old woman. I think you can see those dichotomies in her eyes here."

—Elizabeth Davis, 7 Year Bitch

RoCK

This cover is a detail from a sixteenth-century Dutch master—their still-life paintings were popular for over 100 years. People of that period could read a lot into paintings. For example, different combinations of flowers that didn't ordinarily bloom at the same time of year, or moths and butterflies had a symbolic significance that is lost on us today. The richness of this painting serves the reverb-drenched, wide-open spaces of *Good* well."

—Mark Sandman, Morphine

Morphine
Good *(Accurate/Rykodisc)*

designer
Eric Pfeiffer

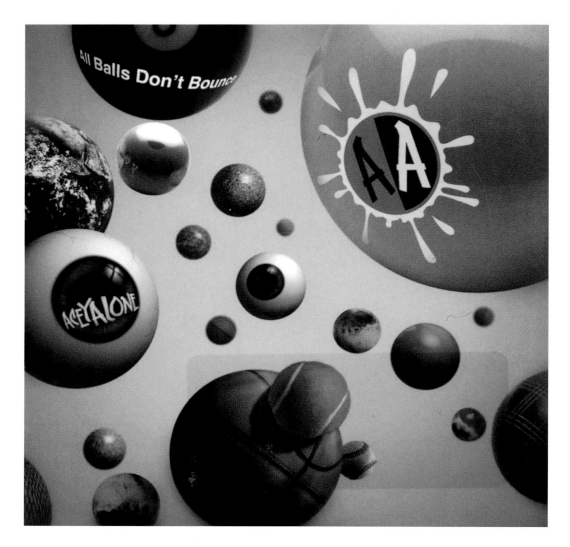

Aceyalone
All Balls Don't Bounce
(Capitol Records)
Exploring all the facets of a particular image is something that any good critic must do, and social critics are no exception. A single object as ordinary as a ball, for instance, can connote everything from an atom to a planet to an eight-ball. This is exactly the kind of rich exploration Aceyalone strives for with the characters that inhabit the hip-hop grooves flowing through this record.

designer
Cimarron/Bacon/O'Brien

art director
Tommy Steele

photographer
Peter Darley Miller

RoCK

Overwhelming Colorfast
Overwhelming Colorfast
(Relativity Recordings)
This image of two furry Lilliputian-sized creatures clinging sleepily, almost oblivious to human fingers forming a peace sign is as good-natured and to the point as the music it accompanies.

designer
Allen Wai

art director
David Beth

photographer
**Jan Du Singh,
Pressenbild/Photoreporters**

I've actually been sort of pigeonholed as being 'The Grunge Photographer,' when in actuality I'm really quite an accomplished studio photographer as well. I did this in an afternoon. It was amazing. We decided that Ed [Eddie Spaghetti] should be the devil. Sub Pop art director Jeff Kleinsmith's wife made the angel's wings and the band brought in a smoke machine, and it just all came together."
—Charles Peterson, photographer

Supersuckers
The Sacrilicious Sounds of the Supersuckers *(Sub Pop Records)*

designer
Kenneth Sherwood

photographer (devil/angel photos)
Charles Peterson

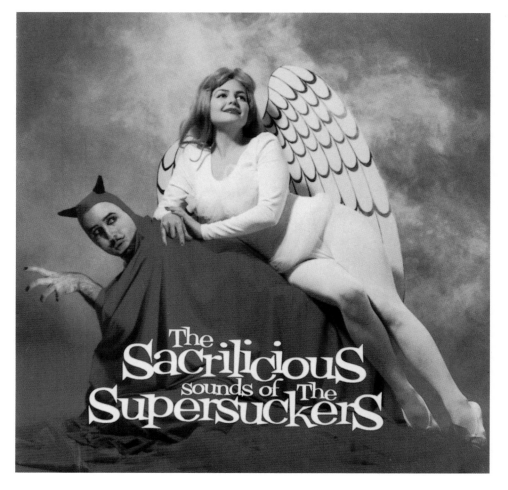

Adam [Jones, Tool guitarist] had a vision of what he wanted done and I do computer animation as well as print work, so that knowledge of computer animation really helped us pull off doing print animation. In terms of—we call it a smoke box with an eye curtain—we had one eyeball to start with and then I created the whole eye curtain. Adam would talk about his concepts and I would sort of explain to him how we needed to produce it so we could have a finished product that we all wanted. With software nowadays you can test your animation to see how it's moving before it's even printed so I was running my animations in [Macromedia] Director to see the movement and make sure everything was lined up correctly and then we would send out our high resolution Photoshop files to our special separator who does this one particular type of separation. I definitely have to give Adam credit because he was the mastermind behind it. We just worked together producing it trying to get a look and feel that would complement the band and enhance the fan's experience, enhance it and make it pleasurable—something that they'd want to look at and feel that they got their money's worth."

—Concetta Halstead, designer, DZN

Tool
Ænima (Zoo Entertainment)

designer
Concetta Halstead, DZN

art concept
Tool

art directors
Adam Jones and Kevin Willis

computer illustrator
Cam De Leon

photographer
Jeff Novac

photographer's assistant
Fabricio Di Santo

sculptor
Adam Jones

smoke box
Cam De Leon

model
Alana Cain

fx consultant
Mark Rappaport

flocker
Shane Mahan and Karen Mason

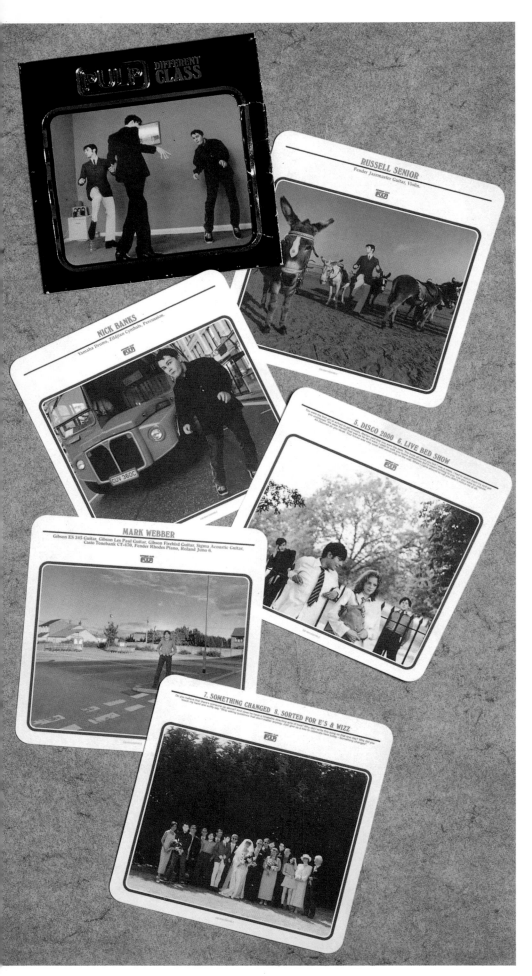

Pulp
Different Class *(Island Records)*

Of all the bands that bounded into the United States as part of what many journalists billed the Second British Invasion, Pulp was certainly the most scintillating. Not content with merely resurrecting the classic Brit-pop sounds of days gone by, they cultivated their retro-blend (allusions to Bowie, T-Rex, the Kinks, etc.) into some fine satire that bites with all the acumen of *Monty Python's Flying Circus*. In fact, the twelve strange pictures featured on the six interchangeable liner cards of this interactive cover design could almost be stills from the sketches of the classic British comedy troupe.

designer
Blue Source

concept
Pulp

photographers
Donald Milne and Rankin

Pulp logo
**The Designers Republic
reprinted courtesy of
Island Records Ltd.**

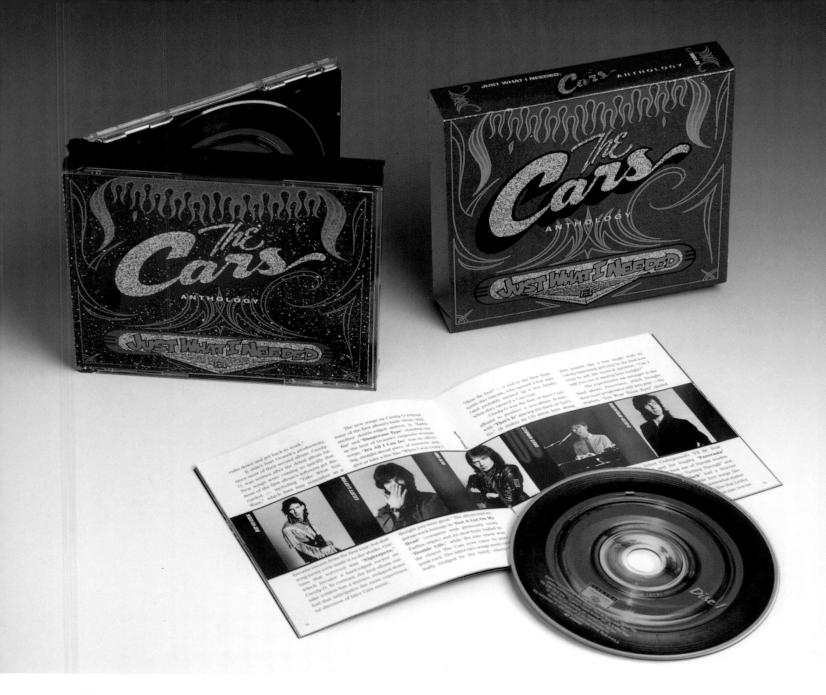

The Cars

The Cars Anthology: Just What I Needed *(Elektra/Rhino Records)*

The Cars were one of the great singles bands of the '80s. Songs like "Good Times Roll," "Candy-O," and "You Might Think" were a definitive element of what New Wave was all about—an important part of the radio soundtrack of the times. This package not only captures the best music that they made, but the colorful spirit of that period in pop music history.

designers
**Monster X and Offerman
Owen Design**

art directors
**Monster X, David Robinson,
and Coco Shinomiya**

front cover pinstriping
Steve Stanford

photographers
**E. J. Camp, David Gahr,
Lynn Goldsmith/LGI B.C. Kagan,
Brian McLaughlin, Michael Ochs
Archives, and Ebet Roberts**

photographer (car detail & guitar photos)
Mark Takeuchi

guitar courtesy of
Elliot Easton, Fender Custom Shop

Everclear
Sparkle & Fade *(Capitol Records)*

Memories tend to sparkle afresh and fade over time. With this cover art, Everclear frontman Art Alexakis assembled a scrapbook of remembrances that tells the band's story as effectively as any of the songs that accompany it.

designer (cover and concept)
A. P. Alexakis

graphic designer
Steven Birch

photographers
family and friends

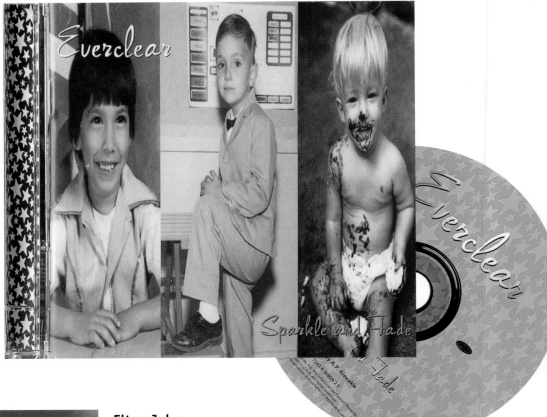

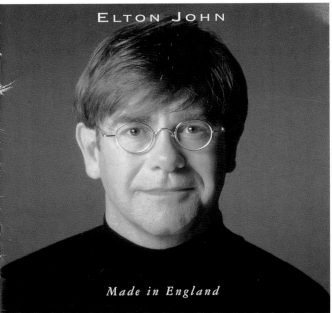

Elton John
Made in England *(Island Records)*

For those who remember Elton John's flamboyant early days, his metamorphosis into one of the more respected down-to-earth singer-songwriters of the post-punk era was somewhat startling. Then again, none of those now-vintage glam trappings would have been so compelling without the very traditional pop composition skills that gave them life. This simple, straightforward, and elegant photo captures the spirit that was always there.

designer
Wherefore Art?

photographer
Greg Gorman

think a lot of what Elton has done during his growth period is simplify things—I think that comes from his sobriety and his focus on life itself in all of his work and all of his energy. When we were doing this session, one of the things that struck me is that Elton really didn't need to hide behind the façade of his wild glasses and crazy hats and everything, and it's one of the reasons we took kind of a straightforward picture. I thought Elton was looking extremely good, and I like the openness and the honesty of the picture. I think Elton has always been an open, very honest person about his life and everything and I think that one of the things that we captured with this picture is the more open, more honest, more vulnerable side of Elton."

—Greg Gorman, photographer

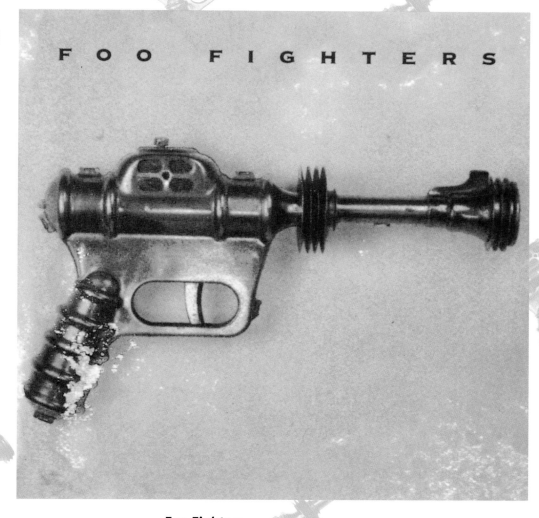

Foo Fighters
Foo Fighters *(Capitol Records)*
A "foo fighter" was the military code phrase for a UFO back in the '50s. Surely the cult following that surrounds UFO speculation is no less strange than the cults that spring up around pop stars. You can take it all as seriously as you choose, and the icons of worship—whether they're 45s or the XZ238 Disintegrator Pistol featured on this cover—will always carry a certain resonance no matter how much you believe.

designer and art director
Tim Gabor

photographer
Jennifer Youngblood

The Best Music **CD** Art+Design

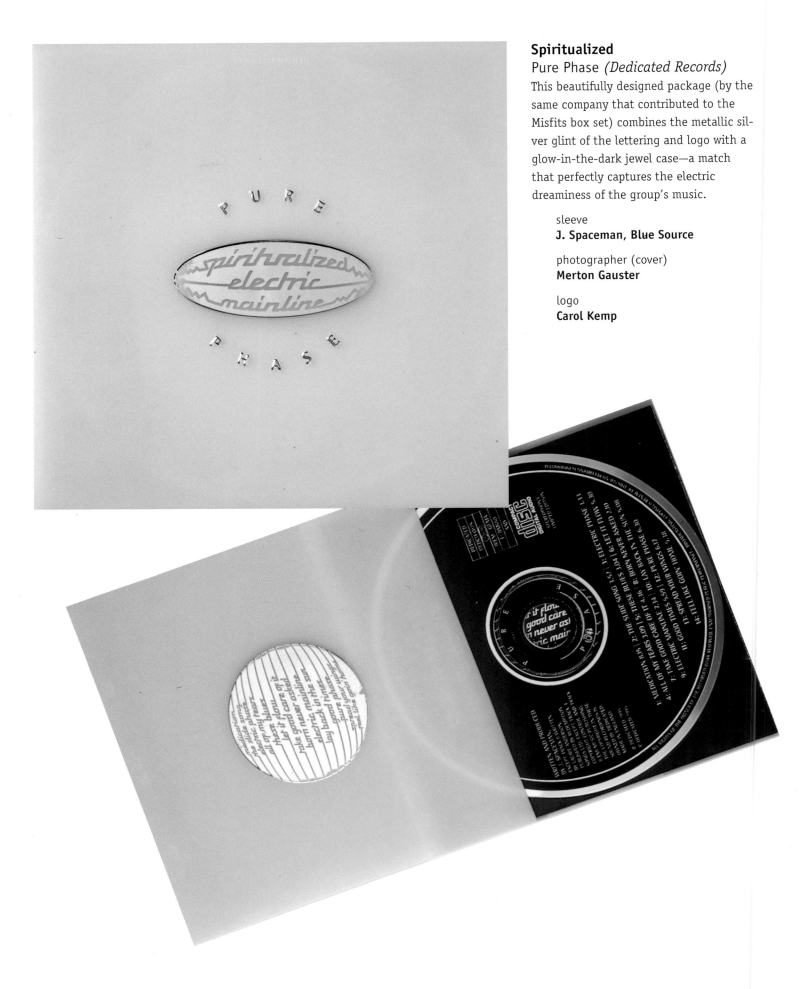

Spiritualized
Pure Phase *(Dedicated Records)*

This beautifully designed package (by the same company that contributed to the Misfits box set) combines the metallic silver glint of the lettering and logo with a glow-in-the-dark jewel case—a match that perfectly captures the electric dreaminess of the group's music.

sleeve
J. Spaceman, Blue Source

photographer (cover)
Merton Gauster

logo
Carol Kemp

In contrast to *Joshua Tree*, these photos were shot in warmer and more colorful surroundings (Morocco, Tenerife, Berlin, and Dublin) to show a different side of U2 than the familiar, very serious one, and in a way, mine too. The shoots were really good fun. The crunch came when we had to make the choice for the front cover. Everyone agreed that there was plenty of stuff, but Bono didn't feel that there was one image to sum up the whole album, so he suggested we use lots of little squares. I was against this, but when I saw it printed I knew he had been right. It works great this way and Steve Averill, the designer, made it look very attractive."

—Anton Corbijn, photographer

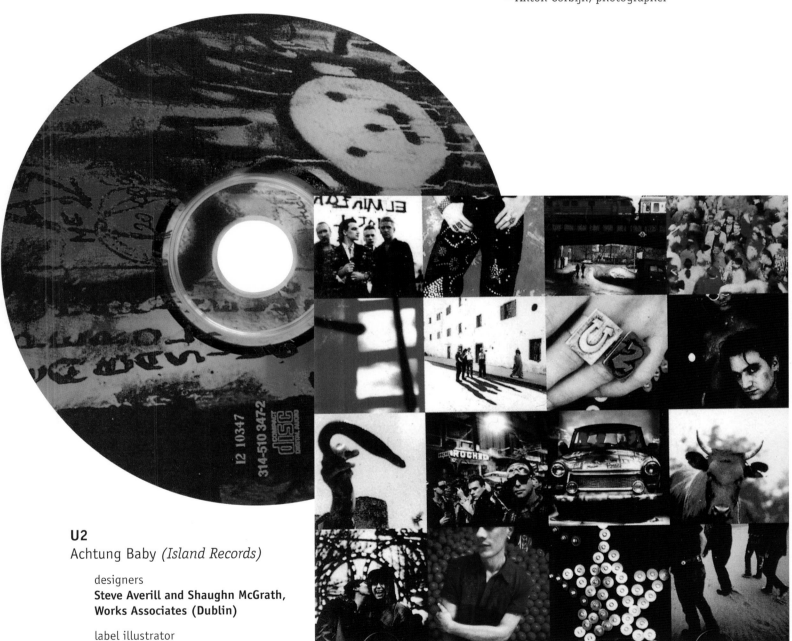

U2
Achtung Baby *(Island Records)*

designers
**Steve Averill and Shaughn McGrath,
Works Associates (Dublin)**

label illustrator
Charlie Whisker

photographers
**Anton Corbijn and Ritchie Smith
reprinted courtesy of
Island Records Ltd.**

David Bowie
Sound + Vision *(Rykodisc)*

Though a profusion of new box sets hits the stores every year, it's rare to find one that's more than a mere compilation, one that truly illuminates the career of a particular artist. The team that put together this landmark box—originally released in the 12-inch-(30-cm) square format to fit LP bins—went to great lengths to create a package that captured not only the sound of Bowie's career but his artistic

vision. Sound + Vision won a Grammy Award for packaging in 1989.

designers and art directors
Roger Gorman & Associates and Reiner Design Consultants, Inc.

photographer
Greg Gorman

liner notes
Kurt Loder

INDEX

The Best Music **CD** Art+Design